Cistercian Studies Series: Number Sixty-six

STUDIES IN CISTERCIAN ART AND ARCHITECTURE

Volume One

CISTERCIAN STUDIES SERIES: NUMBER SIXTY-SIX

Studies in Cistercian Art and Architecture

VOLUME ONE

Edited by Meredith P. Lillich
Foreword by Louis J. Lekai, O. Cist.

Cistercian Publications
Kalamazoo, Michigan
1982

© Cistercian Publications, Inc., 1982

Available in the Commonwealth and Europe from

A. R. Mowbray & Co Ltd
St Thomas House Becket Street
Oxford OX1 1SJ
ISBN 0-87907-866-9

This volume is dedicated to

Louis J. Lekai

Monk, scholar, gentleman

TABLE OF CONTENTS

viii

PREFACE
Louis J. Lekai, O. Cist.

Full understanding and appreciation of the visual arts of a distant past seem to be the privilege of those who grow up surrounded by such monuments. An Italian or a Frenchman, even from small towns away from throngs of tourists, is deeply conscious of his artistic environment. He not only knows and loves every building of the local *piazza,* but even the fountains beyond the dark archways or the altarpieces in the semi-darkness of the local church become a part of his life. He perceives the message of old stones: tales of his ancestors, of past glory or misery, of victory or surrender. Eventually, there develops a snug intimacy between the monument and the man, or more precisely, between the maker and the viewer.

I still remember a sunny afternoon in front of the Pallazzo Publico of San Gimignano. There he was, the elderly gentleman, the local *dottore,* in a dark threadbare suit, but wrapped in an even more conspicuous aura of homely confidence. Noticing my genuine interest, he stepped up to me and offered his services guiding me through the remarkable collection of Renaissance treasures. As he warmed to the occasion and watched my admiring reaction, his eloquence waxed far beyond my limited Italian, but he certainly spoke as if he owned every picture, statue, and manuscript, or had given instructions to the artists on every technical detail. The few bills which he accepted with genuine shyness were the lowest fee I could ever pay for an accelerated course of art appreciation.

Historical art, and particularly architecture, remains still a strange phenomenon to most Americans. Our artistic past does not reach beyond the Classicism or *Empire* of the Founding Fathers. Later imitations of Gothic or Renaissance fail to warm our hearts. For too many of us architecture remains a commodity, furnishing merely a comfortable place to live or work in. When it grows old or fails to serve its original purpose, it is ripe for the ball of the wrecking crew. This has been the sad end of remarkable churches left by their original congregations, ornate hotels of the late nineteenth century with too few bathrooms, mansions too expensive to maintain, railroad terminals of marble and stone--proud but vacant relics of the bygone age of the iron horse. Few could claim to be masterpieces, but they were the best we have ever had. We were unaware of their mute protest. They just had to go.

The studies collected in this handsome volume try to convey to us a message across vast expanses of time and space. For art, in this case visual art, does carry a specific message that could not be delivered through the frozen words of written documents. Language,

even if used by a master, employs the conventional medium of words. These, in the magic workshop of our minds, are translated to ideas, feelings, or logical conclusions. But through the process of this double translation (the author's and of the reader's) much of the intended meaning may be lost or misunderstood. The artists' media are natural rather than conventional. Therefore the message does not call for translation; the meaning penetrates us directly, as laughter radiates happiness, tears evoke compassion.

Religious institutions of the past have left us with an inheritance of great complexity, but it is expressed through all means of communication, including art. The message of the nascent Cistercian Order was the love of solitude, simplicity, poverty, and asceticism. Eloquent masters of words, as Saint Bernard of Clairvaux, have enriched us with the experiences of the monks' work, prayer, and meditation. But the immediacy of cistercian art remains indispensable for the full appreciation of what activated the minds and hearts of those who built Fontenay, painted the initial letters of Pontigny, baked the tiles in Yorkshire, or designed the intricate patterns of grisailles in Obazine. All taken together they convey the same ideas to us, ideas that can better be expressed in the interplay of lights and shadows, balance and proportion, fragile lines or massive monumentality, than in words.

I am sure that the authors of these studies have spent enough time with their subjects to become admirers or perhaps lovers of them. May their experiences bring joy to our hearts, the spark of recognition to our eyes: the same joy that was the sole reward of the monks and nuns who created them.

Our Lady of Dallas Abbey
The University of Dallas

THE COMMON THREAD
Meredith Parsons Lillich

The most appropriate comment to a volume of studies ranging from the opening of the twelfth century to the Dissolution touching such varied bases as aesthetics, archeology, and the history of architecture, sculpture, manuscript decoration, stained glass and tiles—with evidence drawn from beneath the ground and above, from southern Europe, Yorkshire, and California—is not a comment so much as a question: does it make sense to study Cistercian arts as an isolated, distinct field?

It probably won't surprise you that I believe the study of Cistercian arts as a separate field to be appropriate. And so I would like to offer a justification for such study and preliminary observations on the development of an appropriate methodology. What is the common thread? If we are to make a serious contribution by the study of Cistercian arts, we must begin to examine 'Cistercianism' as an aesthetic stance and to establish criteria for identifying and judging it.

Cistercian arts, as they came to be studied in the past, fell into two basic categories: architecture, with its adjacent arts; and manuscript illumination. This is natural enough since no matter how austere an Order chooses to be, its monks must be housed and have an appropriate place of prayer; and they must have books for their life of prayer. There is no field of study of, say, 'Cistercian metalworking'—although the monks also needed chalices and presumably made them. I wonder if it may not someday be possible to identify their work on aesthetic grounds.

But let us return to the recognized fields of architecture, with its windows and its floor tiles and its sculptural articulation, and manuscript production. By what logic do we—can we—group together works of such an enormous time-span as the grisailles of Obazine and the great west window-wall of Altenberg? Is it profitable to study the 'cistercianism' of works so comfortably attuned to their own time and place as Chiaravalle Milanese or the lovely standing Virgin of Royaumont?

I would like to suggest a method for approaching any work of Cistercian art, and some appropriate questions to ask of it. My suggestions are simple and will (I am sure) appear increasingly simplistic as Cistercian art studies evolve.

There is, first of all, a distinctive look and feel about art works of Saint Bernard's lifetime and the immediately succeeding generation. They are not always under-decorated; they are not 'merely' under-decorated. But the emphasis is on the permanence —I should prefer to say, the adequacy—of the materials. The buildings are not grandiose but they are never jerry-built and

their functionalism expands our usual understanding of that term.
The manuscripts are large, the handwriting clear and handsome, the
margins spacious. As decoration is not the unifying factor, some-
thing else clearly is. And current scholarship has begun to estab-
lish, following the pioneer work of Otto von Simson, that in archi-
tecture the factor appears to be abstract and numerical symbolism.
I will develop this point presently, but first I would like to thrash
out a possible equivalent in the medium of manuscript arts. Anyone
who looks at twelfth-century Cistercian manuscripts comes away from
the experience with the impression, first of all, that they are ex-
tremely varied; and secondly, that there is an undefined 'something'
which sets them apart from contemporary non-cistercian works. And
since any abstract symbolism in them cannot, obviously, be of the
same spatial nature as that encountered in architecture, I wonder if
the uniqueness is not to be found in the color. It is my impression
that Cistercian twelfth-century books are painted, in the main, in
four colors: a clear *bleu-de-ciel*, a light pure green, a Chinese
(orange) red, and a sort of Dijon-mustard yellow. One finds these
four colors in the most diverse painting styles; I wonder if a sym-
bolism can ever be established.

To return to the safer ground of architectural symbolism: a
twelfth-century church was considered to be 'Heaven,' the Heavenly
Jerusalem. It was a very ancient concept but no longer expressed
by such primitive methods as painting (or mosaicing) pictures of
heaven on the walls. While some twelfth-century buildings achieved
this 'heavenly' effect by the use of jewel-like materials, breath-
takingly supra-human scale, or weight-defying vaulting, a Bernardine
Cistercian church was an analogy of heaven by virtue of its very pro-
portions. Von Simson's analysis of Fontenay firmly establishes this
point and its Augustinian foundations: each aisle bay is square in
plan (the square being the geometrical representation of the Godhead
to twelfth century neo-platonists); its cube is indicated by the hor-
izontal stringcourse above, there for no other purpose to it. The
elevation is determined by Augustine's 'perfect ratio' of 1:2; the
octave ratio determines the length of the nave of eight bays (Augus-
tine's expression of the mystery of redemption). Note further the
windows, that familiar twelfth century Cistercian pattern of 'oculus
over three lancets'. The circle--unending, unbeginning, infinite--
is the appropriate symbol of the Godhead's unity and eternity; and
the trio of lancets of the Trinity. The church (heaven) is illuminat-
ed by the light of the Trinitarian God. That such meaning was intend-
ed by the windows we can only assume by the frequency of these group-
ings; but that the geometrical proportions of Fontenay were intended
and understood, we *know*, by the placement of the stringcourse, total-
ly unnecessary from a structural point of view. The stringcourse is
an 'intellectual decoration', if you will.

In sum: in analyzing Bernardine architecture we have come to

think it methodologically appropriate to seek numerical symbols and abstract intellectual significance, transmitted in substantial (but not pretentious) materials.

To illustrate what I mean about functional materials, which are basic to the concept of 'Cistercianism' in art, one thinks immediately of Le Thoronet, built of magnificent ashlar stone, not marble, although marble was not infrequently used in that part of France. Another example would be a Pontigny book in the Syracuse University library, of serviceable vellum which has a number of blemishes (holes). One does not look for polished paper-thin uterine parchment in a Bernardine book. There was no reason not to use the blemished vellum; vellum is not notably weakened by such natural holes. And so the early Cistercians simply wrote their magnificent script around the holes.

After the Bernardine period Cistercian art changes in several chartable ways. It transforms the concept of 'sufficient materials' (that is, materials sufficient unto the use thereof) into a rather easier-to-apply aesthetic dictum of simplicity and puritanism of approach; and it softens the rigidity of, though it *does not abandon,* the early symbolic ratios. Thus the Bernardine dormitory wing cross-vaulted throughout was ahead of its time from a basic, engineering point of view, as was the pointed arch which, although native to Burgundy, was exported systematically at very early date for functional utility by the Cistercian Order. The retention of these forms into the next era often carries an aura of recognizable archaism and they thus become a proud Cistercian trademark. It misses the mark to conclude that economy or a failure of the old creative audacity dictated the choice, just as the evolution of the Bernardine binary elevation in the High Gothic three-story format has been totally misread as a 'reduction' or simplification. A great deal remains to be said in Cistercian architectural studies about the binary elevation, first identified by François Bucher in the phrase 'the independence of the stone baldachin'. Augustine's City of Man--waiting, preparing--is below and the City of God--hovering, unreachable--above. Cistercian builders display great creativity in retaining a binary division through many different architectural styles. Gothic triforium elevations like Longpont and Altenberg carry out the binary elevation with remarkable sophistication and within the gothic vocabulary of forms, by the conscious retention of columnar supports to create a distinctive lower level. An awareness of the significance of the binary elevation solves, for a start, the great dilemma of why Cistercians used corbels so much.

The evaluation of post-Bernardine Cistercian works should, it seems to me, focus on these questions:
-- to what degree is this work typical of its time?
-- to what degree is this work typical of its region?
-- to what degree do we, nevertheless, recognize it as Cistercian; and how can this quality in it be defined?
What we are seeking is the identification of three elements which are

at work in any example of later Cistercian building, namely (1) the
aesthetic of Cistercian puritanism or, if you prefer, functionalism;
(2) the reminiscence of Burgundian early-gothic structure (the point-
ed arch, the articulation of structural joints, meaningful proportion)
as well as any symbolism; (3) the local, regional forms and prefer-
ences. It is possible to chart the balance of these three elements
in every Cistercian building, even those in France--beyond Burgundy
where, (2) and (3) are largely the same thing. Furthermore, since
very few monasteries were built in one campaign or never remodeled,
it is also possible to note the changes in the balance of these three
elements in later additions at the same site.

 As an example I would choose Chiaravalle Milanese, a Lombard
house founded by Saint Bernard himself, as the story goes (Chiaravalle,
of course, means Clairvaux). First of all, it hardly seems necessary
to point out the functional (puritan) simplicity of form: no sculp-
ture at all and, in one of the great centers of architectural sculp-
ture, Lombardy, an emphasis on the unadorned material, in this case
warm Lombard brick. Secondly, is there anything at all of Burgundi-
an or Bernardine dicta? The 1:2 elevation is here forcibly overlaid
onto a structure which does not need it or derive from its principles.
Perhaps reminiscent too is the flat chevet with its three oculi over
three lancets. Easiest to recognize of all the elements is the third:
there is no question that one is in Lombardy. Brick; sweeping Lom-
bard screen-facade (the porch was added later); Lombard square tower;
'Lombard bands' decorating the roofline; big Lombard domed-up nave
vaults with slim interior ribbing, supported by doubled aisles which,
as is the custom in Lombardy, are groin-vaulted. And last but not
least, the wonderful knotted columns in the cloister--that totally
anti-classical form which creeps to the surface here and there in
Italian medieval art when no one is looking. After all this is said
and done we have not accounted for the overwhelming, massive nave
piers--not Burgundian, not Bernardine, not Lombard. They are best
analyzed as an example of creative functionalism and binary thinking
on the part of the Cistercian architect (who was without question a
Lombard Italian): they are ultimately and non-derivatively 'Cister-
cian' creations.

 I have applied this set of questions to quite a number of build-
ings and the answers are always informative. I have hopes that an
equally workable approach can be found for other art forms, where the
old answers no longer satisfy. Cistercian grisailles are not necessar-
ily more economical; to produce reasonably clear 'white' glass in the
middle ages required additional care in firing and the use of addi-
tional materials, namely 'glassmaker's soap' (manganese). The gothic
manuscript decoration of Cistercian pen-flourishers (the word is from
Alison Stones) was no doubt cheaper than gold leaf but its very ex-
quisiteness, its infinite variety, and its rich vocabulary of motifs
give pause. Simplification is a word which really does not apply here.

I would submit that the combination of quality workmanship with unpretentious materials marks these works as 'Cistercian.' But what significance did these patterns have, these flourishes, the intricate neverending interlace, the solomon knots, the vigorous vegetal growth? They recur with such consistency--in a Spanish fountainhouse, on a Polish vault, a Danish keystone, a Yorkshire floor--that patternbooks can be assumed. Their sources are being investigated and they are both ubiquitous and legion. Their function, their justification? I have suggested that they functioned in the Cistercian scheme of things much as Franciscan images served a different population, Saint Bernard considering images (even crosses) not only inappropriate, but actually a hindrance, to the monks' approach to God. These patterns were mandalas, 'Andachtsbilde', aids to the monk's central task of contemplation. Their meaning is thus to be sought in Cistercian texts, a task first attempted by Sister Hufgard and now ongoing. The study of Cistercian arts is *in media res*.

To conclude, I would apologize for the evident simplicity of the questions here posed. The formulation of questions, however, is the necessary first step toward understanding, even if the questions are wrong. The basic and appropriate question for us is 'What identifies this work of art as Cistercian?' I believe that in producing answers to that question we will not only come closer to an understanding of the works of art, but to an understanding of the very essence of Cistercianism itself. A form of these remarks was first presented from the chair on the occasion of the first session on Cistercian Art and Architecture to be included in the Cistercian Studies Conference at Kalamazoo, in 1974. The success of that session and those to follow has begotten this first volume of *Studies in Cistercian Art and Architecture*. It therefore seems appropriate to offer these observations here and I do it with great joy.

Syracuse University

THE EARLIEST CHURCHES OF THE CISTERCIAN ORDER

Jean Owens Schaefer

Cistercian architecture has received a considerable amount of attention in the past quarter century.* Much of this attention has been focused on the existence or non-existence of the 'Bernardine plan.'[1] As important as this debate is, it has led scholars to overlook the fact that there existed a good number of Cistercian churches which were built before the purported imposition of this type-plan. A proper study of these pre-Bernardine churches throughout Europe should offer significant contributions to the discussions of, on the one hand, the relationship between the early architecture of the Order and the local architectural environment and, on the other, of the spirituality of the movement at its beginnings.

One fragment of the question of pre-Bernardine architecture shall be presented here, the issue of the earliest churches of the five founding monasteries in Burgundy: Cîteaux, La Ferté, Pontigny, Clairvaux and Morimond. To separate the architecture of these five houses from the other examples of early architecture is in many ways artificial. The justification for their special treatment rests in their special place within the Order and in the special character given these first foundations by the original leaders of the movement.

One aspect of the history of the founding of the Cistercian Order which has been brought into focus in recent years in the work of such scholars as Jean Leclercq and Louis Lekai[2] is the relation of Cîteaux and its founders to the eremitical movement of the late eleventh-century. The men who left the abbey of Molesme in 1098 to establish the 'New Monastery' and who guided it through its first perilous years had long experimented with the eremitic life. St Robert, the Order's founder, had lived with a small group of devout hermits in the forest of Colan and had joined with them in founding Molesme. Along with Alberic and Stephen Harding, he had retreated from Molesme to live a more isolated and ascetic life at a site known only as Vivicus. These three men, Robert, Alberic and Stephen, destined to become the key figures in early Cistercian history, were among those signing a document of 1096-1097, encouraging the monks of Aulps in their experiment of combining the rigors of the hermit's life with a strict observance of the Rule of St Benedict.[3] It is proper, therefore, to see their 'New Monastery' as the last and most successful of their exercises at creating, in Leclercq's apt if unusual phrase, an 'eremitic community.'[4]

The earliest examples of Cistercian ecclesiastic architecture, the first churches at Cîteaux, La Ferté, Pontigny, Clairvaux and Morimond, are given only the briefest mention in the documents and, since they were often of wood, no trace of them remains today. Because the remains are so scanty, it is essential, first, to present

what documentary evidence we do possess concerning these earliest churches.

When Robert, Alberic, Stephen and their followers set out on their experiment, they retreated to a desolate site near Dijon, which was described in the traditional phrase as 'locum horroris et vastae solitudinis, vepribus, et spinetis densum.'[5] In spite of this description, the site may have included among other structures a small oratory dedicated to the Virgin, which could have served as the very first chapel of the Cistercians.[6] In any case, soon after their arrival, the men set about to build a small wooden oratory of their own, in which to carry on the rites of the monastery. Of this building the *Exordium Parvum* says

> After they had cut down and removed the dense woods and thorny thickets, they began to construct a monastery.... and with the aid of Lord Odo, the duke of Burgundy, they completed the wooden monastery.[7]

Manrique, in his *Annales* of 1642, refers to the building as 'a monastery built of sections of roughly squared trees.'[8] That is the extent of our knowledge of the first church built at Cîteaux.

The building which replaced the wooden oratory at Cîteaux (Fig. 1) was still standing in 1708 when it was described by Dom Martène and Dom Durand in their *Voyage littéraire*. The Benedictines said that

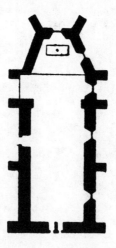

Fig. 1 Cîteaux, consecrated 1106 (after Dimier, *Recueil des plans des églises cisterciennes*, II)

it is one of the most venerable spots at Cîteaux for
it was the sanctuary of the first monks and the church
in which Bernard was received. The church was conse-
crated in 1106 by Gautier, bishop of Chalon. It was
quite small, I do not believe it could be more than fif-
teen feet wide; the length is proportionate; the choir
could be thirty feet. It is vaulted and very pretty.
There are three windows in the sanctuary and two in the
nave.[9]

We can draw from this description no conclusions on the precise
appearance of this little chapel; but we are on relatively safe
grounds to say that it was small and barrel-vaulted. From the
plan of Prinstet of 1702,[10] it appears to be angular, and not in-
ternally divided into bays.

From the example at Cîteaux, the first buildings of each of
the succeeding foundations appear to have been temporary in char-
acter, intended to serve the needs of the small community and to
be replaced as growth required and means permitted.

The first daughter-house of Cîteaux was founded in 1113 and
called La Ferté. According to Janauschek, the founding party left
Cîteaux on May 16 and arrived the following day at the new site;
the church was dedicated on May 18.[11] It has been inferred from
this that the buildings were prepared in advance, either by an ad-
vance party of Cistercians or perhaps by a combination of monks and
lay craftsmen.[12] The advanced preparation of the monastic buildings
would be in keeping with a later statute of the Chapter General de-
creeing that new foundations could not be established until struc-
tures were available in which the regular life of the monastery
could be maintained.[13] It is unfortunate that we have no informa-
tion at all on the nature of these first buildings, whether of tim-
ber or stone; but they were replaced by larger churches and no ac-
counts of them remain.

After the foundation of La Ferté, the number of monks in the
Order continued to grow. Therefore, when Ansius, a hermit priest,
asked to offer his oratory to the White Monks, Stephen Harding
agreed to accept it. The Cistercians took formal possession of the
site on May 31, 1114, and founded the third house, Pontigny.[14] The
first chapel was dedicated to the Assumption of the Virgin, but no
dedication date has been given for it. Its ruins were visited by
Martène and Durand, who describe it only as being behind the later
church and 'small but pretty enough for its time.'[15] Although it
was shown on the monastery plan drawn in 1760, there is nonetheless
some confusion in later publications as to its shape (Fig. 2). The
1760 plan was reproduced by two authors, Chaillou des Barrès and
Henry; both reproduce the plan as rectangular and without an apse.[16]
Later authors have, however, discussed the chapel as apsidal.[17] We

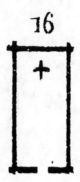

Fig. 2 Pontigny I (after Chaillou des Barrès)

have no information whether the chapel was vaulted.

The founding of Clairvaux took place the following year.[18] The first task which faced Bernard and his companions was to erect the temporary buildings for the monastery. Both Vacandard, in his biography of St Bernard, and Paul Jeulin, in his architectural study of Clairvaux, refer to these buildings as 'a modest chapel and fragile huts of wood.'[19] Manrique gives a fuller account of the early buildings.

> After the monks cleared away the thorn bushes by hand,
> ...they prepared a dwelling place out of trees. It was
> of the kind that Molesme had formerly, and like those at
> the beginning of Cîteaux. Today the humble chapel still
> exists; [it is] about twenty feet long and fourteen wide,
> dedicated to the blessed Virgin. It was built in a few
> days, and it is believed to have served for the divine
> office for some time.[20]

As with the first church at Cîteaux, we can infer little about the exact nature of these wooden buildings. Since, in each case, they were meant for only thirteen men, it is reasonable that they were small. From Manrique's account, it would appear that they were simple but adequate, and that they were meant to be replaced with more permanent buildings.

The chapel which was built as the first permanent oratory in 1116 stood to the west of the present buildings, although there has been some debate about the exact location.[21] The consensus is that the former monastery is represented on the plan of Dom Milley as the 'monasterium vetus' and the 'capella' (Fig. 3, nos. 12 and 13, and Fig. 4, nos. 16 and 17). Thanks to this plan,[22] we have an idea

of the entire layout of a **primitive** Cistercian monastery. The in-
formation of the plan can be augmented by two descriptions, one of
the sixteenth-century, and one from the seventeenth. In 1517, the
queen of Sicily made a visit to Clairvaux; and, in a letter result-
ing from that visit, the old monastery is described:

> Within the exclosure of St Bernard, at the entry gate is
> the room where **Pope** Eugene was received. This room is in
> a small garden; it is of wood, quite small and low, in the
> old fashion.
>
> After it comes the refectory, the length of which is
> between eighteen and twenty paces; it is very low and pan-
> elled. It is quite old. Above is the dormitory of equal
> size. At the top of the stairs is the chamber of Saint
> Bernard, which is very small. His bedstead, which is of
> wood and the head of stone, is close to the roof, where
> there is a window. Close to and adjoining this room is
> the old church, which is a chapel of wood, into **which** St
> Bernard could see through a window which was in his room.
> There is a small garden in front, and the entire thing
> is enclosed by a wall.[23]

The second account is from Dom Joseph **Meglinger,** a Cistercian monk
who **journeyed** to a meeting of the Chapter General in 1667:

> A single roof covers the church and the living quarters
> of the monks, and a simple ceiling separates the refec-
> tory from the dormitory above; in the former there is only
> bare earth for the floor. The kitchen abuts the refectory;
> it is very small but sufficient. From there (i.e., the
> refectory), one climbs to the dormitory which is the same
> size as the refectory. Near the stairs is the cell of
> the mellifluous father, Saint Bernard; [it is] quite small,
> more like a dungeon than a room.
>
> From there we descend to the oratory which is the very
> temple of poverty. The altar is **as bare** as Saint Bernard
> left it; above is a bad painting on wood of Christ on the
> cross. Outside of the choir...are altars, to the right,
> of St **Lawrence,** and, to the left, of St Benedict.[24]

From these descriptions and from the Milley plan, an image of this
oratory begins to emerge. It was small and austere; it was square
in plan, with an aisle running along all four sides of the undivid-
ed central space.

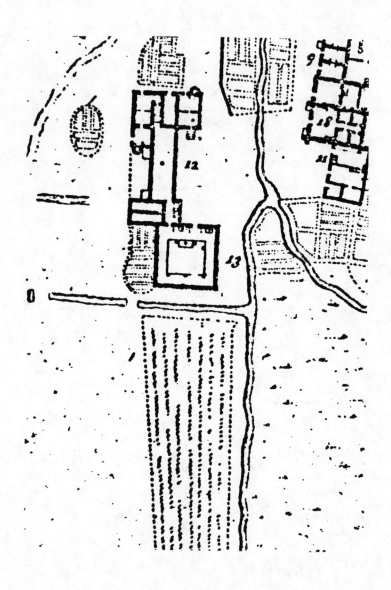

Fig. 3 Clairvaux I: plan (after Milley)

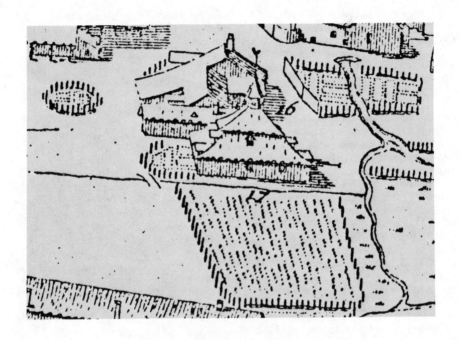

Fig. 4 Clairvaux I: view (after Milley)

It is usually assumed that these buildings, and the chapel in
particular, were of stone.[25] However, the account of 1517 makes
it quite clear that the latter was constructed of wood. We shall
see that this is entirely consistent with the form of the chapel
shown in the eighteenth-century plan and view.

Morimond, like **Pontigny**, was founded at the site of a hermit's
dwelling. The original charter of foundation is lost, but a letter
of confirmation, dated 1126, survives. It tells of a hermit Jo-
hannes who, in the episcopate of Robert, bishop of Langres, founded
his oratory on land granted him by two nobles. Josserand, Robert's
successor, asked him to offer his hermitage to the Cistercians and
Johannes agreed. Late in 1115, the White Monks were installed.[26]
What, however, is known of 'Old Morimond'? Very little--only that,
as Eydoux says: 'it was a place in which a hermit had built an

oratory which was destined to become the first receptacle of the Cistercian establishment.'[27]

An evaluation of these first churches on the basis of these scanty fragments reveals one fact as absolutely certain: the Cistercian Romanesque plan as seen at Fontenay, the 'Bernardine plan,' had not yet developed. At this stage the monks were building small, simple oratories. These should be considered in two groups, those of wood and those of stone.

The wooden churches for which we have documentation are those at Cîteaux and Clairvaux. Of these only the church at Clairvaux can be discussed in detail. The descriptions of the sixteenth and seventeenth centuries and the plan and view of the eighteenth century make clear that this was a square, wooden church with a peripheral aisle and a taller central space. Both the plan and the view show us a building entirely consistent with timber stave construction.[28] Although most of the surviving stave buildings are in Scandinavia, their use was more widespread throughout the medieval period.[29] The characteristics of stave construction are, first, the staves which are erected at intervals around a rectangular core and create a narrow aisle on all four sides, and, second, the steep pitched roof which rises in stages to a small belfry.[30] These are precisely the characteristics of the church at Clairvaux. Furthermore, close examination of the plan of Milley (Fig. 3) reveals small half-round projections at intervals around the inner square--almost certainly the representation of the staves themselves.

There is no information on the architectural form of the earliest stone churches at La Ferté and Morimond. The church of 1106 at Cîteaux was a small, angular, box-like church without internal divisions. It was vaulted, in all probability with a simple barrel vault (Fig. 1). The church at Pontigny was angular and very simple (Fig. 2).

In connection with what architectural tradition should these simple structures be viewed? Perhaps it will help to answer that question if we remember the close association, even spiritual sympathy, which existed between the leaders of early Cîteaux and religious hermits of the time; and if we remember as well that Pontigny and Morimond were established at existing hermitages.

Is there any reason why men who are in such spiritual accord with the hermits that they replaced the humble buildings already erected to serve God? Surely a tiny oratory could suffice for thirteen. At Pontigny and at Morimond just as at Fontenay, Hautecombe, Les Dunes, Aulps and at other sites,[31] the Cistercians took the hermit's structures for their own. In these examples, the earliest Cistercian architecture is a direct continuation of the hermit architecture of the eleventh century. What of the other early churches, especially the first wooden and stone buildings at Cîteaux and Clairvaux? It may be rash to compare vanished structures to a tradition of archi-

tecture which has left almost no trace,[32] but it is reasonable to argue that these buildings had more in common with the simple oratories of hermits than with the distinctive **style** of church architecture which architectural historians call 'Cistercian.'

University of Wyoming

NOTES

*This study was presented at the Conference on Cistercian Studies, Thirteenth Conference on Medieval Studies, 1978.

1. Karl H. Esser, 'Die Ausgrabungen des romanischen Zisterzienserkirche Himmelrod als Beitrag zum Verständnis der frühen Zisterzienserarchitektur,' *Das Münster* (1952) pp. 221–3; Idem, 'Les Fouilles à Himmelrod et le plan bernardien,' *Mélanges saint Bernard, XXIVᵉ Congrès de l'association bourguignonne* (1954) pp. 311–15; François Bucher, *Nôtre-Dame de Bonmont und die ersten Zisterzienserabteien der Schweiz* (Bern: 1957); and Ingrid Swartling, 'Cistercian Abbey Churches in Sweden and the Bernardian Plan,' *Nordisk medeltid: Konsthistoriska studier tillängnade Armin Tuulse, Stockholm Studies in the History of Art*, no. 13 (Uppsala: 1967) pp. 193–8.
2. Jean Leclercq, 'L'Erémitisme et les cisterciens,' *L'Eremitismo in occidente nei secoli XI e XII* (Milan: 1965) pp. 573–80; Idem, 'The Monastic Crisis of the Eleventh and Twelfth Centuries,' *Cluniac Monasticism in the Central Middle Ages*, ed. Noreen Hunt (London: 1971) pp. 217–37; Louis Lekai, 'Motives and Ideals of the Eleventh-Century Monastic Renewal,' *The Cistercian Spirit*, ed. Basil Pennington (Spencer, Mass.: 1970) pp. 27–47; Idem, *The Cistercians* (Kent, Ohio: 1977).
3. J-A. Lefèvre, 'Que savons-nous du Cîteaux primitif?' *Revue d'histoire ecclesiastique* 51 (1956) 19.
4. Leclercq, 'The Monastic Crisis,' p. 226.
5. Angelo Manrique, *Cisterciensium seu verius ecclesiasticorum annalium a conditio cistercio* (Lyon: 1642) 1:10, borrowing from Dt XXXII, 10.
6. J. Marilier, 'Les Debuts de l'abbaye de Cîteaux,' *Mémoires de la société pour l'histoire du droit et des institutions des anciens pays bourguignons, comtois, et romands*, 15 (1953) 120, n. 6.
7. *Exordium Parvum*, III, quoted in the translation of Lekai, *Cistercians*, p. 452. The Latin **text** reads: '...nemoris et spinarum

densitate precisa ac remota monasterium....construere ceperunt
....Tunc domnus odo dux burgundie sancto fervore eorum delecta-
tus. sancteque romane ecclesie prescripti legati litteris roga-
tus. monasterium ligneum quod inceperunt de suis totum consum-
mavit. illosque inibi in omnibus necessariis diu procuravit. et
terris ac pecoribus abunde sublevavit.' Philippe Guignard, *Les
Monuments primitifs de la règle cistercienne* (Dijon: 1878) p. 63.

8. Manrique, p. 10: 'monasterium de sectorum arborum male dolatis
 lignis fabricarunt.'

9. My translation. Edmond Martène, *Voyage littéraire de deux reli-
 gieux bénédictins de la congrégation de saint-Maur....* (Amsterdam:
 1717) pp. 223-4.

10. In the archives of the Côte-d'Or; published in Marcel Aubert,
 L'Architecture cistercien en France (Paris: 1947) 1:109, where
 it is marked by the letter 'M'.

11. Leopold Janauschek, *Originum cisterciensum* (1877; reprint Ridgewood,
 N.J.: 1964) 1:3. See also GCh IV: col. 1019; Instr. col. 238, 240.

12. Archdale King, *Cîteaux and her Eldest Daughters* (London: 1954)
 pp. 107-8; and Philippe Erlanger, *Merveilles des châteaux de
 Bourgogne et de Franche-Comté* (Paris: 1969) pp. 36-7.

13. Guignard, p. 253. In the Consuetudines, cap. XII: 'Duodecim
 monachi cum abbate tertio decimo ad cenobia nova transmittantur:
 nec tamen illuc destinentur donec locus libris. domibus et neces-
 sariis aptetur. libris duntaxat missali. regula. libro usuum.
 psalterio. hymnario. collectaneo. lectionario. antiphonario.
 graduali domibusque oratorio. refectorio. dormitorio. cella hos-
 pitum et portarii. necessariis etiam temporalibus: ut et vivere
 et regulam ibidem statim valeant observare.'

14. Georges Fontaine, *Pontigny, abbaye cistercienne* (Paris: 1928) pp. 4-5,
 citing the cartulary of Pontigny; see also GCh XII: col. 439-41.

15. Martène, p. 58.

16. Abbé Henry, *Histoire de l'abbaye de Pontigny* (Avallon: 1839);
 Chaillou des Barrès, 'L'Abbaye de Pontigny,' *Annuaire historique
 du département de l'Yonne*, 1844.

17. Aubert, I: 153, n. 2; and Anselme Dimier, *Recueil des plans des
 églises cisterciennes* (Paris: 1949) 2: pl. 235. See Fontaine,
 p. 26, fig. 9, for a reproduction of the plan showing the small
 chapel without an apse; and p. 23 for a discussion of the inex-
 actitudes of the eighteenth-century plan. For the fullest dis-
 cussion of the earliest church at Pontigny, see Terry Kinder,
 'Some Observations on the Origins of Pontigny and Its First Church,'
 Church,' *Cîteaux: Commentarii Cistercienses*, 31 (1980), 9-19.

18. GCh IV: col. 796. The earliest document of confirmation is dated
 1121; GCh IV: Instr., col. 156.

19. Elphège Vacandard, *Vie de Saint Bernard* (Paris: 1910) 1: 66-7;
 Paul Jeulin, 'Les Transformations topographiques et architectur-
 ales de l'abbaye de Clairvaux,' *Mélanges saint Bernard* (1954) 325.

20. Manrique, p. 80: 'Tum dumeta fratrum manibus excisa, gratulanti-
 bus incolis, et crediderim etiam adiuuantibus, atque ex arbustis
 habitatio preparata, qualem Molismus olim, qualem Cistercium in
 suis primordiis habuit....Extat hodioque Oratorium humile, longi-
 tudine ad viginti pedes, latitudine ad quatuordecim extensum,
 beatea Virginis sacrum quod paucis tunc diebus constructum, credi-
 tur divinis officiis inseruisse per tempus aliquod.'
 There is a nagging concern that the chapel which Manrique
 describes here, a chapel which he seems to have visited, is in
 fact the same one discussed below. Since it is widely but falsely
 assumed that the chapel described on Milley's plan as 'vetus monas-
 terium' was of stone, it has been disassociated from the 'modest
 chapel of wood.' It is remotely possible that it is the same ora-
 tory visited by our informants in the sixteenth and seventeenth
 centuries. The dimensions given by Manrique, however, do not con-
 form to the shape of the building on Milley's plan. See below.
21. Philippe Guignard, 'Lettre...sur les reliques de saint Bernard
 et de saint Malachie et sur le premier emplacement de Clairvaux,'
 in PL CLXXXV: 1697-1714; Vacandard, 1: 69; and Aubert, 1: 13.
22. Published in Vacandard, 1: 420. One complete set of the engrav-
 ings is in Paris, Bibliothèque Nationale, Estampes (Topographie
 de la France, Aube, Arrondissement Bar-sur-Aube, folios 27, 28, 29).
23. Didron, 'Un Grand Monastère au XVIe siècle,' *Annales archéologiques*
 3 (1845) pp. 236-7.
24. Henri Chabeuf, 'Voyage d'un délégue au chapitre générale de
 Cîteaux en 1667,' *Mémoires de l'académie des sciences, arts et
 belles-lettres de Dijon* (1883-4) pp. 314-17.
25. Aubert, 1: 13-15; Jeulin, p. 326.
26. Aubert, 1: 65; Janauschek, p. 5; and GCh IV, Instr. 159.
27. Henri Paul Eydoux, 'Morimond, 1954,' *Cîteaux in de Nederland,*
 5 (1953), p. 131.
28. I would like to thank Prof. Jean Bony for this suggestion. Bony
 was also kind enough to point out interesting similarities be-
 tween this plan of Clairvaux and the late Anglo-Saxon chapel of
 St Benedict within the precincts of Bury St Edmunds. This is a
 stone building, but Bony has suggested it may be a translation
 into stone of a familiar timber type. See A. B. Whittingham in
 the *Archeological Journal* 108 (1951) p. 181 and the plan opposite
 p. 192. I would also like to thank Prof. Walter Horn for his
 frequent advice and encouragement on matters of medieval timber
 architecture.
29. See Walter Horn, 'On the Origins of the Medieval Bay System,'
 Journal of the Society of Architectural Historians 17 (1958)
 pp. 2-23. There is an early example of stave building in Eng-
 land at Greenstead in Essex. On this and other stave buildings
 in England see Thomas Paulsson, *Scandinavian Architecture* (Lon-
 don: 1958) p. 77; and Gerda Boëthius, *Hallar, Tempel och Stavkyrkor*

TWO PONTIGNY MANUSCRIPTS IN AMERICAN COLLECTIONS

Helen Jackson Zakin

Studies of Pontigny manuscripts[1] have been greatly facilitated by the pioneering work of C. H. Talbot, who edited four seventeenth and eighteenth century inventories of Pontigny manuscripts in 1954.[2] Talbot was able to prepare a finding list for Pontigny manuscripts which included twenty-one books which could be traced in auction catalogues, but could not then be located. Two of these 'untraceable' Pontigny books, both containing writings of St Augustine, have now been found in American libraries.

Syracuse University has in its collection a Pontigny manuscript, known as Smith MS. 1 (See Figs. 1-3)*, which was included in the 1974 exhibition *Medieval Art in Upstate New York*.[3] There is a useful description of this book, a twelfth century copy of St Augustine's *Quaestiones in Heptateuchum* and *Locutiones in Heptateuchum*, in the catalogue of that exhibition.[4] The University of Pennsylvania also has a Pontigny manuscript, a twelfth century codex containing treatises by St Augustine and other authors (Figs. 4-6). This manuscript, known as Latin 63, has been published in the catalogue of that collection as having a 'German' origin.[5]

University of Pennsylvania Latin 63 can be attributed to Pontigny on the basis of an entry in the late twelfth or early thirteenth century catalogue of the Pontigny library, the *Annotatio librorum Pontiniacensium*.[6]

> Alio volumine, sermo beati Augustini de simbolo. De pastoribus, liber unus. De ovibus, alius. Liber beati Ambrosii episcopi, de laude et exhortatione viduitatis. Commonitorium Orosii presbyteri ad sanctum Augustinum, de Priscillianistis et Origenis errore. Responsio Augustini contra predictas hereses, libro uno. Liber unus de correctione Donatistarum. De fide et operibus, unus. Item ejusdem liber de dialectica. Cathegorie Aristotilis de greco in latinum translate a beato Augustino. Epistola Johannis pape urbis Rome, de fide contra Euthicianistas. Collatio beati Augustini de trinitate a se ipso ad semet ipsum, libello uno.[7]

The contents listed in the *Annotatio* correspond very closely with the contents of the University of Pennsylvania manuscript.

Latin 63 includes two sermons and three treatises written by St Augustine *(De pastoribus* and *De ovibus; Responsio ad Orosium de Pris-*

*Figures are found at the back of the book.

cillianistis et Origenis errore, Libro de correctione Donatistarum,
and *De fide et operibus)*; three *Retractationes* excerpts written by
St Augustine *(Retractatio in libro ad Orosium contra Priscillian-*
istas, Retractatio in libro de correctione Donatistarum, and *Retrac-*
tatio in libro de fide et operibus); three treatises spuriously attri-
buted to St Augustine *(De dialectica, Commonitorium ad universam*
ecclesiam destinatum de Mancheis conversis, and *Collatio trinitatis*
a se ipso ad semet ipsum); and a translation of Aristotle's *Categoriae,*
which is spuriously attributed to St Augustine. There is also a
sermon of St Ambrose *(De laude et exhortatione viduitatis)*, a trea-
tise of Orosius *(Commonitorium ad sanctum Augustinum de Priscillian-*
istis et Origenis errore), an unpublished letter of Pope John II *(Epis-*
tola de fide contra Euticianistas de duobus naturis in una persona
Christi), and an incomplete copy of Possidius' catalogue of Augustine's
works.

There are three discrepancies between the description of contents
in the *Annotatio* and the present contents of the Pennsylvania manu-
script. The first sermon, *De symbolo*, written by St Augustine and
listed in the *Annotatio*, is now missing, as is the first part of *De*
pastoribus. The missing texts would fit on sixteen folia, which pro-
bably formed the first two gatherings, now lost, of the University of
Pennsylvania manuscript. The second discrepancy is that Possidius'
catalogue of Augustine's works, included at the end of Latin 63, is
omitted in the *Annotatio* description. Finally, the *Annotatio* descrip-
tion omits any mention of the excerpts from the *Retractationes*.[8]

A description of a volume corresponding to the Syracuse Univer-
sity manuscript is also found in the *Annotatio*.

> Volumen unum locutionum, libris VII. Et in eodem, ques-
> tionum libri itidem septem.[9]

The present contents of the Syracuse book are reversed in this notice,
and, as in the *Annotatio* description of the University of Pennsylvania
manuscript, the prefatory notices from the *Retractationes* have been
omitted.[10]

After the French Revolution, the Pontigny library was confiscated
by the state. About two thirds of the manuscripts disappeared between
1790 and 1829.[11] Some of them were sold to the English collector, Sir
Thomas Phillipps, among them Latin 63, which still bears Phillipps num-
ber 11901.[12] Smith MS. 1, the Syracuse University manuscript, was also
formerly in the Phillipps collection, but the Phillipps number in this
book has been erased.[13]

The Texts

One interesting characteristic of the University of Pennsylvania manu-
script, which is shared by the Syracuse University manuscript, is the

introduction of excerpts from St Augustine's *Retractationes* before
individual treatises. These *Retractationes*, written toward the
end of St Augustine's life, were his revisions and corrections of his
earlier works.[14] Excerpts from the *Retractationes* are found on folios
1r-1v and 139r-139v of Smith MS. 1 (Figs. 1 and 2), and on folios 36r,
43r, and 58r of Latin 63 (Figs. 5 and 6).

In his finding list, Talbot mentioned eight Pontigny manuscripts
containing writings of St Augustine, five of which can be located.
Two are the books here discussed. The remaining three include a copy
of St Augustine's *Sermons* at **Cambridge**, Fitzwilliam Museum, McClean
MS. 104 (Fig. 7);[15] a manuscript containing a number of treatises be-
ginning with *Contra Felicem Manichaeum* at Cambridge University Library,
Add. 3576 (Fig. 8);[16] and a copy of St Augustine's *De nuptiis et con-
cupiscentia* in the Bibliothèque d'Auxerre, MS. 17.[17]

St Augustine did not write *Retractationes* for his sermons. Thus
there are four traceable Pontigny books which contain treatises for
which Augustine wrote *Retractationes* (Cambridge University Library,
Add. 3576; Bibliothèque d'Auxerre, MS. 17; Syracuse University, Smith
MS. 1; and University of Pennsylvania, Latin 63). The appropriate
Retractationes have been inserted in three of these four manuscripts:
the *De nuptiis* in Auxerre, the Syracuse University book, and the Uni-
versity of Pennsylvania codex. *Contra Felicem Manichaeum*, and the
other treatises in the Cambridge University Library manuscript, are
not preceded by their *Retractationes*.

Several years ago, Ghellinck pointed out the inclusion of the
Retractationes excerpts in a famous series of volumes[18] of St Augus-
tine's works from Clairvaux, Bibliothèque de Troyes, MS. 40[1, 2, 3, 6,
9, 10]. The complete collection of *Retractationes* is found in the
first volume of this series, and the excerpts are interpolated in the
other volumes in front of the appropriate treatises. Some of the Au-
gustine manuscripts from the Cîteaux library also have *Retractationes*
prefacing the treatises.[19]

Dom Jean Leclercq has dated the **Clairvaux** Augustine series before
1153, the year of St Bernard's death.[20] Perhaps this group of Augus-
tine volumes was made to satisfy the needs of St Bernard himself,
whose interest in, and reliance on, the works of St Augustine has been
discussed by Martin and by Von Simson.[21] St Bernard may even have sug-
gested this organization of *Retractationes* and treatises to his scribes.[22]
Such an orderly arrangement of St Augustine's writings would seem to
reflect, in microcosm, the systematic and thoughtful organization of
Cistercian life introduced by this abbot of Clairvaux.

It is tempting to suggest that the idea of inserting St Augustine's
Retractationes before his treatises was transmitted from Clairvaux to
Pontigny. 23 Perhaps the scribes at Pontigny were copying Clairvaux
exemplars, or perhaps a scribe from Clairvaux, possibly a student of
St Bernard, had gone to Pontigny to introduce this method. Although
the practice of inserting the *Retractationes* was not unique to Cistercian

Augustine manuscripts,[24] this system, nevertheless, seems character-
istic of Augustine books produced in the scriptoria of this order.[25]
 Two motives for the insertion of the *Retractationes* can be sug-
gested. One possible purpose for this arrangement was to inform the
reader about St Augustine's later thoughts on a particular subject,
and his corrections of his earlier writings. Such a system would re-
semble the modern practice of introducing a book with a short preface.
Later editors, such as Erasmus and the Maurists, relied on the *Retrac-
tationes* as a useful tool for authenticating St Augustine's works.[26]
The Cistercian editors may also have included the excerpts to indi-
cate the authenticity of the treatises.[27]

The Script

The physical appearance of Latin 63 and Smith MS. 1 is similar to
that of other mid-twelfth century Pontigny manuscripts. Books made
at this abbey are characterized by an attractive layout with wide
margins, legible script, and simple, colored initials decorated with
foliate or geometric ornament.
 Mid-twelfth century Pontigny script can be identified as an early
Gothic text hand; it is very clear and legible (Fig. 3). Although
letter forms are becoming more angular, they have not yet evolved in-
to the forms associated with a fully developed Gothic script. Both
the uncial 'd' and the Caroline 'd' are used, sometimes in the same
word. The ampersand appears fairly consistently, rather than the
Tironian note; the cedilla shows up in both Latin 63 and Smith MS. 1.
 Separate hands, using varying forms of the letter 'g', can be
identified in these Pontigny manuscripts. Seven scribes wrote the
Syracuse University book, and four scribes made the University of
Pennsylvania codex. None of these scribes worked on both manuscripts,
but some of the hands which appear in the Syracuse codex can be seen
in other Pontigny manuscripts now in Cambridge, London, or Auxerre.
A scribe who used a very unusual 'g' wrote folios 58v to 63r in Smith
MS. 1, and at least the first folio of a Pontigny book now at Univer-
sity College in London (Figs. 3 and 9).[28] The scribe who wrote folios
97r to 97v, 126v, 153r to 154v, and 163r to 165v in Smith MS. 1, also
printed folio 1r in the Cambridge copy of Augustine's *Sermons* (Fig. 7).[29]
Finally, the scribe who is responsible for folio 64v in a copy of Zach-
ary the Chrysopolitan's *Concordia quattuor evangelistarum* now in Aux-
erre, may have written folios 135v to 148v in the Syracuse manuscript.[30]

Decoration at Pontigny

Decoration in mid-twelfth century Pontigny manuscripts is simpler than
that of many manuscripts made at Clairvaux or Cîteaux.[31] At Pontigny
a limited vocabulary of simple initial forms was used. Initials and
rubrics were written in red in Latin 63; rubrication was written in

red in Smith MS. 1, but the initials were painted in blue, green, and red.

Several different initial styles were employed simultaneously at Pontigny in the mid-twelfth century, and, as early as 1155 or 1160, the Pontigny scriptorium seems to have developed a more elaborate decorative vocabulary. There are at least two Pontigny manuscripts with exactly identical initial styles: the Rabanus Maurus *In Matthaeum* in London (Fig. 9), and MS. 14 at the Bibliothèque d'Auxerre.[32] Some of the initials in the University of Pennsylvania codex are similar to those in the Syracuse University manuscript (Figs. 2 and 5; 2 and 6),[33] and some of the initials in Latin 63 resemble those in MS. 127 at Auxerre.[34]

The development of initial styles in Pontigny manuscripts provides information for a tentative chronology. Walter Cahn has dated a single leaf from Pontigny, now in the Cleveland Museum of Art, to the period ca. 1160-1165.[35] He based his conclusions, in part, on a group of manuscripts associated with Thomas à Becket and his secretary, Herbert Bosham. The Becket manuscripts, which are said to exemplify the so-called 'Channel Style,' could date as early as 1164-1166, the years during which Becket was in exile at Pontigny.[36] Cahn considered the Cleveland leaf to be earlier than this 'Channel Style' group and therefore dated it between 1160 and 1165.[37]

The Auxerre copy of Zachary the Chrysopolitan's *Concordia quattuor evangelistarum* can probably be dated about 1155-1160.[38] The initials in this manuscript are certainly more elaborate than the initials in Latin 63 and Smith MS. 1, and yet not as refined as the initial style of the Cleveland leaf.

At least five Pontigny manuscripts can be dated during the period 1145-1155, because of their restrained decoration and their paleographical similarities. They include: the University College Rabanus Maurus (Fig. 9), the *Sermons* of St Augustine in the Fitzwilliam Museum (Fig. 7), the Augustine codex at the Cambridge University Library (Fig. 8), Smith MS. 1 at Syracuse University (Figs. 1-3), and Latin 63 at the University of Pennsylvania (Figs. 4-6).

Conclusion

The aesthetic appeal of these Pontigny manuscripts results from the combination of thoughtful design and simple ornamentation. One might expect that the parchment would be used sparingly, considering the oft-discussed Cistercian penchant for economy. But each page is carefully laid out so that there is ample space between the lines, and broad margins all around the text. The text script is carefully written with a regularity that produces a rhythmic texture. Some scribes use a rustic capital 'display script' (Figs. 1, 2, and 8) which gives variety to the page.

The major ornamental elements of these manuscripts are the colored

capitals which are frequently decorated with stylized foliage (Figs. 2, 4, and 9). The combination of the crisp strokes of these letters and the delicately rounded vegetal forms produces a very pleasing effect. Indeed, the decoration of these initials is restrained, but that restraint in itself produces a powerful effect of disciplined elegance. As in other Cistercian art forms, the impact of the decoration is increased precisely because that decoration is reduced to a minimum.

In the Syracuse manuscript (Fig. 2), the large, red decorated initial appears on a page with smaller capitals painted red, green, or blue. The large initial begins the treatise; each smaller capital introduces a *locutio*, which is also identified by a red Roman numeral, placed at the end of the previous sentence. The black script serves as a foil for the brightly colored initials. Other important aspects of the page design include the explicit of the *Retractationes* excerpt in rustic capitals, the red rubricated incipit of the treatise, and the careful spacing of the text.

As was mentioned above, there is some variety among these Pontigny capitals. The decorative initial which begins the University College Rabanus Maurus has a three-dimensional quality, particularly in the drawing of its upper arc, from which emerges the upward sweeping palmette (Fig. 9). This initial is painted in shades of red and green; vegetal and geometric motifs, similar to those seen in Latin 63 and Smith MS. 1, are used in this capital.

The initial at the beginning of the Cambridge University copy of Augustine's *Contra Felicem Manichaeum* is quite unlike that of the other Pontigny initials illustrated here (Fig. 8). Brown pen lines and stippling are combined with red and blue-green tempera to create a motif somewhat reminiscent of the 'four-fold' knot which occurs in several Cîteaux manuscripts.[39] The sketchiness of the drawing, the highly stylized foliage ornament, and the use of opaque background color suggest a relationship with a Clairvaux manuscript, Bibliothèque de Troyes MS. 527.[40] These stylistic relationships raise intriguing questions concerning the relationships among Cistercian scriptoria.

Similarities of page layout, script, and organization of text indicate a familial relationship among these Pontigny manuscripts; a concern for craftsmanship and design is especially apparent. This scriptorium was concerned with the visual aspects of book production, as well as the effective arrangement of the texts. In short, the Pontigny books again belie the outdated view that the Cistercians were motivated only by economy and utility.

State University of New York at Oswego

APPENDIX

Description of University of Pennsylvania, Latin 63

Latin on parchment, ii paper + 112 + ii paper folios, 265 x 180 mm.
Text in one column, 32-33 lines, written space 195 x 120 mm. Writ-
ten in early Gothic text hand in brown and red ink, rulings in lead
point. Written by four hands: 1) folios 1r-8v, 10r-23r, 36r-58r,
87r-112v; 2) folios 9r-9v; 3) folios 23r-25v; 58r-78v; 4) folios 79r-
87r. Gatherings usually of eight leaves (1^8, 2^{10}, $3-4^8$, 5^4, $6-9^8$,
10^{12}, 11^8, 12^{10}, $13-14^8$); catchwords on folios 31v, 35v, 43v, 67v,
86v, and 96v. Large red initials with geometric and foliate ornament.
Modern leather binding. Provenance: No ex-libris. Phillipps num-
ber 11901 on folio 1r. Purchased by University of Pennsylvania from
B. Rosenthal, New York, in December, 1953.
Contents:

Fols. 1r-9v, St Augustine, *De pastoribus*

> Incipit is missing; text begins with: ...sos in oves pascenti-
> bus et laetalis... (PL 38:279, line 24)
> Explicit: ...qui vos cogunt ad unitatem.

> Edition: PL 38:270-95

> A page has been cut out of this gathering between folios 4 and
> 5. Part of the text is missing too. The text jumps from PL 38,
> last line of 285 to 287, line 24.

Fols. 9v-23r, St Augustine, *De ovibus*

> Incipit: Verba quae cantivimus, continent professionem nostram...
> Explicit: Ego dominus deus vester, dicit dominus deus noster.

> Edition: PL 38:295-316

Fols. 23r-35v, St Ambrose, *De laude et exhortatione viduitatis*

> Incipit: Bene accidit fratres ut quoniam tribus libris...
> Explicit: ...tenere nequeatis et molestias augeatis.

> Edition: PL 16:233-62

Fol. 36r, St Augustine, *Retractatio in libro ad Horosium contra Priscillianistas*

Incipit: Inter haec Orosii cuisdam hispani presbyteri consultationi...
Explicit: Hic liber sic incipit. Respondere tibi querenti dilectissime fili orosi.

Editions: PL 32:648-9; CSEL 36:183
See also: E. Dekkers, 'Clavis Patrum Latinorum,' *Sacris Erudici* III (1951) 50, no. 250.

Fols. 36r-37v, Orosius, *Commonitorium ad sanctum Augustinum de Priscillianistis et Origenis errore*

Incipit: Beatissime patri Augustino episcopo horosius. Iam quidem...
Explicit: ...eos descendat expectant esse dignare.

Editions: PL 31:1211-16 and 42:665-70; CSEL 18:151-7
See also: Dekkers, p. 102, no. 573.

Fols. 37v-43r, St Augustine, *Responsio ad Orosium de Priscillianistis et Origenis errore*

Incipit: Respondere abiquerenti dilectissime orosi, nec ad omnia debeo...
Explicit: ...quam donare dignatus est caritatem.

Edition: PL 42:669-78

Fol. 43r, St Augustine, *Retractatio in libro de correctione Donatistarum*

Incipit: Eodem tempore scripsi etiam librum de correctione...
Explicit: Hic liber sic incipit. Laudo et gratulor et ammirorum.

Editions: PL 32:650 and 33:792; CSEL 36:186

Fols. 43r-58r, St Augustine, *Libro de correctione Donatistarum*

Incipit: Laudo et gratulor et ammiror...
Explicit: ...corrigendos sanandosque commendat.

Edition: PL 33:792-815

Fol. 58r, St Augustine, *Retractatio in libro de fide et operibus*

 Incipit: Interea missa sunt mihi a quibusdam...
 Explicit: Hic liber sic incipit.

 Editions: PL 32:646; CSEL 36:177

Fols. 58r-78v, St Augustine, *De fide et operibus*

 Incipit: Quibusdam videtur indiscrete omnis admittendos...
 Explicit: ...a quolibet facillime redargui posset.

 Editions: PL 40:197-230; CSEL 41:35-97
 See also: Dekkers, p. 59, no. 294.

Fols. 79r-87r, St Augustine (spurious?), *De dialectica*

 Incipit: Dialectica est bene disputandi sciencia...
 Explicit: ...ab eo quod est lepus, deflexum est.

 Editions: PL 32:1409-20
 See also: Dekkers, p. 65, no. 361; Augustine, *De dialectica:*
 ed. B. D. Jackson, (Boston: 1975).

Fols. 87r-102v, **Aristotle**, *Cathegoriae translate a beato Augustino de greco in latinum* (spurious)

 Incipit: Cum omnis scientia disciplinaque artium diversarum...
 Explicit: ...aut indoctos manifestius erudire.

 Edition: PL 32:1419-40
 See also: Dekkers, p. 66, no. 362; and L. Minio-Paluello,
 'The text of the *Categoriae*: The Latin Tradition,' *The Classical Quarterly* 39 (1945) 63-74.

Fols. 102v-104r, St Augustine (**spurious**), *Commonitorium ad universam ecclesiam destinatum sub qua cautela Manichei si conversi fuerint suscipi debeant*

 Incipit: Cum **manichei** qui consitentur et quos poenitet...
 Explicit: ...in quibus fuerant commendati **deferant**.

 Editions: PL 42:1153-6; CSEL 25:979-82
 See also: Dekkers, p. 94, no. 533

Fols. 104r–106r, Pope John II, *Epistola de fide contra Euticianistas de duobus naturis in una persona domini nostri Iesu Christi*

 Incipit: Dominis filiis merito illustribus atque...
 Explicit: ...filii merito illustres atque magnifici.

 No known editions.

Fols. 106r–109r, St Augustine (spurious), *Collatio trinitatis a se ipso ad semet ipsum*

 Incipit: Cum me pervigil cura fecisset ex somnem his me...
 Explicit: ...curis videre non possunt saltim fidei compendio nanciscantur.

 Editions: PL 42:1207–12
 See also: Dekkers, p. 72, no. 379

Fols. 109r–112v, Possidius' catalogue of the works of St Augustine

 Incipit: Questio de credibilibus. Epistolae contra paganos...
 Explicit: ...libera me de manu peccatorum. de versu psalmi.

 Edition: PL 46:5–22

Description of Syracuse University, Smith MS. 1

Latin on parchment, vi paper + i + 165 + iv paper folios, 345 x
240 mm. Test in two columns, 37 lines, written space 240 x 165 mm.
Written in early Gothic text hand in brown and red ink, rulings in
ink. Written by seven hands: 1) folios 1r-3r, 3v-16v; 2) folio 3r;
3) folios 17r-58r, 81r-96v, 98r-125r, 126v-135v; 4) folios 58v-63r;
5) folios 63v-80v, 147v-152v, 155r-162v; 6) folios 97r-97v, 125r-
126v, 153r-154v, 163r-165v; 7) folios 135v-147v. Gatherings generally
of eight leaves (1-18⁸, 19-20¹⁰, 21⁴); catchwords on folios 152v and
162v; quire signatures at end of each gathering beginning on folio
24v. Red, blue, and green initials with geometric and foliate decor-
ation. 19th century vellum binding.
Provenance: Pontigny ex-libris on folio 165v in pencil. Sold by
Abbé F. Allard to Sir Thomas Phillipps, ca. 1830 (Phillipps number
erased). Auctioned at Sotheby's on 1 June 1864, lot 165, to Howland
(?). Given to Syracuse Public Library (now Onondaga County Public
Library) in 1908 by J. William Smith. On deposit with Syracuse Uni-
versity.

Contents:

Fols. 1r-1v, St Augustine, *Retractatio in libris questionum*

 Incipit: Eodem tempore scripsi etiam libros questionum...
 Explicit: Hic liber sic incipit. Cum scripturas sanctas
 quae appellantur canonicae.

 Editions: PL 32:651-3 and 36:545-7; CSEL 36:191-5

Fols. 1v-139r, St Augustine, *De questionibus*

 Fols. 1v-4r, *Capitula questionum de libro geneseos*

 Fols. 4r-27r, *Liber primus de questionibus; libri geneseos*

 Incipit: Cum scripturas sanctas quae appellantur canonicae...
 Explicit: ...per quem factum est ut ingrederetur.

 Fols. 27v-29v, *Capitula libri secundi de questionibus Exodi*

 Fols. 29v-65r, *Liber secundum de questionibus Exodi*

 Incipit: De obstetricum mendacio quo fefellerunt...
 Explicit: ...maxime illud occidentis ubi erat altare
 sacrificiorum.

Fols. 65r–665, *Capitula libri tercii de questionibus Levitici*

Fols. 66r–87r, *Liber tertius de questionibus Levitici*

> Incipit: Si anima peccaverit aut audierit vocem...
> Explicit: ...quia nimius in eis timor erit ut et levissima quaeque formident.

Fols. 87r–88r, *Capitula libri quarti de questionibus Numerorum*

Fols. 88r–102v, *Liber quartus de questionibus Numerorum*

> Incipit: Quid est quod singulos de singulis eligi...
> Explicit: ...propterea de illis civitatibus pulsus sit.

Fols. 102v–103r, *Capitula libri quinti de questionibus Deuteronomis*

Fols. 103r–115v, *Liber quintus de questionibus Deuteronomis*

> Incipit: In eo quod commemorat moses dixisse...
> Explicit: Propter crucis cornua de Domino intelligitur figuratam.

Fols. 115v–116r, *Capitula libri sexti de questionibus libri Iosuae*

Fols. 116r–124r, *Liber sextus de questionibus libri Iosuae*

> Incipit: Dominus dicit ad Iesuum Nave...
> Explicit: Non illis imputetur

Fols. 124r–124v, *Capitula libri septum de questionibus libri Iudicum*

Fols. 124v–139r, *Liber septimus de questionibus libri Iudicum*

> Incipit: In fine libri Iesu Nave breviter narrator...
> Explicit: ...nisi audiendo vel legendo discantur.

Editions: PL 34:547–824; CSEL 28:2, 3ff.
See also: Dekkers, p. 54, no. 270.

Fols. 139r–139v, St Augustine, *Retractatio in libri locutionum*

> Incipit: Septem libros de septem libris divinarum scripturarum...
> Explicit: ...hoc opus sic incipit locutiones scripturarum.

Editions: PL 32:651 and 34:485; CSEL 36:190–1

Fols. 139v–165v, St Augustine, *De locutionibus*

Fols. 139v–146v, *Liber primus de locutionibus Geneseos*

Incipit: Locutiones scripturarum quae videntur...
Explicit: ...dictum est solet hoc facere scriptura.

Fols. 146v–152v, *Liber secundus de locutionibus* Exodi I

Incipit: Et invalescebant valde...
Explicit: ...ut dictum est et filius israhel.

Fols. 152v–155v, *Liber tertius de locutionibus Levitici*

Incipit: Homo ex vobis si obtulerit dona domino...
Explicit: Septies pro omni numero accipiendum est.

Fols. 155v–159v, *Liber quartus de locutionibus numerorum*

Incipit: Et vobiscum erunt unus quisque secundum...
Explicit: ...rariore in lingua latina quam in greca.

Fols. 159v–162r, *Liber quintus de locutionibus Deuteronomis*

Incipit: Usque ad flumen magnum...
Explicit: ...non facile inscripturis sanctis invenitur.

Fols. 162r–163v, *Liber sextus de locutionibus libri Iesu Nave*

Incipit: Vos autem transibitis expeditiores...
Explicit: ...quam crebo intercurrent.

Fols. 163v–165v, *Liber septimus de locutionibus libri Iudicum*

Incipit: Et factum est postquam defunctus est...
Explicit: ... super quas domus confirmata est super eas.

Editions: PL 34:485–650; CSEL 28:1, 507–629
See also: Dekkers, p. 54, no. 269.

NOTES

1. Part of the research for this paper was carried out during the
 Summer Institute in Basic Disciplines for Medieval Studies,
 held at the University of Pennsylvania in the summer of 1979,
 and funded by the National Endowment for the Humanities. I
 would especially like to thank Professor David Dumville who
 first called my attention to University of Pennsylvania Latin
 63, and who gave me many valuable suggestions. A slightly dif-
 ferent version of this paper was read at the Conference on Cis-
 tercian Studies, Fifteenth International Congress on Medieval
 Studies, May 1980, at Western Michigan University, Kalamazoo,
 Michigan.

 N. B. J. Migne, *Patrologiae cursus completus, series latina*
 is abbreviated as PL in this paper, and *Corpus scriptorum ecclesi-
 asticorum latinorum* is abbreviated as CSEL.

2. C. H. Talbot, 'Notes on the Library of Pontigny,' *Analecta sacri
 ordinis cisterciensis,* X, 1954, 106-168. His finding list is
 at pp. 159-68. For an abstract of a recent study which builds
 on Talbot's work, see: M. Peyrafort, 'La bibliothèque médiévale
 de l'abbaye de Pontigny,' *Positions des Thèses soutenues par
 les élèves de la Promotion de 1979 pour obtenir la Diplôme
 d'Archiviste Paléographe* (Paris: École des Chartes) 97-100.
 Peyrafort, depending upon the recent Oxford dissertation of Chris-
 topher de Hamel (see n. 37 below), concludes: 'En l'absence d'une
 étude plus precise, on peut supposer, mais non affirmer, l'existence
 d'un scriptorium à Pontigny.' The present study attempts such an
 affirmation.

3. Smith MS. 1, from the J. William Smith Collection of the Onondaga
 County Public Library, is on deposit with Syracuse University.
 The manuscript is shelved in the George Arents Research Library.

4. M. Lillich and K. Pennington, 'France (Pontigny?), mid 12th cen-
 tury,' *Medieval Art in Upstate New York,* ed. M. Lillich (Syracuse,
 N.Y.: Everson Museum of Art, 1974) pp. 74-76; see also: S. de
 Ricci and W. J. Wilson, *Census of Medieval and Renaissance Manu-
 scripts in the United States and Canada* 2 (New York: 1937) p. 1884.

5. N. Zacour and R. Hirsch, *Catalogue of Manuscripts in the Libraries
 of the University of Pennsylvania to 1800* (Philadelphis: 1965)
 p. 14; see also: C. U. Faye and W. H. Bond, *Supplement to the
 Census of Medieval and Renaissance Manuscripts in the United States
 and Canada* (New York: 1962) p. 492.

6. The *Annotatio librorum Pontiniacensium* is printed in: *Catalogue
 général des manuscrits des bibliothèques publiques des départ-
 ments* 1 (Paris: 1849) pp. 697-717.

7. Ibid., pp. 700-1.

8. This Augustine manuscript can **also** be identified in some of the
 later catalogues published by Talbot. The 1675 catalogue lists

several manuscripts containing St Augustine's works which are
not described in detail (Talbot, 'Notes,' bottom of page 112 and
top of page 113) which might refer to Latin 63. The 1734 list
mentions one manuscript which probably corresponds to Latin 63:
'S. August. De Symbolo, de fide et operibus, de dialectica, in
4°, xii sec.' (Ibid., p. 120), although Latin 63 might better
be described as an '8°' manuscript. Latin 63 can be matched up
with MS. 121 described in Abbot Depaguy's very careful 1778 in-
ventory (Ibid., p. 132), and MS. 106 on the 1794 list (Ibid.,
p. 144) apparently referred to Latin 63. This book appears as
MS. 121 on Talbot's finding list (Ibid., pp. 160-1).

9. *Catalogue général* 1: 698.
10. The book described as 'secundum Quaestiones in Sacram Scripturam,'
in the 1675 inventory probably corresponds to this codex (Talbot,
p. 112); there are two volumes described as 'S. Augustini, opera
varia, in fol. xii sec.,' on the 1734 list which could refer to
Smith MS. 1 (Ibid., p. 120). MS. 109 on Abbot Depaguy's 1778
list is clearly a description of Smith MS. 1 (Ibid., p. 131), and
MS. 239 on the 1794 inventory probably refers to the Syracuse
University manuscript (Ibid., p. 144). Smith MS. 1 appears as
MS. 109 on Talbot's finding list (Ibid., p. 160).
11. Talbot, pp. 155-8.
12. *The Phillipps Manuscripts: Catalogus librorum manuscriptorum
in biblioteca d. Thomae Phillipps*, introd. A. N. L. Munby,
(reprint London: 1968) p. 206.
13. de Ricci and Wilson, *Census*, p. 1884.
14. The two most frequently cited editions of the *Retractationes*
are: PL 36:583-656; and *Sancti Aureli Augustini Retractationum*,
ed. P. Knöll, CSEL 36 (Vienna: 1902). For an English translation
and further bibliography, see: *Saint Augustine: The Retractations*,
ed. M. Bogan, (Washington, D.C.: 1968).
15. M. R. James, *A Descriptive Catalogue of the McClean Collection
of Manuscripts in the Fitzwilliam Museum* (Cambridge: 1912) pp.
234-7. Listed in the *Annotatio (Catalogue général* 1: 701); see
also Talbot, 'Notes,' p. 160, MS. 120.
16. A catalogue of the Additional manuscripts at the University
Library is currently being prepared. Listed in *Annotatio (Cata-
logue général* 1: 700); see also Talbot, 'Notes,' p. 161, MS. 126.
17. *Catalogue général des manuscrits des bibliothèques publiques de
France* VI (Paris: 1887) p. 11. Listed in *Annotatio (Catalogue
général* 1: 699); see also Talbot, p. 161, MS. 131.
18. Originally there were seven volumes in this Augustine series.
Six of the seven are presently at Troyes; the fifth volume in the
the series has been lost. J. de Ghellinck, 'Une edition ou une
collection médiévale des *opera omnia* de saint Augustine,' *Liber
Floridus: Mittelalterlichen Studien--Festschrift Paul Lehmann*
(St. Ottilien: 1950) p. 70; and J. de Ghellinck, *Patristique et*

moyen âge: Études d'histoire littéraire et doctrinale 3, *Complé-
ments à l'étude de la patristique* (Gembloux: 1948) p. 342.
See also: A. Wilmart, 'L'Ancienne bibliothèque de Clairvaux'
*Mémoires de la société academique d'agriculture, des sciences,
arts et belles-lettres du département de l'Aube* 81 (1917) 136–41;
*Catalogue général des manuscrits des bibliothèques publiques des
départements* 2 (Paris: 1855) pp. 33–42, and F. Bibolet, 'Les
manuscrits de Clairvaux au XIIe siècle,' *Congrès archéologique*
113 (1955) 174–9. The new publication of A. Vernet, *La Bibliothèque
de l'abbaye du XIIe au XVIIIe siècle,* the first volume of which
has just appeared, will undoubtedly contain much useful informa-
tion on this series of Augustine manuscripts.

19. Ghellinck, 'Une edition,' p. 72, note 36.
20. J. Leclercq, 'Les manuscrits de l'abbaye de Liessies,' *Scriptorium*
6 (1952) 52.
21. R. Martin, 'La formation théologique de saint Bernard,' *Saint Ber-
nard et son temps* (Association bourguignonne des sociétés savantes:
Congrès de 1927) 1 (Dijon: 1928) 236–7; and O. Von Simson, *The
Gothic Cathedral: Origins of Gothic Architecture and the Medieval
Concept of Order,* 2nd ed. (New York: 1964) pp. 39ff.
22. Wilmart has suggested that St Bernard was responsible for the de-
velopment of the library at Clairvaux ('L'ancienne bibliothèque,'
pp. 161–4); the abbey had no books when it was first founded, but
there are about 340 twelfth-century books preserved from Clairvaux.
Most of these books were probably made while St Bernard was abbot
from 1115 to 1153. Bernard's role in the growth of the library
would **necessitate** some involvement in the activities of the scrip-
torium.
23. It is interesting to note that Jackson had concluded that the text
of *De dialectica* in Troyes 40[10] was closely related to that in
Latin 63 (Fols. 79r–87r), although he evidently suspected neither
that Latin 63 was a Cistercian manuscript nor that it came from
Pontigny (Augustine, *De dialectica,* p. 40, note 113).
24. The Cistercians were not the first editors to insert excerpts from
the *Retractationes* before the appropriate treatises. I have dis-
covered two pre twelfth-century Augustine manuscripts with *Retrac-
tationes* excerpts inserted before treatises. One of these is an
eleventh-century copy of St Augustine's *Confessions* now found at
Corpus Christi College, Cambridge, MS. 253 (M. R. James, *A De-
scriptive Catalogue of the Manuscripts in the Library of Corpus
Christi College, Cambridge* [Cambridge: 1912] 2: 4–5), and the
other is a sixth or seventh **century** copy of Augustine's *De
civitate Dei* (H.-I. Marrou, 'La division en chapitre des **livres**
de *La Cité de Dieu,*' *Mélanges Joseph de Ghellinck, S.J.* 1,
Antiquité [Gembloux: 1951] pp. 243–4). This copy of the *De
civitate Dei* is particularly noteworthy because it is the earli-
est extant manuscript which includes a table of chapter summaries

at the beginning of the text, preceding the *Retractatio*.

M. B. Parkes, in his very interesting study of Medieval systems of book organization, has suggested that a number of older practices, such as the use of running titles and chapter headings, were revived and improved upon in the twelfth and thirteenth centuries ('The Influence of the Concepts of *Ordinatio* and *Compilatio* on the Development of the Book,' *Medieval Learning and Literature: Essays Presented to Richard William Hunt*, J. J. G. Alexander and M. T. Gibson, eds. [Oxford: 1976] pp. 122-3). The idea of placing the *Retractationes* excerpts before the appropriate treatises was evidently another practice which was reinstituted in the twelfth century, and the Cistercians probably played a key role in this revival.

More innovative systems for indexing and organizing manuscripts were developed in the thirteenth century. R. H. Rouse has already discussed several such devices which were invented at Cistercian houses ('Cistercian Aids to Study in the Thirteenth Century,' *Studies in Medieval Cistercian History* 2, ed. J. Sommerfeldt, [Kalamazoo: 1976] pp. 123-34).

25. There are also twelfth-century non-Cistercian manuscripts which include *Retractationes* excerpts. Among these can be mentioned several books from the English Augustinian priory of Llanthony (M. R. James, *A Descriptive Catalog of the Manuscripts in the Library of Lambeth Palace: The Medieval Manuscripts* [Cambridge: 1932] MSS. 88, 203, 336, 337, 365, and 372) and a manuscript from the English Cluniac priory of Pontefract (N. Ker, *Medieval Manuscripts in British Libraries* 2, *Abbotsford-Keele* [Oxford: 1977] p. 150). In these cases it could be argued that the monastic scribes were working from Cistercian exemplars.

26. The last sentence of each *Retractatio* included the incipit of the treatise to which the Retractatio referred, which made these ninety-three short commentaries useful for determining which works attributed to Augustine were spurious. For information about the printed editions of Augustine's works, see: Ghellinck, *Patristique et moyen âge* 3: 366ff.

27. As Ghellinck points out, the practice of including the *Retractationes* was suspended in the seventh and last volume of the Clairvaux Augustine series, and that volume does include a number of spurious works ('Une edition,' pp. 80-2).

28. Rabanus Maurus, *In Matthaeum*, University College, London, Lat. 7. See: N. R. Ker, *Medieval Manuscripts in English Libraries* 1, *London* (Oxford: 1969) p. 340; Talbot, 'Notes,' p. 163, MS. 173; and *Annotatio (Catalogue général* 1: 709).

29. Cambridge, Fitzwilliam Museum, McClean Ms. 104.

30. Bibliothèque d'Auxerre, MS. 11. See: C. Samaran and R. Marichal, *Catalogue des manuscrits en écriture latine portant des indications de date, de lieu, ou de copiste*, VI, *Bourgogne, centre, sud-est,*

et sud-ouest de la France (Paris: 1968) p. 53, pl. CXCVIII; and
Talbot, 'Notes,' p. 159, MS. 58.

31. For information about illuminated Clairvaux manuscripts, see:
F. Bibolet, 'Les manuscrits de Clairvaux,' *Les Dossiers d'Ar-
chéologie* no. 14 (1976) 86-93; F. Bibolet, 'Les manuscrits de
Clairvaux au XII^e siècle,'; and L. Morel-Payen, *Les Plus beaux
manuscrits et les plus belles reliures de la Bibliothèque de
Troyes* (Troyes: 1935) pls. 5 and 24.

For information about illuminated Cîteaux manuscripts, see:
P. Gras, 'Les Miniatures de Cîteaux,' *Les Dossiers d'Archéologie*
no. 14 (1976) 94-9; C. Oursel, *Les Miniatures cisterciennes à
l'abbaye de Cîteaux au temps du second abbé saint Etienne Harding
(1109-vers 1134)* (Macon: 1960); C. Oursel, *La Miniature du XII^e
siècle à l'abbaye de Cîteaux* (Dijon: 1926).

Illuminated manuscripts from both Clairvaux and Cîteaux are
discussed in: J. Porcher, 'L'Enluminure cistercienne,' M.-A.
Dimier, *L'Art cistercien: France* 2nd ed. (La Pierre-qui-vire: 1974)
pp. 322-45. See also: *Saint Bernard et l'art des cisterciens*
(Dijon: Musée de Dijon, 1953).

32. Rabanus Maurus, *In Matthaeum*, London, University College, Lat. 7,
folio 1r; and Bede, *De templo Solomonis* and Helperic *De compotu*,
Bibliothèque d'Auxerre, MS. 14, fol. 1r. See: Talbot, 'Notes,'
p. 162, and *Annotatio (Catalogue général* 1: 707). For illustra-
tion of MS. 14, see: H. Zakin, *French Cistercian Grisaille Glass*
(New York: 1979) p. 352, pl. 142.

33. For example Latin 63, fol. 97r and Smith MS. 1, fol. 29v; Latin 63,
fol. 43r and Smith MS. 1, fol. 139v; Latin 63, fol. 91v and Smith
MS. 1, fol. 145r; Latin 63, fol. 103v and Smith MS. 1, fol. 74r.

34. Latin 63, fol. 37v, and *Incipit liber de nataliciis seu passionibus
Sanctorum a kalendas Feb. usque ad kalendas Aprilis*, Bibliothèque
d'Auxerre, MS. 127, fol. 101r. See: Talbot, 'Notes,' p. 166,
MS. 309, and *Annotatio (Catalogue général* 1: 716).

35. W. Cahn, 'A Twelfth-Century Decretum Fragment from Pontigny,'
The Bulletin of the Cleveland Museum of Art 62 (1975) 48, 51-54.

36. C. R. Dodwell, *The Canterbury School of Illumination* (Cambridge:
1954) pp. 108-9.

37. In a recent Oxford dissertation, which I have not had the oppor-
tunity to read, Christopher de Hamel has suggested that the
'Becket/Bosham' manuscripts were made in Paris rather than at Pon-
tigny (letter, 21 March 1980). This might effect the dating of
the Cleveland leaf and of the other manuscripts discussed here
slightly.

38. Samaran and Marichal, *Catalogue des manuscrits*, 6, pl. 198.
For an illustration of another decorated capital, see: Zakin,
French Cistercian, p. 350, pl. 140.

39. Zakin, *French Cistercian*, p. 133, note 4.

40. *Catalogue général*, 2, p. 230; Zakin, *French Cistercian*, p. 353,
pl. 143; and Morel-Payen, *Les plus beaux manuscrits*, pl. II, fig. 5.

MONASTIC GOALS IN THE AESTHETICS
OF SAINT BERNARD

Elisabeth Melczer and Eileen Soldwedel

While the theoretical writings of St Bernard have in the past been analyzed with a great deal of attention to deduce from them the theology of St Bernard--properly speaking, his mystic theology--and while Cistercian art has also been the object of a number of important studies, Cistercian literature as such has been but seldom related to Cistercian art. The reason lies no doubt in the fact that we have hardly any theoretical writing of St Bernard on aesthetics *per se*. Since the single overriding and all-subsuming preoccupation of the Saint was with mystic theology, practically everything he said or wrote pertains to mystic theology--and only by inference, or implicitly, to anything else. Therefore, to elucidate St Bernard's concepts on aesthetics one must consider the implicit aesthetic notions contained in, or derived from, his theological writings.

Bernard of Clairvaux's Sermons indicate he was undoubtedly sensitive to beautiful things:

> Not everything, therefore, that is black is on that account ugly. For example, blackness in the pupil of the eye is not unbecoming; black gems look glamorous in ornamental settings, and black locks above a pale face enhance its beauty and charm.[1]

But he determined to ignore beauty by a conscious act of will: 'For the sake of Christ...all that is beautiful in sight and sound and scent we monks have left behind.'[2] Consequently, it is a mistake to regard him as either opposed to art *per se* or as a pharisee concerned with the Cistercian 'Image'.[3] It was the misuse of art that Bernard opposed, images with scant religious symbolism or purpose, 'curiosities' and unnecessary sumptuous display, all of which only 'impedes the recollection of those who should be praying.'[4]

To St Bernard, the artistic expression appropriate to each state in life varied. 'Those in the world were not yet spiritually strong; they still needed milk rather than solid food.'[5] Bernard's statement that ornamentation was needed in the cathedral 'to rouse devotion in a carnal people incapable of spiritual things'[6] was echoed by William of St Thierry. In the cathedral and the parish church images of Christ's passion and resurrection were needed 'so that the weak spirit which is only able to think of material objects and their properties may have something to which it can apply itself and cling with devout attention, as befits its degree.'[7] To Bernard

even the trappings of papal display, which (he warned Eugenius III) marked the pope as a successor of Constantine rather than of Peter, 'must be allowed for the time being' because the Roman public expected them.[8]

Monastic Contemplation

But what was suitable for the worldly throng in the cathedral was not suitable for the monk in the cloister. 'We monks are differently situated than bishops; they have a duty to their people, not all of whom are spiritual, and they must try to stir up their devotion by material things.'[9] The material objects and images needed as didactic tools to persuade the laity were detrimental to the monastic state, the aim of which was to strive toward the knowledge of God through contemplation.[10] Contemplation of the mysteries celebrated through the liturgical year was 'God's royal road,'[11] the single, overwhelming task of the Cistercian monk. But contemplation was only a means toward an end, the mystical union with God attained through the stages of spiritual ascent referred to by Bernard as the progressive kisses of the feet, hands and mouth. The passage 'let him kiss me with the kiss of his mouth' St Bernard interprets as 'an unreserved infusion of joys, a revealing of mysteries, a marvelous and indistinguishable mingling of the divine light with the enlightened mind, which, joined in truth to God, is one spirit with him...'[12]; as 'a contemplative gift by which a kind and beneficient Lord shows himself to the soul with as much clarity as bodily frailty can endure.'[13] Such a kiss constitutes the highest stage of the spiritual life.[14]

The sensory images of art were a barrier to the 'kiss of his mouth,' for the soul must first transcend every material reality and every corporeal image before it could attain union with the absolute spirituality of God. This was a frequent theme in St Bernard's Sermons: mons:

> The coming of the Word was not perceptible to my eyes, for
> he has no color; nor to my ears, for there was no sound;
> nor yet to my nostrils, for he mingles with the mind, not
> the air....His coming was not tasted by the mouth, for there
> was no eating or drinking, nor could he be known by the
> sense of touch, for he is not tangible.'[15]

Elsewhere Bernard stated: 'The Divine Substance, my brethren, must not be conceived as something corporeal, nor does It possess, like our human nature any distinction of bodily members. God is a pure Spirit....'[16]

Sensory images and even **language** itself were an impediment to the soul in its quest for mystical union:

Let my soul die the death of the angels also so that, es-
caping from the memory of all present things, she may
strip herself, not alone of the desires, but even of the
images of inferior and corporeal objects and may converse
spiritually with those whom she resembles in spirituality
...to be able to contemplate truth without the help of ma-
terial or sensible images is the characteristic of angelic
purity....Blessed is the soul which can say in this sense:
'Lo, I have gone far off, flying away: and I abode in the
wilderness.' But you have not flown far, unless, by the
purity of your mind, you are able to rise above the images
of sensible objects, which are constantly rushing in upon
you from every side.[17]

There are no words to describe the indescribable: '...that which
is unchangeable is uncomprehensible, and hence cannot be expressed
in language. Where, I ask, can you find the words to pay worthy
tribute to that majesty, or properly describe it, or adequately
define it?'[18] So too, the unmediated contact of the soul with God,
ecstasy, was beyond definition:

Do you suppose, if I were granted that experience, that
I could describe to you what is beyond description?....
Oh, whoever is curious to know what it means to enjoy the
Word, make ready your mind, not your ear! The tongue does
not teach this, grace does.'[19]

That sensory images were a barrier to contemplation was empha-
sized by St Bernard: 'There is here [in contemplation] as I think
no need or use of material, sense transmitted images of Christ's
Flesh or Cross or any other representation which belongs to the weak-
ness of His mortality.'[20] William of St Thierry stated even more
forcefully: 'If I envisage for you my God, any form whatever, or any-
thing that has a form, I make myself an idolater.'[21]

St Bernard's views on images paraphrase Cassian's *Conferences*.[22]
Chapter 73 of the Rule of St Benedict specifically recommends the
Conferences as an 'example for monks and instrument of virtue.'[23]
There was a copy of Cassian at Cîteaux while St Bernard was abbot,[24]
and St Bernard's thought was undoubtedly influenced by the Fathers
of the Desert.

It is relatively easy to state what St Bernard thought monas-
tic art should not be: it should not be a distraction, a stimulus
to vagabond imagination. There are references throughout his Ser-
mons to the 'restless intrusion of sensible images' that disturb the
rest of the soul in God.[25] Nor should monastic art interfere with
the 'discipline of the eyes.' St Bernard viewed the 'discipline of
the eyes' as vital to prevent curiosity, which 'was the beginning

of all sin' and 'rightly considered the first step of pride.'26

Monastic Simplicity and Community

The function of art in the Cistercian monastery was to provide a setting which would be conducive to contemplation by reflecting the simplicity, order and collective nature of community life in purity of line, superior structural harmony and serene luminosity. In brief, art was to be appropriate to the cloister, the 'paradise' --'the city surrounded and defended with a wall of discipline'27-- within which the Cistercian would persevere until death.

Simplicity meant the removal of the superfluous: 'Remove what is superfluous, and thou shalt see an increase of what is good and necessary. What thou subtracted from superfluity is added to utility.'28 When superfluous display is removed, one reveals the intrinsic beauty of the materials, their harmony of proportion and craftsmanship. One reveals a simplicity in which 'Less is More' or, to quote St Bernard, 'for so perfect is the beauty and the charm of this...that you cannot change a single iota without spoiling it.'29

Simplicity became for the Cistercians a quality of life. It was understood, together with immortality and free will, as one of the three fundamental characteristics of the soul; it is simplicity that made the soul alike to, or at least an image of, the Word.30 To St Bernard, the theological virtues upon which the ascent towards the Divine was predicated were themselves considered 'mirrors of simplicity;'31 and the soul's successful progression towards the Divine was considered to be conditioned by its simplicity. 'There is no virtue more indispensable for us all at the beginning of our conversion than humble simplicity.'32 The connotative values of the word for St Bernard were not merely uncomplicated and non-complex, but also essential, pure and unique.

There is a collective spirit in Cistercian art which reflects the common will. The object was to direct the thought to God, not to the artisan or his creative skill. Names of Cistercian architects have been related to Fountains, Clairmarais and Himmerod,33 but their work was the expression of a community and not that of an individual. Just as the individual will was to be lost in obedience to one's religious superior, so individualized self expression, 'singularity,' was to be lost in communal expression. As Leclercq has noted, 'singularity is a form of self-sufficiency with pride as its foundation....It consists, for the monk, in seeking his own interests, in deviating from the "common will" by preferring his "own will".'34 St Bernard repeatedly condemned singularity in all its forms:

He Who is subsisting Truth has no love for singularities; divisions do not please him. He 'standeth in the midst', that is to say, He is found in the common life and disci-

pline, uniformity of **observance** is His delight. How long,
therefore, O miserable man, wilt thou pursue thine own
little particularities?[35]

The unity of plan and construction among Cistercian foundations
begun during St Bernard's forty years as abbot of Clairvaux is so
striking that the term 'Bernadine Plan' has been coined.[36] The twen-
ty-two monastic sites begun under the direct supervision of St Ber-
nard all have rectilinear chevets and flat-ended transepts with two
or three chapels separated from each other by a wall. Why such an
insistence upon the flat wall and the straight line? It has been sug-
gested that the reason was economic; that it was cheaper to build so and
easier to add on to, for further expansion.[37] While it is true that
the plan presented certain advantages in construction since one did
not have to lay out complex curves or to precalculate the vault's thrust
in the chevet foundations,[38] the Bernardine Plan was not adopted for
economy or for efficient construction. The Cistercians built as they
did by choice, not by necessity. St Bernard wanted to remove all dis-
tractions from the 'workshop of prayer': the functional austerity of
the Cistercian interior should offer no stimuli which would interfere
with contemplation. William of St Thierry expressed the Cistercian
architectual ideal in the following terms:

> For what is within us is benefited in no slight degree by
> what is around us, when it is arranged to accord with our
> minds and in its own way to correspond with the ideals we
> have set before us...a spirit that is intent on interior
> things is better served by an absence of decoration and
> trimming in the things around it.[39]

Light

Cistercian architecture is stripped of color and decoration be-
cause the Word was without color or form or dimension: to St Bernard,
the soul needed to transcend those material categories if it was to
achieve the mystical experience. On the other hand, Cistercian interiors
are luminous, bathed in light: this must have necessarily served as an
aid to contemplation. Cistercian architects were probably influenced by
St Bernard's light imagery: the use of sunlight to symbolize the physi-
cal presence of the Divinity in the sanctuary.[40]
 Examples of light imagery abound throughout Bernard's writing.
Illumination is made variously part of the qualities, attributes,
substance and activity of the Word, God the Father, Christ, the Vir-
gin, the soul and the just. At times the divinity is simply identi-
fied with white light, 'The white light and most pure refulgence of
the Godhead.'[41] 'The Word is the light....Happy are you if you too

can say "Your word is a lamp for my feet and a lantern for my path"'[42];
St Bernard speaks of the '...light of God'[43]; refers to God as 'the
Father of all light'[44] who dwells 'in inaccessible light'[45]; and 'The
Father is also Light since the Son is Light of Light.'[46]

Christ, '"the Brightness of eternal Light" enclosed Himself in
the Lantern, so to speak, of the glorious, the most pure and spot-
less Flesh....and which is manifestly signified by this most light
and luminous cloud upon which...the Lord was to ascend....'[47] The
Lamb becomes the lamp: '..."the Lamb is the Lamp thereof." Here,
then, is the answer: "I will show him My salvation, so that, as the
Evangelist says, the Lamb shall become his Light."'[48] Christ illu-
mines the darkness: '...who by this purpose has come into the world,
that, living here in men, with men, and for men, He may illuminate
their darkness, lighten their labours, and guard them from all dan-
ger.'[49] Still elsewhere we read: 'The light of Christ should
shine.'[50]

We reach some of the deeper implications of the light mystic of
St Bernard when the Cistercian abbot meditates upon the very name of
Jesus: 'Is it not by the light of this name that God has called us
into his wonderful light, that irradiates our darkness and empowers
us to see the light?'[51] Quoting St Paul, he writes: 'You the faith-
ful were darkness once, but now you are light in the Lord.' That
name 'illuminated his native land'; He carried it 'like a torch.'[52]
The apex of St Bernard's Christocentric light mysticism is the *Hymn
to the Name of Jesus,* a magnificent string of light imagery applied
to Christ:

> O Jesus, sweetness of my heart,
> The Fountain of life, and light, and love,
> To me the joy of joys Thou art....[53]

> The Sun of truth shines bright and clear
> Within the soul where Thou art guest;[54]

> Come, come, Lord Jesus, best of kings
> A brighter radiance on me cast;
> Come, Source whence light eternal springs.[55]

> Thy brightness, Jesus, shames the sun.[56]

> For Thou love's consummation art,
> The bliss and sunshine of my mind.[57]

> Sole Splendour of the land of light[58]

> Yea, mercy's never-failing source,
> Eternal Brightness of the blest;
> Drive clouds and sadness from our course
> And let Thy light upon us rest.[59]

The metaphor of the Sun of Justice appears a number of times:
'Therefore I may say that then a man is spiritually born, when the
Divine Sun of Justice is rising in his soul, illuminates the dark-
ness of his sins...'[60]; '...radiant Sun of Justice...'[61]; 'the Sun
of Justice...has shown Himself amidst the gloom of this place of
our banishment as a burning and shining torch, or large and bril-
liant flame, in order, namely, that all who desire to be illumin-
ated may approach and be united to Him...'[62] 'The corporeal sun
which shines in the heavens is very useful and very necessary. Yet
...its light needs to be moderated or it will hurt our delicate
eyes. This is no fault of the sun, but is due to our own fragil-
ity. It is the same with the Sun of Justice.'[63]

The highest state of mystical union, the 'kiss of his mouth', is
associated with light and luminosity. In the Second Sermon on the
Song of Songs St Bernard speaks of the 'kiss' as 'a marvelous ming-
ling of the divine light with the enlightened mind...'[64] In *De
diligendo Deo,*[65] the soul in ecstasy is described as air flooded
with light, and in Sermon 17 of the *Song of Songs*:

> '...he [Lord] leads us on from brightness to brightness
> because he is the Spirit of the Lord. Sometimes he
> fills us with rapture by communication of his light,
> sometimes he adapts himself to our weakness and sends
> beams of light into the dark about us...let us stay
> always in the light, always walk as children of the
> light.'[66]

The body was a barrier preventing the Bride from gazing 'upon
that sublime noontime brightness....To penetrate to where light is
total, to...make your home where light is unapproachable, that is
beyond the scope of an earthly life or an earthly body...Do you not
know that as long as you live in the body you are exiled from the
light?'[67] Sermon 57 reminded Cistercians that 'as long as this mere
crumbling wall of the body stands, this ray of intense brightness
will pour itself in not through open doors but through chinks and
crevices.'[68]

One of the sublime passages of St Bernard's light imagery is
contained in the Sermon for the Sunday within the Octave of the
Assumption in which Mary is represented as 'clothed with the sun':

> ...Not without reason, therefore is Mary represented as
> clothed with the sun, since she has penetrated the un-

fathomable abyss of divine wisdom to a degree that is
almost incredible; so that we can say of her **that** she is
immersed in that ocean of inaccessible light as utterly
as is possible to any created nature not deified by **hypo**-
static union. She is plunged, I say, in that heavenly
fire wherewith the Prophet's lips were Purified....To
her it is due not merely to be lightly touched with that
fire, but to be completely surrounded with it, to be
utterly enveloped and absorbed in it. Most intense, un-
doubtedly, is the light and heat of this Woman's clothing,
in whom everything is so beautifully **bright** and warm that
it would be impius to suspect **her of** containing anything,
I do not say darksome, but even obscure or otherwise than
perfectly luminous...'[69]

The soul is described as luminous and radiant: 'When the soul
enters into its third degree of knowledge, in repentance she is
warmed, in amendment she is set on fire; in solitude she becomes
all luminous and radiant, so that the whole man is renewed within
and without'[70]; or burning and shining.[71] The just are also de-
picted as shining: '"Then shall the just shine", those who posses-
sed little learning in this life being now as resplendent in glory
as they that had greater; for they shall shine as the sun of the
kingdom of their Father.'[72] The just are, by the authority of St
Paul, 'the sons of light and day rather than of night and of dark-
ness'[73] desiring to be granted 'to see the sun **today**'[74] and know-
ing that 'It was night all over the world before the dawn of the
True Light.'[75] In a letter to Baldwin, Archbishop of Pisa, St Ber-
nard directed him 'to be like **St** John. Let your light shine before
men, yet so as to burn before God as well, so that men may say of
you: He was a burning and shining light.'[76]
The metaphoric language of light is applied to concepts other
than to the just and to divinity. 'Light is purity, light is the
love which does not insist on its own way.'[77] Light is splendor
and joy: '...splendour of light and fervour of charity...illumine
the **loftiest** mysteries of God'[78]; 'The joy of the new light is an-
nounced [to the shepherds]'[79]; 'Happiness of heaven is called light
because of its purity'.[80] The splendor of the world of the spirit
is rendered in terms of light: 'Eyes that are accustomed only to
darkness will be dazzled by the brightness of the spiritual world,
overpowered by its splendor...its peerless radiance...'[81] In a re-
markable instance, light appears as beauty, as a beautiful garment:
'He [our Divine Head] at once "clothed Himself with a change of gar-
ments," He "**put** on beauty" and appeared covered "with light as with
a garment"'.[82]
At times, light is contrasted to darkness: 'He is the Light
that shineth in darkness, and the darkness did not comprehend It'[83];

'Brightness of the true and living light shall occupy all things...
expelling the shadows and the darkness.'[84] We find a remarkable
instance contrasting sin with true light in the context of the sim-
ile of a taper:

> '...our sins...''separate between us and God.'' There-
> fore, as soon as these are removed we are placed in
> contact with the true light of the world, to be enlight-
> ened by and, as it were, made one with It; just as when
> we want to light an extinguished taper we touch it to
> another that is burning and shining...'[85]

There are a few instances in which St Bernard conveys the notion
of an excess of light. The eye is dazzled and one cannot endure its
brightness: 'He dwelt in ''light inaccessible'' and there was no one
able to endure His brightness'[86]; and '...thy eyes shall be dazzled
by such an excess of light, where each of the just shall shine as the
sun....'[87] But these are atypical examples. St Bernard's more com-
mon imagery is that of a divine light or illumination that man, in
the higher stages of monastic contemplation, is indeed able to bear.
St Bernard's light imagery may have been influenced by St Augus-
tine, who conceived of intellectual perception as resulting from an
act of illumination in which the divine mind enlightens the human
mind: 'In proportion as it is united to God through love, the pure
soul will be flooded with intelligible light through which it sees,
not by bodily vision but by the intelligence which is, as it were,
its interior eye....'[88] St Augustine does not hesitate to call Christ
Light in a proper and not merely in a figurative sense. 'Neque enim
et Christus sic dicitur lux quomodo dicitur lapis; sed illud proprie,
hoc unique figurate.'[89] But there was an important difference between
the two Saints: color was a positive element in St Augustine's aesthe-
tic perception. We read in the *Confessions*: 'The eyes love soft and
bright colors.'[90] Elsewhere, St Augustine writes that 'Light--the
queen of colors--bathing all which is beheld, adds its color. Visible
light which illuminates the earth, forms the day, gives objects their
beauty and brings out their various colors.'[91] St Bernard, on the
other hand, considered color a distraction.

ORDER

Delight in order and in orderly arrangement, and a marked con-
sciousness of an assigned and predetermined place are also important
elements in St Bernard's aesthetic conception. Explaining why the
just shall rejoice in the punishment of the wicked, Bernard writes:

> 'because the beautiful order established by divine provi-
> dence will produce an inexpressible delight in him who has

zeal for justice and love of equity. For...thou shall
clearly and perfectly behold everything arranged in the
most admirable order, his own place assigned to every-
one, or rather everyone assigned to his own place.'[92]

In the same context, God is called 'the great Disposer of all.'[93]
Speaking of the creation of the universe, St Bernard emphasizes
the disposition and the ordering of its various parts.[94] The very
essence of God is order: 'From the beginning, my brethren, God
has shown His predilection for order, and nothing out of order has
ever been acceptable to Him whose very Essence is order.'[95]
 Obedience and discipline are subsidiary categories of order.
'Obedience is better than sacrifice.'[96] 'The man whose character
I most admire...is the man...who never contends with his superiors
...'[97] Particularly important is the relationship St Bernard traces
between contemplation and obedience. True contemplation is built on
'the flowers of obedience.'[98] To St Bernard, order, obedience and
discipline are aspects of a single totality of structured existence,
an organic whole whose parts are integrated and coordinated with
constant care and high **exactitude**. The manifestations of this struc-
tured existence comprise each element of life devoted to the fulfill-
ment of the mystic union with God: the architecture of the cloister
no less than the liturgy, the aesthetic of pure simplicity and un-
decorated surfaces no less than the contemplative steps in the mystic
ascension towards God. Within such a totality of concerns, the sense
of order and luminosity of Cistercian fenestration, with its rigor-
ously composed geometric or foliated patterns, constitutes a part
within a whole. But nothing is insignificant or inconsequential if
it assists in one way or another the monk's world of contemplation.
Cistercian grisaille windows thus correspond to the quiet austerity
and calculated purposefulness of the Cistercian monastery.

 St Bernard indeed possessed a highly developed aesthetic sen-
sitivity which was structured to be correlated with and subordinate
to his mystical theology. St Bernard's supposed blindness to beauty
is more myth than reality, probably originating at the time of his
quarrel with Suger and the writing of the *Apologia* which has, over
the years, caused much misunderstanding. But it is not in the satir-
ic lines of the *Apologia* that one should look for Bernard's **aesthetics**.
Instead, St Bernard's theory of monastic art reveals itself in the cor-
pus of his writings, and in the totality of his theological conception
translated into the purity of line, simplicity, serene luminosity and
superior structural order that constitutes indeed Cistercian art.

Syracuse University and Edmonds Community College

NOTES

1. Bernard of Clairvaux, SC 25.3; *Sermons on the Song of Songs II*, tr. Kilian Walsh, OCSO, Cistercian Fathers Series, 7 (1976) p. 51. See also: *Sermons for the Seasons and Principal Festivals of the Year*, '...here, too on earth we may perhaps find many things which appear to be beautiful in their own order....' tr. Priest of Mt Melleray (Dublin: Browne, 1925) 3:7.

2. Bernard of Clairvaux, *Treatises I: Apologia to Abbot William*, tr. Michael Casey, CF 1 (1970) p. 64.

3. Caroline A. Bruzelius, 'Cistercian High Gothic: the Abbey Church of Longpoint and the Architecture of the Cistercians in the Early Thirteenth Century,' *Analecta cisterciensia* 35 (1979) 10, 14.

4. Bernard, *Apologia*, pp. 63-66.

5. Bernard of Clairvaux, SC 1.1; *Sermons on the Song of Songs I*, tr. Kilian Walsh, OCSO, CF 4 (1976) p. 1. See also William of St Thierry: *Meditation*, 10.iv, tr. Penelope Lawson, CSMU, *On Contemplating God, Prayer, and Meditations*, CF 3 (1971) pp. 152-53.

6. Bernard, *Apologia*, CF 1: 64. See also Letter 319 to the Roman people, *Letters of St Bernard of Clairvaux*, tr. Bruno Scott James, (London: Burns and Oates, 1953) pp. 392-93.

7. William of St Thierry, *The Golden Epistle*, XLIII.174, tr. Theodore Berkeley, OCSO, CF 12 (1971) p. 69.

8. Bernard of Clairvaux, *Five Books on Consideration*, 4.vi, tr. John Anderson and Elizabeth Kennan, CF 37 (1976) p. 117.

9. Bernard, *Apologia*, CF 1: 63-66.

10. To St Bernard, each state in life has an appropriate epistemology. The monk acquired knowledge through contemplation, the secular clergy through training in the contemporary schools and the layman received all the information he needed for salvation from the secular clergy. See John R. Sommerfeldt, 'Epistemology, Education and Social Theory in the Thought of Bernard of Clairvaux,' *Cistercian Studies Series* 28 (1977) 171, 174, 179.

11. SC 43.4; *On the Song of Songs* II: 223.

12. SC 2.2; *On the Song of Songs* I: 9.

13. SC 4.1; Ibid., p. 22.

14. Basil Pennington, OCSO, 'Three Stages of Spiritual Growth According to St Bernard,' *Studia Monastica* 11 (1969) 321-22.

15. Bernard of Clairvaux, SC 74.5, *On the Song of Songs* IV, tr. Irene Edmonds, CF 40 (1980) p. 90.

16. *Sermons for the Seasons*, 2:378.

17. Bernard of Clairvaux, SC 52.5; *Sermons on the Song of Songs* III, tr. Kilian Walsh, OCSO and Irene Edmonds, CF 31 (1970) 53-54; ET Sommerfeldt, *Studies in Medieval Culture* 1 (1964) 54, (PL 183 col. 1031).

18. SC 51.7; *On the Song of Songs* III: p. 45.

19. SC 85.14; *On the Song of Songs* IV: p. 210.

20. *St Bernard's Sermons on the Canticle of Canticles*, tr. by a
 priest of Mt Melleray (Dublin: Brown and Nolan, 1920) 2:17.
21. *On Contemplating God, Prayer and Meditations*, CF 3, p. 73.
22. Cassian, *Conferences*, ed. by Philip Schaff and Henry Wace, The
 Nicene and Post Nicene Fathers of the Christian Church, First
 Series, (New York: 1894) 11:403, col. 1.
23. Dom Hubert Van Zeller, *The Holy Rule. Notes on St Benedict's
 Legislation for Monks* (New York: Sheed and Ward, 1958) p. 461.
24. Musée de Dijon, *Saint Bernard et l'art des cisterciens* (Catalog)
 #50, p. 32.
25. SC 14.5; *On the Song of Songs* I: 101; SC 23.16; Ibid. II: 41.
 William of St Thierry compared sensory images to 'unclean birds'
 that 'perch upon him [God's servant] or fly around him, so that
 the sacrifice of his devotion is either snatched from the hand
 that holds it or, often, is defiled to the extent that the offer-
 er is reduced to tears.' *The Golden Epistle*, XVI.63, CF 12: 34.
26. Bernard, *The Steps of Humility and Pride*, X.38; *Treatises* II,
 CF 13 (1974) 66.
27. *Sermons for the Seasons* 3:531.
28. *St Bernard's Sermons on the Canticle*, 2:169, quoted by Sister
 Kilian Hufgard, OSU, 'A Theory of Art Formulated from the Writ-
 ings of St Bernard of Clairvaux,' Ph.D. Dissertation (Western
 Reserve: 1957) p. 150.
29. *Sermons for the Seasons* 1:310; quoted by Hufgard, p. 219.
30. *On the Song of Songs* I, p. xiii.
31. Ibid.
32. *Sermons for the Seasons*, 2:28.
33. Geoffroi d'Ainai was responsible for Fountains in England and
 Clairmarais in Flanders according to Marcel Aubert, *L'Architec-
 ture cistercienne en France*, 2nd ed. (Paris: 1947) 1:97. Achard,
 monk-architect of Clairvaux, supervised the German abbey at Him-
 merod: Francois Bucher, 'Cistercian Architectural Purism,' *Com-
 parative Studies in Society and History* 3 (1960-61) 98.
34. Jean Leclercq, 'Saint Bernard of Clairvaux and the Contemplative
 Community,' *Contemplative Community, an Interdisciplinary Sym-
 posium*, ed. M. Basil Pennington, CS 21 (1972) 96.
35. *Sermons for the Seasons*, 2:282; see also 3:303.
36. K. H. Esser, 'Über den Kirchenbau des Hl. Bernard von Clairvaux,'
 Archiv für Mittelrheinische Kirchengeschichte, (1953), cited by
 Bucher, *Comparative Studies in Society and History* 3, 98.
37. Hufgard, pp. 179, 195.
38. Bucher, *Comparative Studies in Society and History* 3, p. 99.
39. William of St Thierry, *The Golden Epistle*, p. 61.
40. Helen Zakin, *French Cistercian Grisaille Glass* (New York, Gar-
 land: 1979) p. 149.
41. *Sermons for the Seasons*, 2:279.
42. SC 85.2; *On the Song of Songs* IV: 197.

43. *Sermons for the Seasons* 1:198.
44. SC 10.7; *On the Song of Songs* I: 65.
45. SC 3.4; Ibid., p. 23.
46. *Sermons for the Seasons,* 1:355.
47. Ibid., 1:11.
48. Ibid., 1:306-7.
49. Ibid., 1:52.
50. SC 20.4; *On the Song of Songs* I, 149.
51. SC 15.6; Ibid., pp. 109-10.
52. Ibid.
53. *Sermons for the Seasons,* 1:447.
54. Ibid., 1:449
55. Ibid., 1:454.
56. Ibid., 1:454.
57. Ibid., 1:454.
58. Ibid., 1:455.
59. Ibid., 1:455.
60. Ibid., 1:440.
61. Ibid., 1:56.
62. Ibid., 1:331.
63. Ibid., 1:159.
64. SC 2.2; *On the Song of Songs* I: 9.
65. PL 182:991.
66. SC 17.8; *On the Song of Songs* I: 132.
67. SC 38.5; *On the Song of Songs* II: 190.
68. SC 57.8; *On the Song of Songs* III: 103.
69. *Sermons for the Seasons* 3:261-2.
70. Ibid., 1:333.
71. Ibid., 1:334.
72. Ibid., 1:34.
73. Ibid., 1:358.
74. Ibid.
75. Ibid.
76. Ep 115; *Letters of Bernard of Clairvaux,* p. 173.
77. SC 62.8; *On the Song of Songs* III: 159.
78. *Sermons for the Seasons,* 1:336.
79. Ibid., 1:416.
80. Ibid.
81. SC 3.2; *On the Song of Songs* I: 17.
82. *Sermons for the Seasons* 1:408. The metaphor is Pauline: Romans 13:12.
83. Ibid., 1:8.
84. Ibid., 1:331.
85. Ibid., 1:331.
86. Ibid., 1:401.
87. Ibid., 1:202-03.
88. *De Diversis Quaestionibus:* PL 40:83, Q. XLI, 2; 30-31; following

Chapman, *St Augustine's Philosophy of Beauty* (New York, 1939) p. 64.
89. *De Genesi ad litteram* IV, 28; PL 34:315.
90. X.XXXIV, 51; PL 32:800-1; Cfr. Chapman, 50.
91. *Epistolarum Classis* II, CXX, 10; PL 33:457; Cfr. Chapman, 50.
92. *Sermons for the Seasons,* 1:206.
93. Ibid.
94. Ibid., 1:337.
95. Ibid., 1:430.
96. SC 19.7; *On the Song of Songs* I: 145.
97. SC 23.8; *On the Song of Songs* II: 33.
98. SC 46.5; Ibid., p. 244.

PROBLEMS OF NON-DECORATION IN THE ARCHITECTURE
OF CISTERCIAN BUILDINGS

Joselita Raspi Serra

This essay is a marginal note to a well-known topic: that of the prohibition of decoration in Cistercian architecture, an interdiction still evident in the thirteenth and fourteenth centuries. St Bernard's program, set forth in the *Apologia ad Guillelmum*,[1] resulted in a considerable sobriety of compositional elements, an absence of ornament both inside and outside the structure. The undecorated lintels of portals, the tympana usually bare (if indeed present at all), the simple moldings used to outline apertures--all reflect the Bernardine principles of the *Apologia,* as Aubert[2] has noted with French examples.

Nonetheless, the idea of a complete avoidance of figural motifs does not seem to us totally acceptable. More exactly, it does not seem to us that the Bernardine directives were interpreted by the Cistercians exclusively in such a negative, limiting sense. The hypothesis that, at times, positive allusions were made to fundamental Christian themes, may be supported by the fact that the modular relationships of Cistercian buildings are often given iconographic interpretations.[3] Furthermore, the existence on both French and Italian monuments of lintels decorated with grape clusters does not seem to us to be a deviation from the prohibition against decoration; rather, it represents a transcendental reference, an ideological statement with symbolic meaning.

Patterns of grape clusters entwined around the motif of the cross, as well as more rigidly geometric abstractions of vegetal motifs, do indeed break up the starkness of the facade. The influence of motifs from the decorative vocabulary of the Ile-de-France, obvious in later examples, is not yet present here. In a number of cases a clearly established group of forms is used: at La Bénisson-Dieu (Loire, late twelfth century), the portal has a lintel decorated with a cross and a tympanum with stylized vegetal motifs; at S. Martino al Cimino (Viterbo, early thirteenth century), the lateral portal presents a cross with grape clusters (Fig. 1); on the lateral portal of S. Galgano (Siena) we find clusters of grapes reminiscent of classical prototypes (Fig. 2); at Casamari, a magnificent maze of vine leaves decorates the tympanum (Fig. 3), and even the cloister portal is decorated with stylized vegetal motifs (Fig. 4) recalling those of the transennae of the same building (Figs. 5 and 6). This list could be enlarged further. The thematic formula remains the same, even in its most subtle variations. It is a revival of Early Christian iconographic motifs: the cross, often webbed; the grape cluster; and stylized floral patterns, which can also be related to abstract vegetal motifs in early medieval

sculpture. We have already indicated in a previous study that this
return to earlier motifs cannot be interpreted as a continuation of
traditions still in use; rather, it is a deliberate and intellectual-
ized reference to decorative prototypes selected for the power of
their symbolism, and thus rooted in the principle of the Bernardine
'spiritualis effiges.'[4]

Actually it would seem quite absurd for the Cistercians to con-
tinue sculptural forms which were in common use[5] and which had been
employed by the Cluniacs; whereas, how likely it is that the Cister-
cians would make use of an iconographic allusion, since the thematic
reference would serve to transcend the immediate, visible image to
reflect the underlying idea. It is thus that some of the more subtle
Christian themes were stated by the Cistercians, by means of an image
bearing a clear symbolic reference, an image by which the individual
observer, transcending immanent reality, could attain the vision to
be meditated upon. This utilization of motifs of allusive content
can also be interpreted as a new emphasis on the abstraction of all
physical form. In this sense the decoration no longer has real value;
instead it becomes a denial of itself, turning into a transcendent
ideological statement.

One should emphasize, furthermore, that there is a rapid evolu-
tion in the appearance of these Cistercian motifs. Actually the forms,
once they are adopted by the Cistercians and 'programmed' with symbol-
ic meaning, develop in new ways which are linked increasingly with the
most advanced stylistic influences of the visual arts. The grape clus-
ter of San Galgano will eventually absorb the new, classical tendencies
of the Pisan style;[6] and the luxuriant tangle of foliage of Casamari
will begin to take on the characteristics of the newly observed vegeta-
tion of gothic French sculpture.[7]

In the case of the latter development, there is almost a merging
of the various stylistic sources: the early, indigenous Italian proto-
types of the Cistercian motifs, and the influence of the gothic French
style which appears in Italy from the late twelfth century on. The
Italian sculpture influenced by the Ile-de-France has an undeniable
and inherent realism, a naturalism which is ultimately a renewal of
the antique, classical idiom: for example, the fully rounded bunches
of grape clusters, the life-like leaves, and the rich and intricate
vegetation inhabited by intertwined animals. Pertinent French examples
of this gothic realism include, among others, the sculpted supports of
the portals of the collegiate church of Mantes and of Reims cathedral,
as well as the lintel of the cathedral of Bourges.[8] In Italy one can
find local examples of French inspiration similar to those we find in
France.[9]

In reality the apparent tangle of influences indicates a new de-
velopment of the motifs. The phenomenon must be understood not as
the exhaustion of the Cistercian formulas, as might seem apparent,
but rather as a new transformation of them. As evidence, one can

point to a series of sculptural decorations on Franciscan buildings
or on monuments rebuilt in the Franciscan era, all of them in the
Tuscia (the old territory corresponding today to north Latium and
southern Tuscany). These sculpted reliefs, executed with consider-
able heaviness, recall ancient Early Christian prototypes. This re-
semblance should not be considered simply as a rediscovery of those
prototypes, but instead as a variation of formulas borrowed from the
Cistercians, in accordance with the tendency of the preaching orders
to take over various forms while at the same time depriving them of
their ideological content. Thus with great ease the friars exploit
themes and their possibilities for popularization.[10] The adaptation
and alteration of Cistercian practices can also be noted in the struc-
tural types used by the mendicants, precisely in order to reach the
'carnal people' whom they did not refuse but, on the contrary, for
whom they existed.

From the transformations of the Cistercian forms by the friars
a compromise emerges, a compromise which introduces a new visual
stylistic language in Italian sculpture. The Early Christian proto-
types, now freed from thematic and symbolic obligations, continue to
draw from their classical roots while adapting themselves to the needs
and uses of the thirteenth century society of Italy. This visual lan-
guage spreads, by means of the friars specifically, through vast strata
of the population.

Thus the examples cited above from the area of Viterbo, which
utilize familiar prototypes, constitute remarkable examples of the
degree of diffusion of these motifs. Examples such as the slab of
S. Francesco di Tarquinia (Fig. 7), or the fourteenth-century relief
in the museum of Viterbo (Fig. 8), which is almost a Renaissance de-
velopment of the subject, are clear indications of the extent of this
new popularization.[11] To those examples one can add the lunettes of
the Ospedale di Capranica (Fig. 9), or of S. Francesco di Vetralla
(Fig. 10),[12] in which the Como-Lombard style--superimposed upon Cis-
tercian prototypes--seems to undergo a classical renewal.

From these examples belonging to a small region, it seems evi-
dent that the first Cistercian idiom, even when it was considerably
altered, was not lost. The Italian Cistercians were not as comfor-
table with the Cistercian decorative formulas as with the architec-
tural formulas; hence the decorative formulas were modified in ac-
cord with indigenous traditions.

University of Salerno

NOTES

1. Migne, *Patrologia Latina,* 182, col. 916.
2. M. Aubert, *L'Architecture cistercienne en France* (Paris: 1947)
 1: 356.
3. On the question see A. M. Romanini, 'Povertà e razionalità
 nell'architettura cistercense del XII secolo,' in *Povertà
 e ricchezza nella spiritualità dei secoli XI e XII,* Todi,
 15-18 ottobre 1967 (Todi: 1969) 191-225.
4. See J. Raspi Serra, *La Tuscia romana* (Milan: 1972) 116.
5. On the diffusion of the Como-Lombard decorative current which
 also maintains in its vocabulary forms of Early-Christian pro-
 venance, see G. De Francovich, 'La Corrent comasca nella scul-
 tura romanica europea,' *Rivista del R. Istituto di Archeologia
 e Storia dell' Arte,* 6 (1937) 225-94.
6. In this regard see M. Salmi, *La Scultura romanica in Toscana*
 (Florence: 1928).
7. On the argument, see R. de Lasteyrie, *L'Architecture religieuse
 à l'époque gothique en France* (Paris: 1929) 2: 276 ff.
8. De Lasteyrie, figs. 863, 864, 865.
9. De Lasteyrie, p. 279.
10. See J. Raspi Serra, p. 192.
11. The relief of S. Francesco of Tarquinia is cited by P. Toesca,
 Il Medioevo (Turin: 1927) 902, n. 56; he also calls the lunette
 of the Museo Civico of Viterbo 'romanesque' (p. 903, n. 57).
 For Salmi *(La basilica di S. Salvatore presso Spoleto* [Florence:
 1951] 63, 68) it is a work of the beginning of the thirteenth
 century and already 'gothic', 'the magnificent small lunette of
 of the Museo of Viterbo'.
12. For De Francovich, the lunette of the Ospedale of Capranica re-
 enters the 'como-lombard' current; note the fabulous capacity
 for phantasy of the author, who interprets classicism also as a
 return to antique local iconographic sources. In 1207, the church
 S. Francesco of Vetralla belonged to the Cistercians.

This paper was read at the Eleventh Conference on Medieval Studies,
Kalamazoo, May 1976.

THE MEDIEVAL REMAINS OF SINNINGTHWAITE NUNNERY

John A. Nichols

Sinningthwaite Priory was a Cistercian monastery for women*
founded in Yorkshire, England, around 1160 by Bertram Haget.[1]
Its history, like the history of the Cistercian nunneries in
medieval England, has yet to be told. Progress is being made,
however, toward the writing of the nuns' history not only within the
Cistercian order but also in medieval civilization.[2] This article
produces yet one more phase in the story of the English Cistercian
nunneries since it details the remains of the physical site where
the nuns of Sinningthwaite lived until the convent was suppressed
in 1535.

Altogether twenty-seven houses of Cistercian nuns existed in
England during the Middle Ages.[3] Of these, some physical remains
can be found at fifteen locations,[4] and of the fifteen, contemporary
use is still being made of four of the houses.[5] Sinningthwaite has
the distinction of being the only Cistercian convent where individu-
als now live in a house which was one of the cloistral buildings of
the nunnery. While modern alterations have been made to accommodate
the farming family which owns the site, architectural and sculptural
aspects of the building's past are still observable.

The site of the nunnery is nine miles west of York near a small
village named Bilton-in-Ainsty. All that remains of the convent is
a sturdy two-story stone building (fig. 1) which was the south range
of the cloister. The dwelling stands nearly 40 feet high to its
peaked roof and is 26 feet wide and 52 feet long. The stone walls
vary between 2 and 2 1/2 feet thick and at different places one can
ascertain that a narrow space exists between the stone thus creating
an inner and outer wall for the building. The ground floor is ac-
cessible through three doorways, while the upper floor can only be
reached by means of two interior stairs.

The inside of the building contains six rooms. The upstairs has
three chambers nearly equal in size which extend over the whole length
of the house. The walls have now-blinded round arches which spread
from one chamber into the next and are detectable only on the intern-
al stone surface. The floor of the second story is supported by hand-
hewn wood beams which run the length and breadth of the rooms. The
bottom floor also has three chambers which are accessible from both
the north and south sides of the building. The easternmost chamber
corresponds to what would have been the warming room of the nunnery.
In it are found a stairway leading up to the second floor, a fire-
place with chimney on the east face, and a stone sink (fig. 2) still
in place. The middle chamber is a hallway which has two doors at
each end and the second stairs which lead to the upper floor. The

westernmost room is the kitchen of the present owner but its medieval purpose can not be gauged with certainty.

The south range of a monastery traditionally contains the frater or dining hall for the religious.[6] While one can be fairly certain that the nuns of Sinningthwaite dined in the building, it is impossible to say if they ate in the upper level, bottom level or both stories of the structure. At Nun Cotham, another Cistercian nunnery in Lincoln, an ecclesiastical visitor noted on July 9, 1440 that the nuns dined in an upper frater where they fed on fish and food made of milk, while a downstairs frater was used to feed on the grace of flesh.[7]

There is a marked difference between the rather drab interior of the south range of Sinningthwaite compared to the exterior of the dwelling since the outside has some good medieval architectural and sculptural features. The building contains a Late Norman doorway in the center of the north wall and Perpendicular windows on both the north and south sides.

The twelfth-century portal is a fine example of English Romanesque or Norman style. The door was used by the nuns to enter the south range from their cloister garth. On the right of the door (Fig. 1) are two blank arches which may have been the start of a modest arcade decorating the cloister. While the interior of the door is unembellished molding, the 8 foot, 6 inch high exterior is most attractive with one order of leaf capitals over plain free-standing columns. Above is an arch with the familiar zigzags on the wall surface which are so distinctive of the English Norman style.[8] The zigzags meet and intersect under a roll molding; their spandrels have leaf motifs (Fig. 3). At each end of the roll molding is a snake's head (Fig. 4) with a tempting smile that displays the forbidden fruit in its mouth.

Roll moldings in Norman architecture often end with shapes of human or animal heads. One example near Sinningthwaite is found at Holy Trinity church in Stonegrave where a ram's head carved into the molding dates from around 1140.[9] The symbolism of the ram refers to Christ who leads as the ram leads the herd.[10] The meaning of the serpent and apple at Sinningthwaite, which would have been seen by the nuns on a daily basis, is obvious.

The last major architectural features on the south range are the windows in both the upper and lower stories on the north and south sides of the building. All are designed in the English Perpendicular style, of the late fourteenth through fifteenth centuries. The two windows (Fig. 5) on the south side of the range are aligned almost directly over each other for the upper and lower stories. Both have mullions which create six equal lights. The windows are not in good repair and the boarding or bricking up of individual panels is observable. The Perpendicular windows on the north face are in better condition and have four and three lights respectively on the two second-story windows (Fig. 1).[11]

The Perpendicular windows and the identification of the Norman arches on the inner walls of the upper chambers can permit some conclusions about the building's architectural construction and alterations. The location of the round arches above the Perpendicular windows of the internal walls makes it evident that Norman style windows from the late twelfth century were in place before the Perpendicular were installed. Given the facts that Norman masonry from the convent (Fig. 6) is cemented into modern walls of the farm and that the Norman portal is still in situ, it is certain that the nunnery building was originally designed in Late Norman style. It is also apparent that the nuns rebuilt the windows because of some particular need; perhaps a fire had occurred, a rearrangement of the interior chambers was desired, or a prioress did not like the old style and wanted more light. Whatever the cause, the Norman style windows were replaced in the late fourteenth or fifteenth centuries by the Perpendicular ones.

While one can appreciate the fine pattern of late Norman zigzag in the arch over the doorway or the symbolic meaning of the serpent with accompanying fruit, one must not forget that the buildings tell us about the history of the women who lived there. When these data are combined with the written documents about Sinningthwaite, a clearer picture develops about this nunnery's past. For example, the architecture confirms the foundation date of around 1160 since the Late Norman style lasted in England until 1190. Moreover, the replacement of the Norman windows with the Perpendicular indicates a need or affluence necessary to allow the nuns to order the alterations. The addition of this information to that of all twenty-seven Cistercian convents in England will allow for the writing of the nuns' history, and ultimately to an assessment of the contributions that these women made to the Cistercian order, to medieval civilization, and to women's history.

Slippery Rock State College
Slippery Rock, Pennsylvania

NOTES

*This study was part of an architectural review of English
Cistercian nunneries presented at the Conference on Cistercian
Studies, Fifteenth International Congress on Medieval Studies, 1980.

1. David Knowles and R. Neville Hadcock, eds., *Medieval Religious
 Houses in England and Wales* (New York: St. Martin's Press, 1971)
 pp. 272, 276.
2. Some recent articles which attest to this progress are Sister
 Michael Connor, 'The First Cistercian Nuns and Renewal Today,'
 Cistercian Studies 5, no. 2 (1970) 131-68; Sally Thompson,
 'The Problem of the Cistercian Nuns in the Twelfth and Early
 Thirteenth Centuries,' *Medieval Women,* ed. Derek Baker (Oxford:
 Blackwell's, 1978) pp. 227-52; and Coburn V. Graves, 'English
 Cistercian Nuns in Lincolnshire,' *Speculum* 54, no. 3 (July
 1979) 492-99.
3. Knowles and Hadcock, p. 272.
4. A good and accurate guide to the location and description of
 the remains can be found in Nikolaus Pevsner's series, *The
 Buildings of England.*
5. The current status of the physical remains of the nunneries, as
 well as measurements and photographs, were the result of a re-
 search tour made by the author in July and August 1979.
6. For typical physical plants see: John Nichols, 'The Architectur-
 al and Physical Features of an English Cistercian Nunnery,' *Cis-
 tercian Ideals and Reality,* ed. John Sommerfeldt (Kalamazoo,
 Michigan: Cistercian Publications, 1978) pp. 319-28.
7. William Alnwick, bishop of Lincoln, visited the house and noted
 that the subprioress of Nun Cotham, Dame Elena Frost, declared:
 'Item petit quod refectorium seruetur omni die, cum sit vnum
 refectorium superius in quo vescuntur piscibus et lacticiniis,
 et aliud inferius in quo ex gracia vescuntur carnibus, et quod
 nullatinus compellantur ad aulam priorisse, ne misceantur secu-
 laribus.' A. Hamilton Thompson, 'Visitations of Religious Houses
 in the Diocese of Lincoln, 1436-1449,' *Canterbury and York Soci-
 ety* 33 (1927) 249.
8. For examples, see Banister Fletcher, *A History of Architecture,*
 18th ed. (New York: Charles Scribner's, 1975) pp. 553-77 and
 Robert Stoll, *Architecture and Sculpture in Early Britain* (New
 York: Viking Press, 1966) pp. 30-3.
9. Stoll, p. 331, pl. 180.
10. George Ferguson, *Signs and Symbols in Christian Art* (New York:
 Oxford University Press, 1959) pp. 23-4.
11. For examples of Perpendicular windows see John Betjeman, *English
 Architecture* (New York: Macmillan, 1972) pp. 40-7 and Bryan Little,
 Abbeys and Priories in England and Wales (New York: Holmes and
 Meier, 1979) p. 121.

THE CISTERCIAN CHURCH AT MORTEMER:
A REASSESSMENT OF ITS CHRONOLOGY AND POSSIBLE SOURCES

Philip F. Gallagher

The abbey of Mortemer was founded in 1134 in a wooded valley of upper Normandy on the southern edge of the Forest of Lyons, a site about twenty miles southeast of Rouen and forty-five miles northwest of Paris.[1] Mortemer lay just inside the Norman Vexin, an area of keen dispute between the Anglo-Norman-Angevin kings and the Capetians during the twelfth century. The abbey was founded as a migration, sponsored by King Henry I, from the nearby Benedictine priory of Beaumont, itself founded only four years previously on a plot of land just west of the Anglo-Norman fort at Gisors by the fort's constable, Robert of Candos. Although the abbey did not affiliate with the Order of Cîteaux until 1137, the migration to the Valley of Mortemer was thoroughly Cistercian in purpose in as much as the monks judged their previous site to be too exposed to the world. Mortemer, on the other hand, was a narrow, secluded, desolate valley.[2]

Description

By the 1150s or 1160s the abbey began building the church whose ruins still exist. Lying on an east-west axis, it was built in the normal plan of the Latin cross (Fig. 1). The nave measures about 163 feet in length.[3] The central vessel, about 39 feet wide, was flanked by side aisles, each almost 14 feet in width. The overall width of the nave was thus about 67 feet. Like Fontenay, this nave was divided into eight bays and may thus be termed 'Bernardine'. The side walls are now buried in rubble but there remains a door leading from the nave to the cloister at the easternmost bay on the south. This feature too is common in Cistercian churches.

East of the nave was a transept measuring more than 31 feet in width (west to east) and more than 138 feet in length. The western walls were divided into four bays, each about 24 1/2 feet wide. Beginning on the line of its eastern wall and extending eastward for about 16 1/2 feet were six rectangular chapels—three on each arm. At the south end of the transept were two doors: one leading (on ground level) to the sacristy, the other (at the top of the night stairs) to the dormitory. These features are all typical of the twelfth-century Cistercian church.

Beyond the transept to the east was a presbytery two bays deep, measuring about 35 feet east to west and about 87 1/2 feet north to south. Its two bays housed four rectangular chapels, the westernmost of which opened onto the transept and thus were actually among the six transept chapels already mentioned.

Around the presbytery to the east was an ambulatory in hemi-cycle, off of which radiated five absidioles (or little apses) each housing a small chapel. The radius of the hemicycle (from the easternmost point on axis west to the easternmost point of the presbytery) was about 44 feet. The ambulatory, swinging around on both sides of the presbytery toward the west, finally merged into what can be thought of as the extension eastward across the transept of the side aisles of the nave.[4] Mortemer thus represents a point in Cistercian evolution well beyond Fontenay and suggests that the abbey had a sizeable number of monks who were also priests.

From what has been said about the church's radiating chapels it is obvious that, while Mortemer's chevet was not square-ended, it was not absidal in the Pontigny manner either. Its exterior did not describe a simple polygon. Rather its absidioles projected outward, somewhat in the manner of the cathedral style of the Ile de France. Is it possible that we have here the very first Cistercian chevet that can be termed 'French' as opposed to the more reserved style of Pontigny?[5] While Cistercian in many respects, the groundplan of its chevet suggests the possibility of some change in the direction from which Mortemer was receiving architectural influences.

Little is known of the church's manner of construction. It has long been considered customary among Cistercians to utilize the materials at hand in the immediate vicinity for construction. Although the current excavations may provide some new insight into this matter, the description of Marcel Aubert is straightforward: 'At Mortemer (Eure), the church...is constructed in kidney-shaped chunks of flint, covered in some places with a plaster-like coating, in others with a facing of dressed stone which is used throughout for the supports, arches, piers [and] belting courses.'[6] The walls themselves have ashlar facings in some places, framing the rubble and its mortar. The source of the ashlar has not been determined and would be a useful thing to know as it might comment to us about the abbey's attitude toward the building. The exposed escarpment of the Seine near Les Andelys, just a few miles to the south, would have been an accessible source for limestone. If we knew that the ashlar and flint were taken from nearby sources it would reinforce the generally strong Cistercian characteristics of the entire building enterprise.

The vaulting at Mortemer appears entirely unexceptional. No visible supports of the vaulting over the nave remain, but the Ranjards asserted on the basis of early nineteenth century lithographs that it was eventually rib-vaulted.[7] (See Fig. 2) The side aisles, on the other hand, were groin-vaulted.[8] The transept and the presbytery were rib-vaulted.[9] The chapels of the chevet were so shallow that a single vault, five-branched, covered them as well as the corresponding bay of the ambulatory; such five-branched keystones have been excavated.[10] Absolutely nothing remains of the vaulting at Mortemer today. Our know-

ledge of it must be thought of as something less than certain, although
what we can reasonably conjecture does not suggest anything outside the
Cistercian tradition of the twelfth century.

Consideration of the elevation of nave and transept at Mortemer is
more rewarding. Within the general history of Cistercian elevations,
at least during the twelfth century, we have here something rather
unusual. Cistercian elevations in the twelfth century were governed
by the type of vaulting and the Cistercian lack of interest in height
as an aesthetic aspect of church architecture. The latter contrasted
sharply, of course, with the objectives of Gothic design in the Ile
de France. In sum, most twelfth-century Cistercian churches had but
a two-story elevation: an arcade and clearstory. The absence of a
triforium level altogether was the rule. Blind-arcaded triforiums
were exceptional (although there were some important exceptions) and
Cistercian churches with arcaded openings with triforium passages
behind them were rare.[11]

At Mortemer, we currently know almost nothing certain about the
design of the nave's bays, but they would seem to have had a two-
story elevation, if one can rely on a series of sketches executed in
1824 by various artists. While it would be impossible to make a pre-
cise description of the interior elevation of the nave on the basis
of these sketches, what they do offer is sufficient to indicate that
there probably was no triforium, in the Cistercian tradition. One
lithograph shows elongated and rather sizeable clearstory openings
(Fig. 3); in another view (Fig. 7) they seem placed high enough above
arcade level to have allowed for a middle story. A third view (Fig.
2), however, gives no suggestion that one was articulated.[12] Another
artist[13] so designed the bays that a triforium seems out of the ques-
tion (Fig. 4). Note that the proportions and the relationships of
facade to nave elevation vary in all four views.

With respect to the transept we are on much firmer ground. Of
the south arm, three-fourths of the west wall and a part of the end
wall still stand; of the north arm, part of the northernmost bay of
the west wall and most of the end wall are extant (Fig. 9). The
eastern walls have been completely destroyed, although columnar sup-
ports and their capitals of the northernmost chapel remain standing.[14]

Mortemer's transept has a three-story elevation. Of its four
bays on the west wall, the arcade level of the northernmost and south-
ernmost is bare, while the bays adjoining the crossing have pointed
arches leading westward into the side aisles. The bottom level of
the end walls is bare excepting the two small doorways on the south
leading into the sacristy and conventual quarters.

In the entire north arm the middle story is an open triforium,
much destroyed, whose design can be essentially recovered with the
help of A. Joly's lithograph of 1824 (Fig. 5): contiguous doublets
in pointed arch, each set beneath a relieving arch in half-circle.
The colonnettes separating the interior arches are said to have been

en délit.[15] Behind the arcading there runs a triforium passage
which probably continued around the entire transept. In the clear-
story level of the north end wall there is a large oculus or rose
about 13 feet in diameter. The clearstory design of the west wall
is largely obliterated, but the remaining molding along its north-
ernmost side suggests there was an elongated window, perhaps with
a round arch. It does not appear to have been splayed.

Even aside from the pierced openings themselves, the three-
storied horizontality of the north arm is emphasized by a molded
stringcourse (separating the clearstory from the triforium)[16] and
structural differences between the stories. The coating over the
rubble on the lowest level was painted (perhaps centuries later?)
to affect the appearance of ashlar. This facing is now peeling off,
revealing the rubble structure underneath. The triforium and clear-
story, on the other hand, were faced very carefully in cut stone,
the visual articulation of which is emphatically horizontal, espe-
cially in the triforium (Fig. 9).

Against the bare west wall of the southernmost bay of the south
arm there probably rested the night stairs to the dormitory.[17] Be-
tween the two bays, from the floor to the springing of the vault,
there rose a vault respond ending in a leafed capital just below the
clearstory (Fig. 6). The south arm also had a triforium opening in-
to a passageway. Set within each of two round arches sharing a com-
mon center column was a single pointed arch. It should be noted
that this design, perhaps repeated in the ruined south end wall, is
similar to, yet different from that of the north arm. In the clear-
story is a deeply splayed window with rounded arch opening to the
outside of the church. The upper story of the end wall would appear,
from the little that remains,[18] to have had an oculus similar to that
in the north.

Of the interior elevation of the presbytery, ambulatory and hemi-
cycle there is nothing standing to describe nor was there in 1824.
Apart from the base of the apsidal walls which reveals the chevet's
layout, little remains.[19] Thus, whatever judgment can be made about
Mortemer's interior elevation with respect to Cistercian architecture
must be made on the basis of the transept for the most part. If the
nave was two-story in its elevation, it was entirely within the main-
stream of twelfth-century Cistercian architecture. The transept, on
the other hand, certainly was not.

One major element remains in our description of the twelfth-
century church at Mortemer: its facade. Nothing now stands, but a
number of engravings make it possible to envision the facade in some
detail, albeit with reservation. In a lithograph of 1824 (Fig. 2)
the facade's interior is shown divided into three sections, corres-
ponding to the nave and its flanking aisles. In the center section
was a door, drawn in pointed arch. There may have been smaller doors
in round arch opening into the aisles, but this is not certain. In

both flanking sections was a sizeable window in round arch. Above
the center door was a splayed triplet of ample proportions, each
window in pointed arch framed by colonnettes with bases and capitals.
Above the triplet was an oculus, seemingly identical to that of the
north transept. In the gable two small windows in round arch lit the
area above the vaulting. On the whole, the visual effect is rather
simple.

Viewed from the west, the facade's appearance was somewhat dif-
ferent and decidedly busier. Two views by Enfantin show that the
rose (or oculus) stood, not alone, but between arcades of doublets
in pointed arch (Figs. 3 and 7). Another view of unknown date (Fig.
4), while differing with regard to the shape and proportions of the
windows and arcading, confirms the basic arrangement just described
as well as the evidence of Figure 2 that the arcading flanking the
rose was blind. Each of the triplet windows was framed by colonnettes
with bases and capitals outside as well as in.

The center door, seen from the west, is depicted in none of the
previous sketches--it always manages to be hidden in the foliage. No
existing view known to me depicts this door in the context of the en-
tire facade, but J. Jorand's drawing of 1824 provides an unintegrated,
close-up study of the main elements of the portal's appearance (Fig.
8). The arch of the door is drawn round rather than pointed as in
Figure 2. The arch was embellished with three orders of voussoirs;
each had a pattern of rather intricate molding. The voussoirs con-
tinued down the sides of the door as three columns, each set into right-
angled steps of finely cut ashlar. No bases are shown, but the capi-
tals[20] were flat-leafed and far less 'fussy' than the dominant impres-
sion of the upper facade given in Figures 3 and 7.

In sum, Mortemer's west portal essentially projects an impression
of simplicity. It is well within what one would expect of a twelfth-
century Cistercian abbey. The facade as a whole, however, is some-
what otherwise. Its horizontality is clearly, forcefully and meticu-
lously articulated by string courses and almost all of its upper le-
vels are consumed by decorative windows and arcading. Placing it in
the broad perspective of twelfth-century Cistercian facades,[21] Morte-
mer's facade was rather highly decorated for a twelfth-century Cister-
cian church.

Chronology

Mortemer's abbey church was built in at least three and perhaps
four separate campaigns. It is difficult to date each precisely, but
each can be separated from the others. A chronology can be developed
on the basis of the Ranjards' assessments, the sketches of the early-
nineteenth century and the abbey chronicle.

The chronicle describes the abbacy of Adam (1138-1154) as a per-
iod of constant building activity,[22] but no work on the abbey church

is mentioned. Work on the church began during the reign of Abbot
Stephen (1154-1164). 'At this time,' says the chronicler, 'the
distinguished king of England, Henry [II], founded the church...
and finished it up to the monks' choir in three years. For this
project he gave [the abbey] more than a thousand pounds.'[23] What
he means, it would seem, is that the monks built the nave end of
the church first. But precisely how much was completed is not clear.
Nor is it explicitly stated when the work began and ended.

According to the Ranjards,[24] the first campaign saw both the
completion of the nave and the beginning of work on the transept;
of the latter, the base of the west and south walls of the south
arm was built. There are, indeed, some valid reasons for including
the lower sections of the walls of the south arm in the first cam-
paign: 1) the capitals and bases in the nave, side aisles *and* low-
er south transept are contemporaneous with one another but clearly
prior to the rest of the capitals and bases in the transept (which
must, therefore, belong to a later campaign); 2) the colonnettes of
the south arm's vaulting indicate a change in plans after the com-
pletion of the lower walls. Each point deserves further comment.

The Ranjards held that the capital and base of the column sup-
porting the arcade leading from the transept to the south aisle are
contemporary with the south aisle itself.[25] Furthermore, they are
earlier than all other capitals and bases in the transept. The ar-
cade under discussion has one extant support--a column engaged in a
divided dosseret: on each side of the column are two colonnettes
wedged into rectangular set-backs from the main column. The capi-
tal has a rectangular abacus surmounting alternatively concave and
convex moldings; adorning the capital are four largely stalk-like
water leaves. The design is considered poorly executed. The base,
molded with two *tori* separated by a wide but shallow *scotia*, is fas-
tened by griffes to a cubical pedestal. Elsewhere in the transept,
however, the capitals and bases are of a later style. The capitals
are adorned with leaves ending in crockets; the bases present the
same molding patterns as the one just mentioned, but the design is
judged more vigorous and better executed.

A second Ranjard argument for including the lower walls of the
south transept arm in the first church campaign is that the colon-
nettes which support the vaulting over its bays were only secondar-
ily incorporated into the walls, that is, the division of the tran-
sept into four rib-vaulted bays was apparently not a part of the
church's plan when the lower wall was constructed. Furthermore, the
bundle of shafts in the southwest bay changes diameter half-way up.[26]

What the Ranjards have adequately demonstrated is, I believe,
that a break in the work did occur after an initial campaign and
that the base of the walls of the south arm was built prior to the
completion of the transept. They would date this entire first cam-
paign in the three years between 1154 and 1157.[27] There is absolutely

no reason, however, to accept their date of 1157 for the conclusion
of the first campaign. The date is arbitrary, judging by the silence
of the evidence, and is probably based on their assumption that this
three-year campaign began in 1154, the first year of Stephen's abbacy.
All we can say is that the first campaign took place in some three-
year period between 1154 and 1164.

The hypothesis of a hiatus between a first and second campaign
would seem to be confirmed by the chronicle which mentions no work
at all on the church during the reign of Abbot Geoffrey (1164-1174).[28]
A second campaign apparently began only with the abbacy of Richard
(1174-1179). According to the chronicle, Abbot Richard 'laid all the
foundations for finishing the chevet of the church and with the help
of King [Henry II], who gave him one hundred pounds for the work, he
raised it somewhat higher than the ground.'[29] Note that work on the
transept is not specifically mentioned. It is probable that work on
it too began again, but there is no reason to conclude that it was
finished by 1179, even though the construction of the chevet was un-
der way.

In short the chronicle makes very little attempt to particular-
ize various stages in a second campaign. That the Ranjards should
have done likewise is somewhat astonishing. Their efforts at estab-
lishing a detailed chronology for the second campaign can be summar-
ized in their own words: 'First the transept, of which the base of
the west and south walls of the south arm had been built, was complet-
ed. A choir with ambulatory was added. And the finished church was
able to be consecrated on March 8, 1209....'[30] As I hope to show,
they have rather nonchallantly compressed a number of significantly
contrasting developments into one vague, extended second campaign.

Of the three sentences quoted immediately above, the first con-
tains a major and untenable presupposition: that the south arm of
the transept was finished during the same campaign in which the north
arm was both begun and completed. That both arms were finished be-
tween 1174 and approximately 1200 is most probable. But if both arms,
save the base of the walls of the south, were built in a second cam-
paign, that is, at approximately the same time and under the same ar-
chitectural leadership, one should expect to find them essentially
identical in design and articulation. As we have described above,
this is not the case. The Ranjards, however, made no note at all of
the differences in design between the south and north arms which are
apparent in triforium and clearstory.

In their description of the triforium and clearstory designs the
Ranjards ignored the disturbing fact that Joly (Figs. 5 and 6) showed
the triforia in the west walls of the north and south arms to be strik-
ingly different and the clearstory windows to be probably different.
The differences in triforium design need not be repeated here; we have
fully noted them above. With respect to the clearstory, the heart of
the matter can be quickly pointed up. Above the triforium, said the

Ranjards, 'each arm of the transept was lit, from the west, by two
large windows with pointed arch, framed by colonnettes....'31 *Were*
the clearstory windows pointed? The views of both Joly (Fig. 6)
and Enfantin (Fig. 7) clearly show the clearstory windows in the
south to have been round-headed. The clearstory window in the north
arm is nearly obliterated: not enough now remains nor was there
enough in 1824 for us to know its shape. That both clearstory win-
dows were the same cannot be asserted: the window in the south was
splayed; what remains in the north does not seem to have this char-
acteristic. Surely the north and south arms of the transept were by
no means identical. The point is this: the Ranjards have not given
adequate consideration to the design characteristics of the transept.
 This variation in triforium and clearstory designs strongly
suggests a difference in campaigns, a change of plans, perhaps the
surfacing of a new architectural influence on the abbey. Before of-
fering a more detailed chronology of this transept, let us consider
some of the most likely sources of differing architectural influences.

Architectural Influences and the Abbey's History

 It is not difficult to comprehend the zest with which architec-
tural historians have often pursued the sources of a given monument.
Pursuit is intriguing in itself and success is historically valuable.
But the quest is also dangerous. John Bilson long ago commented that
'there is perhaps no more difficult question in the study of medieval
architecture than this question of the influence of one school or one
district on another, and it is often very easy to mistake mere analog-
ies for influence.'32 As difficult as these questions are, they must
be considered. Let us examine the most probable sources of influence
on Mortemer in the twelfth century.
 The most constant source of influence on Mortemer in the twelfth
century was probably England. The abbey was founded by King Henry I
(1100-1135) and aided throughout the century by his daughter (Mathil-
da) and his successors: Stephen (1135-1154), Henry II (1154-1189)
and Richard I (1189-1199). As already noted, Mortemer's beginnings
were linked to the Anglo-Norman fort at Gisors guarding the frontier
on the Epte. During almost every decade of the century the Norman
Vexin was a place of considerable tension. In 1196 Richard I forti-
fied the escarpment overlooking the Seine at Petit Andely in order to
block the Capetian's easiest route from Paris to Rouen. This fort,
Château Gaillard, was only a few miles south of Mortemer; in fact,
many of the abbey's holdings in arable and vineyard were within sight
of the fort. To be realistic we must acknowledge that these rulers
had more than a pious interest in the abbey. Here was a site just a
few miles from the Capetian border, an important place to make an ex-
hibition of their wealth and influence. In their long-term struggle
with Louis VII (1137-1180) and Philip II (1180-1223), the Anglo-

Normans and Angevins must have been hoping to draw an immeasurable
interest from their investments in Mortemer.

Henry II was at least twice a donor to the church's construc-
tion.[33] Richard I is not known to have made any bequests specifi-
cally intended for the church, but the chronicler notes that he gave
the abbey extensive properties and charters confirming his largess.
This king is portrayed as a close friend of Abbot William (1180-1200):
Richard invited him to his coronation in England and chose the abbot
to be his confessor and spiritual advisor. The chronicler goes so
far as to brag that the king loved the monks of Mortemer above all
others of his realm.[34]

Abbot William was himself an Englishman, as were the first two
abbots, Alexander (who governed the community from 1130 to 1137) and
Adam (1138-1154).[35] The generosity of the archdeacon of Derby, Fro-
ger, who was Henry II's almoner and from 1159-1184 the bishop of Séez,
was also a constant during the second half of the century. Much of
Froger's generosity was specifically directed toward the community's
architectural needs.[36]

There were other likely sources of influence as well. The ab-
bey's Norman connections are obvious. Though geographically on the
very eastern edge of the duchy of Normandy, Mortemer was only a short
distance from the archdiocesan town of Rouen. Surely we may assume
that many of its monks were Normans as were the countless lords who
donated fields and other sources of income to the abbey.[37] It was al-
so governed by two Norman abbots: Geoffrey (1164-1174) and Richard
(1174-1179).[38] Under Geoffrey no work was done on the church, but
this fact does not eliminate the probability of increasing Norman in-
fluences on the abbey. Under Richard, work went forward on the che-
vet and the transept.

There were also close links between Mortemer and the Soissonais
to the east. When Mortemer affiliated with the Order of Cîteaux, it
did so through the abbey of Ourscamp, near Soissons. In 1137 Ours-
camp sent a group of its monks to live with the 'Benedictines' of
Mortemer and in the following year one of them, Adam, became Morte-
mer's first Cistercian abbot and remained in this position for six-
teen years.[39] When Adam died in 1154, the prior of Ourscamp, Steph-
en, became Mortemer's abbot and governed it until 1164. Abbot Steph-
en, the chronicler tells us, was a native of the Soissonais. At one
time he had been a canon at Noyon. After 1164 Stephen held abbacies
at Ourscamp and Elant and then, following a period at Clairvaux as a
simple monk, he returned to Mortemer to live out the rest of his
days.[40] The extent of the architectural influences brought from the
Soissonais to Mortemer by these abbots is conjectural, of course,
but it seems reasonable to assume that any such influences could have
survived their actual reigns.

Lastly, there were possible ties between Mortemer and the Ile
de France. On the whole the links were probably few and inconstant,

at least until the end of the century and the demise of the Ange-
vins in 1204. But even during the twelfth century, one of the ab-
bey's granges was across the Epte near Gerberroy.[41] Also, Abbot
William is known to have been a dialectician at Paris before his
conversion to the monastic life and the Cistercian Order.[42]

Mortemer's relations with all these areas are borne out by the
architectural designs of the transept and chevet. In the transept,
the triforium design of the north arm is Norman and rather earlier
than the triforium design of the south. The motif of pointed arches
set within the round relieving arch occurs frequently in Norman ar-
chitecture and in those churches influenced by it.[43]

On the other hand, the design of the triforium and clearstory
of the south arm is not particularly Norman. Rather, it bears a
strong resemblance to the triforium-clearstory designs of certain
Cistercian churches in Britain, especially Roche (Yorkshire) as well
as Dundrennan (Scotland) which was greatly inspired by the Yorkshire
Cistercian churches. That there was a connection between Roche and
the Continent has long been recognized. Geoffrey Webb believes that

> Roche is a very early example of the exploitation of
> the middle storey in a Cistercian building; there is
> said to be no earlier surviving example in France,
> though it seems likely from the general character of
> the Roche work that some Cistercian prototypes may
> have existed in Picardy.[44]

Peter Fergusson, who has studied the Cistercian churches of Roche
and Dundrennan, also links the style of many Yorkshire abbey chur-
ches to the same area. 'It is interesting,' he comments,

> that Roche, Kirkstead, and Newminster all belong to a
> group of monasteries associated with Fountains; Kirk-
> stead and Newminster were direct offspring, Roche was
> indirect via Newminster. French influence from Picardy
> is discernable at Fountains from the 1150s....Kirk-
> stead, Roche, and Newminster, all...show the existence
> of a group of *fully vaulted three-storey churches* in
> the north of England *in the decades 1165-85 whose
> sources lie in north-east france.*[45]

This exploitation of the middle story by a Cistercian church
as early as the 1170s or 1180s is so unusual[46] that one cannot but
ask about the possibility of a connection between these Yorkshire
churches (such as Roche) and Mortemer. It seems unlikely that there
was a direct link in either direction between Roche and Mortemer but
similarities in design of the interior elevation suggest the possi-
bility that both churches may have derived their similar three-story

designs from a common ancestor, perhaps in Picardy--or perhaps just south of Picardy, in the Soissonais which was only a short distance to the east of Mortemer.[47]

Chronology Again

Such are the probable sources of architectural influence on the transept designs. We offer now a provisional chronology. The transept was a product of three campaigns, rather than two as envisioned by the Ranjards. 1) During the first, under Abbot Stephen's direction (1154-1164), the lower walls of the south arm were built in a spirit harmonious with that of the nave (built during the same campaign). The plan was very simple--Stephen probably did not intend to have it rib-vaulted.[48] 2) After a hiatus of perhaps ten years or more,[49] Abbot Richard (1174-1179) supervised the erection of the north arm with its strong Norman design in the articulation of the triforium. A new plan was implemented: a decision was made to rib-vault the transept and this vessel was divided into four bays. Richard was deposed in 1179[50] and so the south arm was not completed until 3) a third campaign, probably in the 1180s, under the direction of Abbot William (1180-1200). Again the plan was altered, but not in a way that affected the vaulting option already chosen: the change was confined to the introduction of a different motif in the triforium and perhaps clearstory of the south arm.

When was the chevet built? The evidence is meager. The chronicle states that it was begun by Abbot Richard; it must have been completed by Abbot William. 'The church,' says the chronicle, 'which King Henry had made as far as the monks' choir, was completed during [William's abbacy].'[51] The Ranjards essentially accepted the chronicle's verdict, although they also assumed that William reigned as abbot until 1205 rather than until 1200.[52] But whether we date the completion of the chevet in the 1190s or even as late as 1205, it is nonetheless remarkable because its groundplan seems to have been conceived between 1174-1179.

The adoption of a French-type chevet between 1174 and 1179 would predate the introduction of the Pontigny-type chevet. This dating would, I think, make Mortemer's chevet the earliest French-type chevet in a Cistercian church: the fully French chevets of Longpont (in the Soissonais) and of Royaumont (in the Ile de France) date from c. 1200-1227 and 1228-1235 respectively.[53] The resemblance of the groundplan of Mortemer's chevet to that of Noyon cathedral, ca. 1155-1170,[54] might provide an explanation. Noyon is also in the Soissonais, only a few miles from Ourscamp, an abbey with close connections to Mortemer in the twelfth century.

On the other hand, there is the tantalizing report of a lost eighteenth-century engraving by Carpentier,[55] which showed flying buttresses on the chevet. Noyon did not have any nor would they be

likely at Mortemer before the thirteenth century. We might ask if
the visible remains of Mortemer's 'French chevet' are not actually
ruins of a chevet later redone, perhaps after the Capetian victory
in 1204 (there was a building campaign in the 1220s when the abbey
reconstructed its chapterhouse-dormitory complex). If we were some-
how to discover that, after he overran Château Gaillard, Philip Au-
gust also invested in Mortemer as a symbol of his newly-won politi-
cal dominance in the Vexin, we would not be surprised. The Capetians
would have been just as eager to use Mortemer to political advantage
as the Angevins had been. These reflections, even if plausible, re-
main speculative since the question of the chevet's date cannot be
adequately approached until a thorough excavation is completed. For
the present we are left with the testimony of the chronicle that the
church was completed by 1200.

Any chronology of the facade also rests on uncertain evidence.
Since nothing of it remains (save a corner buttress in the south-
west), our judgment must presently rely on the sketches previously
considered; the chronicle is of little help. Assigning a date to
the center door is made more difficult by the nature and content of
Jorand's sketch, but it could conceivably have been executed during
the first campaign. If the facade, on the other hand, was begun be-
tween 1154 and 1164, it was surely completed or redone during the
last decades of the century. The sketches of Joly and especially
of Enfantin suggest that the upper facade was executed during the
abbacy of William, perhaps in the 1180s and even as late as the
1190s. As do the transept and the chevet, the facade represents
a later period in the evolution of Cistercian churches.

Conclusion

This, in sum, is how we should seek to understand this church,
both its architecture and its history: we must see Mortemer in the
perspective of many influences. The materials of its construction
seem characteristically Cistercian in their likely provenance. The
nave of the 1150s or 1160s is clearly, too, a Cistercian product:
its layout in eight bays, the vaulting combinations with which it
was covered, the restrained style of its capitals and bases, its
probable two-story elevation. The chapel layout in the transept
is also dictated by Cistercian custom.

The three-story elevation of the transept, however, was defi-
nitely outside the mainstream of Cistercian tradition and indicates
a strong presence of other influences by the late 1170s and 1180s.
Whether these are to be traced to England and Normandy, to the Sois-
sonais and Picardy, or more generally to the north of France it is
hard to say. Hopefully, study of other sites, Cistercian and other-
wise, will give us an answer. The church's chevet, seemingly fin-
ished in the 1190s, goes not to Pontigny and the Cistercian main-

stream for its inspiration but to the 'cathedral' style of the Ile
de France. How strong the influence was we do not know: the che-
vet's elevation and the design of its bays are both unknown. And
finally the facade: surely redone in the 1180s or later, it is
still Cistercian beyond doubt, but belongs to a later generation
that was becoming interested in decorative aesthetics.

Neither the historical events that shaped Mortemer's monastic
life nor the influences upon it and its architecture are easy to
determine, but surely they were varied. We have tried to expose
some of them. The Ranjards wrote[56] that one looked in vain at Mor-
temer for such influences: all they admitted seeing was the 'im-
placable rigor...[of the] rules dictated by Saint Bernard,' a judg-
ment which stands in certain need of reassessment.

Brooklyn College of the
City University of New York

NOTES

1. Material from this paper was first presented at the Fifth Cistercian Conference, Tenth Conference on Medieval Studies, 1975. For her generous encouragement and advice the author wishes to thank Professor Meredith P. Lillich of Syracuse University on whose suggestion this study was undertaken.

2. Cartulary of Mortemer (Paris, Bibliothèque Nationale, MS latin 18369), fols. 1ʳ-2ᵛ. The chronicle of Mortemer fills the first twelve folios of the cartulary. An edition of the chronicle was published by Charles Bouvet, 'Le récit de la fondation de Mortemer,' *Collectanea ordinis Cisterciensis reformatorum* 22 (1960) 149-68, but it contains many errors in transcription. The remaining forty-five folios of the cartulary contain little that relates directly to the architectural history of the abbey, but the chronicle itself is indispensable. My references are to the unpublished MS, hereafter referred to as *M*.

3. Indicated measurements are based on the generally reliable work of Robert and Michel Ranjard, 'Abbaye cistercienne de Mortemer,' *Bulletin Monumental* 97 (1938) 237-75, hereafter referred to as Ranjard.

4. The 1938 Ranjard plan was brought up to date by the late Anselme Dimier's *Recueil de plans des églises cisterciennes*, 2nd ed. (Paris: 1967), *Supplément*, p. 108 and pl. 204, on the basis of excavations; see more recently the plan in Inventaire général des monuments et des richesses artistiques de la France, Commission régionale de Haute-Normandie, *Eure. Canton Lyons-la-Forêt* (Paris: 1976), figs. 178, 181 and p. 114. The Inventaire includes a series of useful photographs though the text must be used with caution.

5. See below, 'Chronology Again.'

6. 'A Mortemer (Eure), l'église...est construite en blocage de rognons de silex recouvert tantôt d'un parement de pierres d'appareil, surtout utilisé pour les supports, arcs, piédroits, chaînages.' Marcel Aubert, *L'Architecture cistercienne en France*, 2nd ed., 2 vols. (Paris: 1947), 1:267. Compare Ranjard, p. 242; Inventaire 1976, p. 113.

7. Ranjard, pp. 244-45. The lithographs appeared in J. Taylor et Charles Nodier (eds.), *Voyages pittoresques et romantiques dans l'ancienne France*, 17 vols. in 27 (Paris: 1820-63), *Ancienne Normandie* 2 (1825).

8. An engaged column, surmounted by a capital, received the supporting arch which separated the bays of the aisles. Ranjard, p. 244.

9. Ranjard, pp. 245-46; Aubert 1:251.

10. Inventaire 1976, p. 114 and fig. 233.

11. Aubert 1:267-305, passim.

12. Compare Inventaire 1976, figs. 182, 180, 177 (from Taylor and

Nodier, *Voyages pittoresques*).

13. The view is here reproduced from René Herval, *Beautés de la Normandie: l'abbaye de Mortemer à Lisors* (Rouen: 1956) p. 7. See also Inventaire 1976, fig. 183, where the artist is named Guyot; and p. 116, where the artist is named Engelmann 'after Schroeder.' The original is in a private collection.

14. See illustrations in Ranjard, p. 247; Inventaire 1976, figs. 196-201.

15. Aubert 1:287.

16. The 1824 lithograph omits this stringcourse on the end wall. Compare figs. 5 and 9.

17. Ranjard, pp. 248-9.

18. See photographs of the south transept in Inventaire 1976, figs. 185-91.

19. See Inventaire 1976, figs. 194-5, for capital and base of a colonnette of the axial radiating chapel. A lost eighteenth-century engraving purportedly showed flying buttresses and a continuous roof covering the radiating chapels (Inventaire 1976, p. 114).

20. Five other capitals appear in Jorand's drawing, isolated from their settings (see fig. 8). The abacus-profiles vary considerably, as do the proportions and even the styles and areas of carving. It is impossible to decipher what this confusion tells us about how these five capitals might have fitted into the 'great west door', though they are so identified by the caption. Some may have decorated the inside of the portal, as shown in fig. 2.

21. See Aubert 1:351-8 and, for example, the facades of Fontenay, Cadouin, Bellaigue, Clermont or Thoronet. 'The facades of Cistercian churches are simple, especially in the twelfth century, with no decoration and nothing besides vertical buttresses and the pierced orders of doors and windows,' (p. 351).

22. *M*, fols. 6^v, 7^r.

23. 'Tunc fundavit ecclesiam illustris rex Anglie Henricus...et usque ad chorum monachorum in tribus annis perfecit, in quod opus plusquam mille libras dedit.' *M*, fol. 8^r. In light of this fact, the previous assertion of the chronicler that Queen Mathilda (the wife of King Stephen) promised to build a church for Mortemer and 'afterwards partly finished it' ('postea in parte complevit') seems curious. Whatever endowment Mathilda may have established for a church at Mortemer does not seem to have been a factor in its construction until at least the time of the work endowed by King Henry II. *M*, fol. 4^r.

24. Ranjard, pp. 245-7.

25. 'Et l'arcade que reliait le bas-côté méridional au croisillon correspondant était certainement contemporaine de ce collatéral.' Ranjard, p. 245. For illustrations see Inventaire 1976, figs. 185-8.

26. Ranjard, pp. 245-6. See fig. 6. The Ranjards also offer other reasons for assigning the lower walls of the south arm to the first campaign but they are not very compelling. That the colonnette, receiving the formerets (of the vault), inserted into the west wall has its capital higher than the other colonnettes does not argue anything particular to the south arm; the same is true in the north arm. That the south's walls are not uniform in construction from top to bottom likewise cannot be used to prove anything about the south arm: the same construction pattern was followed in the north arm.

27. Ranjard, pp. 239, 242, 245.

28. *M*, fol. 9^{r-v}.

29. *M*, 10r. 'Omnia fundamenta capitis ecclesie perficiende iecit et cum adiutorio regis, qui ei centum libras ob hoc donavit, aliquanto altius a terra elevavit.'

30. 'Alors le transept, dont au moins la base des murs ouest et sud du croisillon méridional avait été bâtie, fut achevé. Un choeur avec déambulatoire le continua. Et l'église terminée put être consacrée le 8 mars 1209....' Ranjard, p. 239.

31. '...Chaque bras du transept recevait le jour, du côté ouest, de deux grandes fenêtres en tiers-point accostées de colonnettes' Ranjard, p. 248.

32. John Bilson, 'The Architecture of the Cistercians,' *Archaeological Journal* 66 (1909) 278.

33. *M*, fols. 8r, 10r.

34. *M*, fols. 11v, 12r.

35. *M*, fols. 1v, 6r, 10r.

36. *M*, fol. 11r. Bishop Froger gave Mortemer 800 pounds toward the completion of the church. Earlier in his life, while he was still the archdeacon of Derby, he had built Mortemer's chapterhouse. *M*, fol. 7r.

37. Evidence for this statement can be found, passim, throughout the one hundred seventy-three acts of Mortemer's cartulary. A transcription is available through University Microfilms International; Philip F. Gallagher, *The Monastery of Mortemer-en-Lyons in the Twelfth Century--Its History and Its Cartulary* (unpublished Ph.D. thesis, 1970), pp. 183-296.

38. *M*, fols. 9^{r-v}.

39. *M*, fols. 3v, 4^{r-v}, 6r.

40. *M*, fols. 7r, 8v, 9r.

41. The abbey's holdings south of Gerberroy are confirmed and/or described many places in the cartulary, for example, *M*, fols. 6v, 9v, 17r, 18v and 23r.

42. *M*, fol. 10^{r-v}.

43. For examples, see Marcel Anfray, *L'Architecture normande, son influence dans le Nord de la France aux XIe et XIIe siècles* 2 vols. (Paris: 1939) 1:131-60, passim.

44. Geoffrey Webb, *Architecture in Britain: The Middle Ages* (Harmonmondsworth, 1956) p. 82.

45. Emphasis mine. Peter J. Fergusson, 'Roche Abbey: The Source and Date of the Eastern Remains,' *Journal of the British Archaeological Association*, Third Series, 34 (1971) 41. See also Peter Fergusson, 'The Late Twelfth-Century Rebuilding at Dundrennan Abbey,' *The Antiquaries Journal*, 53 Part 2 (1973) 232–43. For photographs of Roche's transept, see Fergusson, 'Roche Abbey', pl. IX (1) following p. 42; for Dundrennan's transept, see Fergusson, 'Dundrennan Abbey', pls. XL a (north transept) and XLI b (south transept) between pp. 236 and 237.

46. Strangely enough, however, it also occurs at Aulps in Haute-Savoie.

47. The Yorkshire-North France connection has also been suggested by Jean Bony who finds Roche reminiscent of 'some buildings of the north of France, such as Dommartin...where a certain Cistercian influence was also apparent.' Tracing the influences is very difficult for '...all the great Cistercian churches of the north of France have disappeared in the course of centuries....All we can say is that the style of Roche resembles the Gothic architecture of northern France, especially that of Picardy,' 'French Influences on the Origins of English Gothic Architecture,' *Journal of Warburg/Courtauld Institutes* 12 (1947) 6.

48. Ranjard, pp. 245–6.

49. It would be helpful to know the reason for the halt in construction. By the end of Abbot Geoffrey's reign (1164–74), Mortemer was in debt; in speaking of Abbot Richard who followed, the chronicler says: 'Cum autem regimen ecclesie Mortuimaris suscepisset, invenit eam maximis debitis obligatam....' *M*, fol. 10r. My unpublished study of the abbey's holdings suggests that the debt was in part run up by Geoffrey's purchases of arable and vineyard. While the incurrence of such a debt partially explains Geoffrey's inability to continue the enormous expenditures of church-building, the fact of the debt makes Abbot Richard's resumption of construction hard to understand.

50. Abbot Richard's deposition is a matter of mystery. Mortemer's documents are totally silent about both the fact and the reasons for it. That Richard was deposed is attested to by a letter of Bishop Arnulf of Lisieux to Abbot Peter of Clairvaux (1179). See Frank Barlow (ed.), *The Letters of Arnulf of Lisieux*, Camden Society, Third Series, 16 (London: 1939) p. 180.

51. 'Ecclesia quam rex Henricus usque ad chorum monachorum fecerat tempore ipsius tota perfecta est....' *M*, fol. 11r.

52. Ranjard, p. 239. The date of Abbot William's death is uncertain. There are two sources: 1) an entry in the additions made to the twelfth-century chronicle of Sigebert of Gembloux which was at Mortemer (Paris, Bib. Nat. MS lat. 4863) and 2) a sixteenth-century marginal note in the cartulary of Mortemer (fol. 12r). The

sixteenth-century tradition gives his death-date as February 13, 1205. The earlier tradition, which we have accepted (after G. Pertz, *Monumenta Germaniae historica, Scriptores* 6:466) says that William died on February 9, 1200.

53. Aubert believed both Longpont and Royaumont to have been inspired by the cathedral of Soissons (Aubert 1:221-4). This is also the opinion of Caroline Bruzelius, 'Cistercian High Gothic: The Abbey Church of Longpont and the Architecture of the Cistercians in the Early Thirteenth Century,' *Analecta Cisterciensia* 35 (1979). She comments on the chevet of Mortemer, which she considers an isolated unicum, on pp. 5, 57-62. For Royaumont see also Robert Branner, *St. Louis and the Court Style in Gothic Architecture* (London: 1965) ch. 3.

54. See Charles Seymour, Jr., *Notre-Dame of Noyon in the Twelfth Century: A Study in the Early Development of Gothic Architecture* (New Haven: 1939), p. 100.

55. L. Régnier, 'Excursion à Lyons-la-Forêt, Mortemer et Lisors,' *Mémoires de la société historique et archéologique de Pontoise et du Vexin* 28 (1908) 75-88. See Inventaire 1976, p. 114.

56. Ranjard, p. 275.

SACRAMENIA IN SPAIN AND FLORIDA:
A PRELIMINARY ASSESSMENT

Joanne E. Sowell

In a letter to the architect of William Randolph Hearst dated July 4, 1925, the art dealer Arthur Byne wrote the following:

> The monastery [of Sacramenia] is located in one of the most desolate corners of Spain. It is of Cistercian origin dating principally from the twelfth century.... The present owner of the monastery and property is quite willing to sell but is intelligent enough to more or less appreciate its value....Assuming for the moment that you would be interested in the cloister columns and capitals ...also the Chapter House complete...this much I think could be had for about $35,000. I would say that this sum was the maximum; I may be able to do considerably better in which case Mr. Hearst would benefit....You must take into consideration that this is probably the only twelfth century cloister and Chapter House to be had in Europe today; that the complications involved in buying a thing of this sort are without end; that I have to smooth innumerable paths with money, and last but not least, the demolition and packing must be carefully superintended by myself.[1]

Sacramenia, the monastery in question, is near Segovia. It was founded in 1141 when King Alfonso VII offered land to Abbot Bertrand of L'Escale-Dieu in southern France. Raymundo, the first Abbot, and his monks arrived from L'Escale-Dieu in 1142 to establish the fifth Cistercian foundation in Spain.[2]

Sacramenia continued to serve the monastic life until 1835, when it was taken over by the Spanish government and sold into private hands.[3] In 1925, when Arthur Byne recommended Sacramenia for purchase by William Randolph Hearst, the cloister had been walled up and used for grain storage and the other buildings used to store farm equipment. Several of the monastic buildings had fallen into ruin but the cloister, chapter house and refectory remained in good condition.[4] After the purchase by William Randolph Hearst, Byne drew up detailed plans in which every stone was numbered to insure that these structures could be reconstructed accurately (Fig. 1).[5] The buildings were dismantled, the stones crated and shipped to New York. Originally destined for San Simeon, California, the boxes were quarantined in New York because of fear that the packing materials might carry hoof and mouth disease. The boxes were opened, the

packing materials burned, and the stones repacked, but the boxes remained in storage in a New York warehouse until after Hearst's death in 1951.

In 1952 E. Raymond Moss and William S. Edgemon, two Florida land developers who had been negotiating with Hearst since the forties, bought the monastery buildings and shipped them to Florida to be rebuilt as a tourist attraction. At the site in North Miami Beach a crew of eight stonemasons was assembled, headed by Allen Carswell who had worked earlier for John D. Rockefeller on the Cloisters in New York. Originally intending that the reconstruction be completed in three months, the masons were shocked to find that stones had been interchanged in the repacking, and that the packing lists made in Spain would be nearly useless in the rebuilding. As each stone was needed workers had to search through thousands of numbered pieces laid out at the site. Nevertheless, the stonemasons completed the rebuilding of the cloister, refectory and chapter house in nineteen months. The complex served as a tourist attraction until it was purchased by the Episcopal Church in 1965. Today the buildings are the property of the Diocese of Southeast Florida and function as the Parish Church of St Bernard de Clairvaux.

The accuracy of the rebuilding is confirmed not only by the stone setting plans drawn in Spain by Arthur Byne, and a set of photographs taken for Hearst, but also by a description published in 1944 by L. Torres Balbas, who was writing from notes and photographs taken prior to 1925 when the buildings were dismantled.[6] Balbas described the original layout of the conventual buildings which lay to the south of the church and were arranged according to the usual Cistercian plan (Fig. 2). On the eastern cloister walk, beginning at the north, were a small niche serving, according to Balbas, as the armarium, the ruins of what must have been the sacristy, and the chapter house. To the south of the chapter house the buildings were in ruins. On the southern cloister walk there remained only the refectory, set perpendicular to the cloister, and the kitchen. Balbas described one other vaulted building which he identified as a granary, which lay to the west of the complex.

The cloister, chapter house and refectory, which were moved to Miami, appear basically as they did in Spain. The cloister is a square formed by seven bays on the north, west and south sides and eight smaller bays on the east. Because the cloister was set against the southern wall of the church, which has remained in Spain, the exterior wall of the northern cloister walk in Miami is a reconstruction. The columns and capitals of the north and west cloister walks date from the thirteenth century, and the columns of the south and east walks date from the Renaissance (Figs. 4 and 5). The vaulting over the cloister dates from the fifteenth century. The thirteenth-century refectory stands, as it did in Spain, perpendicular to the south cloister walk. Because the walls of the refectory were made

of rubble, they could not be transported. Thus the original parts of the refectory, as reconstructed in Florida, are the pointed transverse arches and the window moldings (Fig. 6). The chapter house stands on the east cloister walk.

The most interesting problems posed to the architectural historian by the monastic complex of Sacramenia concern the church in Spain and the chapter house in Florida. Both these buildings deviate from the typical plans and as such occupy significant places in the history of twelfth-century Cistercian architecture.

The church of Sacramenia has been dated by Balbas to the end of the twelfth and early thirteenth centuries.[7] Its eastern end is composed of a semicircular central apse flanked by two smaller chapels on each side (Fig. 2). The chapels are arranged in a stepped formation so that the external chapels project only about half as far from the transept arms as the internal chapels. All four chapels are semicircular on the interior and rectangular on the exterior. The main apse ends in a semicircle on both the interior and exterior.

Cistercian churches have often been categorized by the plans of their apses into four or five basic types.[8] While Sacramenia does not fit into any one category it can be related to two types: the echelon or stepped arrangement, and the arrangement in which a central semicircular apse is flanked by rectangular chapels.

The echelon arrangement has sometimes been called the 'Benedictine plan.' In the typical plan both the apse and chapels are semicircular, an arrangement modified in the chapels at Sacramenia which are encased in rectangular walls. The Benedictine plan is believed to have been popularized by the plan of Cluny II, built under Abbot Mayeul and consecrated in 981. This plan was common in Benedictine monastic churches as well as in other important churches in the Romanesque period.[9] Before the middle of the twelfth century most such plans belonging to Cistercian churches in France has been taken over from other orders, a notable exception being the abbey of Reigny, begun by the Cistercians in 1134.[10] The plan with stepped chapels seems to have been most common in German abbeys founded from Morimond.

In twelfth-century Spain the Benedictine plan was employed in several non-Cistercian buildings such as Siguenza and Tarragona Cathedrals. The plan is found only with substantial variations in the Cistercian churches of Sacramenia (where the semicircular chapels are encased in rectangular walls) and at Oya (where both the main apse and the chapels are rectangular on both the interior and exterior).

The second plan type which can be related to Sacramenia is that with a semicircular central apse and chapels ending in a straight wall. Hanno Hahn has placed Sacramenia in a Spanish group with Huerta, La Oliva, Valbuena and Meira, churches all begun in the twelfth century.[11] Sacramenia can be compared especially to the variation of this type in which the semicircular chapels end in straight walls on the exterior. In this group can be placed the

twelfth century churches of Altenberg I, in Germany, and Bonneval, Sénanque and Le Thoronet, in France. The Provençal abbeys of Sénanque and Le Thoronet have been most often cited as possible models for the arrangement at Sacramenia.[12]

Thus, the plan of the eastern end of the church of Sacramenia can be described as a combination of the stepped arrangement with that employing semicircular chapels enveloped in a rectangular wall. The architect of Sacramenia, combining two important twelfth century Cistercian solutions, created what appears to be a unique arrangement found in no other twelfth-century church.[13]

Second only in importance to the church of a Cistercian monastery was the chapter house, usually built with particular care and always vaulted. Some mid-twelfth-century examples were covered with simple groin vaults, but generally ribbed vaults were used. Cistercian chapter houses were square or rectangular in plan, sometimes composed of only one bay, but more often divided into two rows of bays by columns along the north-south axis. A third common arrangement was that composed of nine bays placed in rows of three with vaults carried on four central columns.[14]

The plan of the chapter house of Sacramenia, now rebuilt in North Miami Beach, is a rather peculiar variation of this third type. It is made up of six full bays vaulted with ribbed vaults and three half bays covered with half vaults. These three bays appear at the western end of the chapter house adjoining the cloister. (Fig. 3). The ribs of the vaults are semicircular in section while the transverse arches are rectangular in section. The diagonal ribs do not rest on a colonnette or shaft, but terminate in a point (*en fuseau*) between the transverse arches (Figs. 7 and 8). This is a Burgundian arrangement which the Cistercians spread all over Europe in the twelfth century. It appears often in southern France and Spain, and analogous constructions to that at Sacramenia can be found in the chapter houses of the twelfth-century Cistercian monasteries of Flaran, Fontfroide and L'Escale-Dieu, the mother house of Sacramenia.[15] Whereas Balbas dated the chapter house to the thirteenth century, Walter Cahn has moved the date up to the third quarter of the twelfth century, based partially on the characteristics of the vaulting.[16]

Arthur Byne, writing to Hearst's architect Julia Morgan, asserted in 1925 that the chapter house of Sacramenia was 'as fine as any preserved in Spain.'[17] The beautifully carved capitals confirm his assertion (Fig. 9). Two major types of capitals can be found in the chapter house, one covered with a net of rope-like foliage and the other made up of curving stylized foliage and volutes. Three of the four central capitals are of this second type. The abaci of these capitals are crisply carved in floral designs. Cahn has related the second group of capitals to the local style of the region of Agen and the Bordelais. They also resemble some Spanish capitals such

as those of the Cathedral of Jaca.[18] Cahn suggested that this rela-
tively rich decoration, when compared to more austere capitals of
related Cistercian chapter houses of Spain and southern France, pro-
vided further evidence that the chapter house of Sacramenia was a
rather early work, built before the code of austerity for decoration
of Cistercian buildings had solidified.

One enters the chapter house from the cloister through a semi-
circular portal formed by columns and flanked by double semicircular
openings in which two arches are set in under a second pair. The
central columns carrying these double arches are thus arranged in a
cross pattern (Fig. 10). The same arrangement of the entryway is
found at L'Escale-Dieu, the mother house of Sacramenia. The capitals
of the columns at L'Escale-Dieu are much more restrained, however,
than those at Sacramenia. Nevertheless, these two buildings are very
similar and share not only the arrangement of their entryways and
vaulting types. The chapter house of L'Escale-Dieu is built on the
same peculiar plan of six full vaults and three half vaults, as are
the chapter houses of two other Spanish foundations of L'Escale-Dieu,
Veruela and La Oliva.[19] These two buildings can be dated later than
those of L'Escale-Dieu and Sacramenia by the more complex ribs of
their vaulting and the elaboration of the cloister entryways. Cahn
has assigned the earliest date to the chapter house of Sacramenia.
The chapter house which now stands in Florida might thus assume the
significant position of the model for the chapter houses of L'Escale-
Dieu and her two other Spanish daughters.

The preceding discussion has surveyed the present state of the
research on the monastery of Sacramenia. The history of the building
since its acquisition by Hearst needs more careful examination since
many of the details are still shrouded in rumor. More importantly,
the architectural history deserves further study. Cahn's redating
of the chapter house places its construction before that of the church,
and thus the relationship between these two buildings must be more
carefully explored. This comparison, as well as a comparison of the
chapter house capitals with other twelfth-century capitals in Spain,
and a more thorough study of the vaulting type of the chapter house
of Sacramenia as it occurs elsewhere in Europe requires a reap-
praisal of the dates of the chapter houses of Sacramenia and L'Escale-
Dieu.

Florida State University
Tallahassee, Florida

NOTES

This article is based on a paper delivered at the Fifteenth
International Congress on Medieval Studies held in Kalamazoo,
Michigan, May, 1980. It has grown out of my preliminary study
toward a dissertation in art history at Florida State University
under the direction of Professor François Bucher.

1. This passage was taken from a typed copy of a letter written
 by Arthur Byne to Julia Morgan, 4 July 1925, files of Mrs
 Jeanette Campbell, North Miami Beach Public Library, North
 Miami Beach, Florida. Also available in the Monastery of St
 Bernard de Clairvaux Archives, North Miami Beach, Florida.
2. L. Torres Balbas lists Moreruela (founded 1131), La Oliva
 (1134), Bellofonte (1137, moved to Valparaiso in 1232) and
 Osera (1140) as the four earlier foundations in Spain. L.
 Torres Balbas, 'El Monasterio Bernardo de Sacramenia (Segovia),'
 Archivo español de arte 17 (1944) 201-2.
3. Balbas (pp. 200-2) provides the fullest treatment of the early
 history of Sacramenia. See also: Jack Bondurant, *The Strange
 Story of the Ancient Spanish Monastery* (Miami: Monastery Gar-
 dens, Inc., 1954), pp. 5-23, an interesting if somewhat fanci-
 ful little book.
4. In a letter written in 1925 to Julia Morgan, Byne mentioned
 the various buildings of the complex. The kitchen, located at
 the southwest corner of the cloister, was described as blackened
 by soot but in good condition. When Byne visited the site his
 meals were cooked there. Although a kitchen was included in
 his plans of the complex in Spain, Hearst evidently decided
 against transporting it to the United States. Copy of a letter
 from Arthur Byne to Julia Morgan, 15 October 1925, North Miami
 Beach Public Library and Archives of Monastery of St Bernard
 de Clairvaux.
5. Copies of a series of seventeen stone setting plans made in
 Spain by Byne have been preserved in the Archives of the Mon-
 astery of St Bernard de Clairvaux.
6. Balbas, pp. 207-11.
7. Balbas, p. 207.
8. See Georg Dehio and Gustav Bezold, *Die kirchliche Baukunst des
 Abendlandes* (1887; rpt. Hildesheim: Georg Olms, 1969) 1:527;
 and Wolfgang Krönig, *Altenberg und die Baukunst der Zisterzien-
 ser* (Bergisch Gladbach: Altenberger Dom-Verein e.V., 1973),
 pp. 17-30. For divisions of Spanish Cistercian architecture
 see: Henri Paul Eydoux, 'L'Abbatiale de Moreruela et l'archi-
 tecture des églises cisterciennes d'Espagne,' *Cîteaux in de
 Nederlanden* 5 (1974) and L. Torres Balbas, 'Inventaire et clas-
 sification des monastères cisterciens espanols,' *Actes du*

congrès d'histoire de l'art tenu à Paris en 1921, 2 (Paris: 1924) 119-25.

9. See especially: E. Lefèvre-Pontalis, 'Les Plans des églises romanes bénédictines,' *Bulletin monumental* 76 (1912) 437-85. For a more recent treatment of the echelon plan in Cistercian architecture see: Krönig, pp. 24-30.

10. The east end of Vaux-de-Cernay, once thought to be an important link between the Benedictine and Cistercian plans, has now been shown to have been built by the Congregation of Savigny. See: Marcel Aubert, 'L'Abbaye des Vaux-de-Cernay,' *Bulletin monumental* 92 (1933) 195-206. For a discussion of several churches of echelon plan which were acquisitions of the Cistercians see: Hanno Hahn, *Die frühe Kirchenbaukunst der Zisterzienser* (Berlin: Gebr. Mann, 1957), p. 127.

11. Hahn, p. 190.

12. Elie Lambert cautioned against relating the form of the chapels too closely to those found at Sénanque and Le Thoronet, pointing out that the circular form embedded in a rectangular wall occurs earlier in Spain in Mozarabic architecture. See: Elie Lambert, *L'Art gothique en Espagne aux XIIe et XIIIe siècles* (Paris: Henri Laurens, 1931), p. 92. However, in Mozarabic architecture this form appears most often as a chapel of horseshoe shape encased in a rectangular wall. Balbas ('Sacramenia,' p. 225) has found very little evidence for Mozarabic influence at Sacramenia, and thus the French source seems the more likely choice.

13. L. Torres Balbas ('Sacramenia,' p. 219) stated that he knew of no similar arrangement, in Spain or outside, in the architecture of the twelfth and thirteenth centuries.

14. Marcel Aubert, *L'Architecture cistercienne en France,* 2nd ed. (Paris: Vanoest, 1947) 2:51-70.

15. For a list of monuments vaulted in such a manner see: Balbas, 'Sacramenia,' p. 223.

16. Walter Cahn, 'Romanesque Sculpture in American Collections: XIV The South,' *Gesta* 14 (1975) 78.

17. Copy of a letter from Arthur Byne to Julia Morgan, 4 July 1925, North Miami Beach Public Library and Monastery Archives.

18. Cf: José Gudiol Ricart and Juan Antonio Gaya Nuño, *Arquitectura y escultura románicas,* Ars Hispaniae, 5 (Madrid: Editorial Plus-Ultra, 1948), p. 132, fig. 208.

19. J. R. Marboutin suggested that such a disposition resulted at L'Escale-Dieu from an early change in the placement of the wall of the chapter house leading to the cloister. J. R. Marboutin, 'L'Abbaye cistercienne de Lescaledieu (Haute-Pyrénées),' *Bulletin monumental* 92 (1933) 76.

SANTA MARIA DE OVILA: ITS HISTORY
IN THE TWENTIETH CENTURY IN SPAIN AND CALIFORNIA

Margaret Burke

In 1931 William Randolph Hearst purchased the Cistercian monastery buildings of Santa Maria de Ovila, located in the province of Guadalajara in Spain.* Ovila had existed for over seven hundred years, isolated from centers of population and from well-traveled roads. Founded in the late twelfth century by King Alfonso VIII of Castile, the monastery was one of the establishments which the king promoted along the border of country he had recently reconquered from the Moors--a place which would attract needed settlers and which might serve as a refuge in case of attack or raids. The small monastic community at Ovila thrived and knew its greatest prosperity in the thirteenth and early fourteenth centuries, but thereafter its fortunes declined. Though the church was rebuilt in the fifteenth and sixteenth centuries and ambitious constructions were begun again in the seventeenth century, the success of attempts to revitalize the community was short-lived. Finally, in 1835, when the inhabitants had dwindled to four monks and one lay brother, the monastery was secularized. The properties fell to private owners, who sold the roof tiles and other removable parts. The major buildings were still standing when the sale to Mr. Hearst was arranged by an expatriate American art dealer, Arthur Byne, who lived in Madrid and conducted a profitable business of selling Spanish works of art and architecture to collectors.

At the time Mr. Hearst envisioned the construction of a private castle in forested country in northern California. This project, unlike his palatial residence at San Simeon, would be a single large building with towers and turrets, built around a central courtyard. It was to be located at a place called Wyntoon, on the McCloud River near Mount Shasta, and would replace a house built there for his mother Phoebe Apperson Hearst by architect Bernard Maybeck, which had recently burned. Mrs. Hearst's house had been called Wyntoon Castle, although it was simply a summer residence. The new Wyntoon Castle would indeed be a castle, in appearance as well as in size; and to provide a proper setting Hearst increased the size of his mother's modest property to 66,000 acres. Miss Julia Morgan, Hearst's architect for San Simeon, would provide the necessary technical knowledge for her client's visions of Wyntoon; Byne was commissioned to find architectural treasures in Spain to be incorporated into the major rooms of the castle.

Arthur Byne had wide connections in Spain and many influential friends. Among them was a wealthy director of the Bank of Spain who not long before had purchased the monastery and farm-lands of

Santa Maria de Ovila.[1] Byne thought that the venerable buildings
might well suit his client, as they included fine, vaulted structures
dating from the twelfth to the seventeenth century. Fortuitously the
new owner--the most recent of a series of politician-proprietors--was
interested in selling the monastery buildings,[2] then in a ruinous
state with bushes and small trees growing from the vaulting, the roof
tiles having long since been removed and sold.[3] All wooden appurten-
ances such as doors and window frames had been carried away and at
least one of the massive walls seemed about to collapse.

In December 1930 Arthur Byne drove to the monastery, in mountain-
ous country about ninety miles from Madrid. With 'the temperature
near zero and the snow swirling around'[4] he quickly drew a plan of
the church and made photographs and sketches of the other major build-
ings. These he sent to Mr. Hearst who--following Julia Morgan's en-
thusiastic recommendation--agreed to take the parts of the monastery
that Byne considered usable in the castle project. These consisted
mainly of columns, capitals, vault ribs, door frames, and window em-
brasures. From those buildings whose masonry was of particularly fine
workmanship the facing stones of the vault cells and walls would also
be taken.[5]

Immediately Julia Morgan and her staff drew preliminary sketches
for Mr. Hearst's castle, employing monastery structures in the plan
of the ground floor. She then called upon architect and engineer
Walter Steilberg, who often collaborated on her projects. Supplying
him with prints of the preliminary drawings, she sent him to the site
in Spain where he was to be consultant and supervisor. Meantime Ar-
thur Byne had already begun the work of the dismantling or, as he call-
ed it, the *delapidation* ('I use the word in its Latin sense,' he said).[6]

It appears unlikely that Mr. Byne drew a plan of the layout of
the monastery buildings before their demolition, since his client had
no intention of re-erecting the entire complex as it existed in Spain.
Moreover, although Byne was a skilled draftsman and took interest in
art-historical matters, he was at that time working with utmost haste
to ship the monastery stones out of the country, aware that the recent
change in government in Spain might bring the project of dismantling
to a halt.

One plan of the monastery does exist from that time. It was drawn
by a Spanish physician, Doctor Francisco Layna Serrano, whose family
came from Ruguilla, a village that had once belonged to the monastery
of Ovila. Dr. Layna had long been attempting to interest government
officials in the preservation of Santa Maria de Ovila, among the few
ancient monuments then remaining in the province of Guadalajara.[7] But
whereas Arthur Byne's project profited from what he called the 'slop-
over' period between the dictatorship and the elections for a new
government in Spain,[8] Dr. Layna's mission unhappily failed. Neverthe-
less--as he wished that the monastery might not be completely forgot-
ten--he wrote a monograph on Santa Maria de Ovila and included a plan,[9]

drawn after the buildings had been dismantled.

As might be expected Dr. Layna's plan, drawn partly from memory, is not entirely accurate; but it does show the layout of the major monastic structures.[10] My plan (Fig. 1) derives from the plans of Layna and of Julia Morgan with changes dictated by a study of the photographs and the stone-setting diagrams made prior to the dismantling.

As was typical for a medieval monastery the principal buildings were arranged around a cloister edged by walkways. The church bordered the north side of the cloister. At the east side, adjoining the south transept of the church, lay the monks' wing. It included the sacristy, the library, the chapter house and what was probably the monks' common room; a spacious dormitory was located above these rooms, giving the monks easy access to the church for services during the day and night. The south wing of buildings, opposite the church, contained the refectory, the kitchen, the pantry and very likely a warming room *(calefactorium)*. At the west lay the *bodega*, a plain, utilitarian building whose ground floor and basement were the store-house and wine cellar and whose upper story served as a dormitory for the lay-brothers.

The major buildings of the monastery had not yet been dismantled when Walter Steilberg arrived at the monastery site on March 9, 1931. To Julia Morgan in San Francisco he wrote: 'The chapter house and the refectory...are the rooms which appeal to me as the finest on account of their dependence for effect upon simple structural lines.'[11] The refectory (on the south side of the cloister courtyard) was a large, rectangular building about 27 feet by 85 feet on the interior, with walls five feet thick and with exterior wall buttresses. The interior space was divided into four square units by four bays of vaulting, whose ribs descended to corbels and made a pattern of huge pointed arches along the walls. The simplicity of the long walls was broken by narrow, deeply splayed windows and by a lectern placed high on the west wall, for the monk assigned to read to the community at meal times. A wide entrance doorway, deep and handsomely molded, provided access from the cloister. Constructed in the late twelfth century, the refectory was of a style transitional between Romanesque and Gothic, whereas the chapter house (in the east wing or monks' wing), a smaller, intimate room approximately 31 feet by 45 feet on the interior, was clearly Gothic in style, built in the early thirteenth century.[12] Its construction, however, may have been roughly contemporary with that of the refectory because, in medieval abbeys, the chapter house generally showed the most careful construction, the finest workmanship and often an advanced style. At Ovila the chapter room followed the traditional plan, with two columns placed on the north-south axis, dividing the space into six compartments of rib-vaulting.[13] The entire building had a sculptural quality, especially noticeable on the façade where there was a deeply

recessed triple archway supported by piers with colonnettes.[14] Mr.
Steilberg was also attracted by the room above the chapter house--
the dormitory for the twelve monks and the novices. This was a spa-
cious room spanned by huge transverse arches that extended to the
floor. 'I suggest,' he wrote, 'that these be used over the swimming
pool'[15]--that is, the indoor swimming pool planned for Wyntoon Castle.

Steilberg then saw the *bodega*, which had not been included in
Hearst's purchase. He was happily surprised to find that it was 'a
splendid room 27 feet by 90 feet, with a fine simple "tunnel" vault.
For my part,' he wrote, 'I would rather have it than the chapel
(church).'[16] Julia Morgan, following Mr. Hearst's instructions, im-
mediately cabled WILL TAKE BODEGA[17]--but Hearst later changed his
mind. The *bodega* is the single major building of the monastery now
remaining at the site in Spain. Apparently the *bodega* and the re-
fectory were the earliest of the permanent buildings at Ovila. One
assumes their precedence not only because of the rugged simplicity
of their style but because such utilitarian buildings, necessary for
the life of the community, were often the first to be erected.

Probably the last of the major structures built during the ini-
tial building campaign (begun by Alfonso VIII and continued by his
successors Enrique I and Fernando III) was the church consecrated
in 1213.[18] According to an anonymous document cited by Dr. Layna it
was three-aisled with five chapels and was very magnificent.[19] This
church was reconstructed in the fifteenth and sixteenth centuries,
becoming at that time a single-aisle building. Following the prac-
tice then current its 'monks' choir,' formerly occupying the central
aisle of the nave, was moved to a raised gallery or tribune at the
west end of the church,[20] to provide ample space in the nave for
laymen who by that period were generally permitted to attend services
in monastic churches.[21] The ceiling of the east end and transept of
this new church had a rich and complicated pattern of rib-vaulting.
The single-aisle nave, also rib-vaulted, had tall, spindly columns
along its walls and was less effective.

Walter Steilberg was disappointed with the church (and the qual-
ity of its masonry showed deterioration) but he did observe that it
had 'a fine Renaissance (Plateresque) portal.'[22] Arthur Byne, who
had earlier considered that his client owned enough Renaissance art,
immediately informed Mr. Hearst that the portal could be obtained for
$1,500. 'In the open market in Spain,' he wrote, 'this portal is
worth $8,000 to $10,000.'[23] Mr. Hearst bought it. The portal is
now the only part of the monastery that has been re-erected in Cali-
fornia.

The cloister gallery on the south side of the sixteenth-century
church was the last major work at the monastery. Under construction
in the first quarter of the seventeenth century, work on the new
cloister ended abruptly when only eleven bays of the projected 32

had been completed. It is likely that at an earlier time the clois-
ter had a timber-roofed gallery, because corbels to support roof
beams existed along the front face of the chapter house and on the
long wall of the *bodega*; yet no wooden·remnants nor parts of a sup-
porting arcade were evident in 1931. Dr. Layna believed that the
south aisle of the original three-aisle church covered the area lat-
er occupied by the cloister walk[24]--that is, the aisles were simply
cut off when the church was reconstructed. There were also, origin-
ally, five chapels (as noted in the early manuscript quoted in n. 19
above). The arrangement with 'five chapels'--presumably two in each
transept plus the apse--instead of only one on each transept provides
a logical resolution of the plan for the east end of the church, be-
cause it joins the sacristy directly to the south wing of the tran-
sept, as was usual in a church of Cistercian plan. Dr. Layna made
no comment concerning the length of the nave of the thirteenth-century
church. From a careful study of the monastery plan and the plans of
the churches which were closely related to Ovila[25] I propose that the
original nave may have been four bays long instead of three (Fig. 2).
Such a plan would permit a cloister of the traditional square plan,
would leave ample space between the cloister gallery and the *bodega*
for a walkway for the laybrothers (who were not allowed to enter the
cloister), and would provide access from the lay-brothers' walkway
directly to the narthex or porch, a structure which usually preceded
a Cistercian church.

When Walter Steilberg arrived at Ovila early in March 1931 the
dismantling of the cloister gallery operation was well under way, and
the vaulting had already been removed. Sixty-seven men were employed
on the project, and that figure would soon be increased to one hun-
dred. The skilled masons and carpenters lived at the site; Byne pro-
vided bedding for them and a cook, and he had food supplies trans-
ported from Madrid. Unskilled laborers, who provided their own food,
came from the surrounding countryside, some of them walking two hours
from their mountain homes before working from sunrise to sunset and
then returning to their homes at night. Arthur Byne was a very ef-
ficient administrator and had already completed all preparatory work.
Wooden centering was being constructed to support the stones of each
arch during dismantling. He had transported to the site a trench
railway used in World War I, whose tracks could be brought into any
of the buildings; and its small push-cars when loaded with stones
were pushed to the bank of the River Tagus, one quarter of a mile
away, and then directly onto a 'ferry'. No bridge existed over the
river, which at that time of year was a treacherous stream about
100 feet wide; so Byne had his men construct a barge or 'ferry' guid-
ed by a cable threaded between vertical rollers (which could compen-
sate for the frequent fluctuations in water level). The cable was
strung across the river at an angle so that the heavily laden ferry
was propelled partly by the swift current. On the opposite bank the

cars and their stones were hauled up a steep cliff by means of a
windlass. There the stones were loaded onto trucks and carried to
Madrid, where eighteen men were employed making wooden crates. The
carved stones were packed first in excelsior, then placed in the
crates; the plain stones were wrapped in matting and bound with me-
tal straps. All were then sent to Valencia from where they were
shipped, in eleven shiploads, to San Francisco.[26]

Before Walter Steilberg had arrived Byne had also devised a
system of markings for the stones and had his draftsman, a Señor
Santos Perez, make scale drawings (plans of vaulting and elevations
of interior walls) on which each stone was drawn and marked with
its particular number, corresponding to the number marked on the
stone. These drawings were the stone-setting diagrams. Photocop-
ies of these diagrams which are the property of the De Young Museum
are the principal evidence we have for construction of the monas-
tery buildings.

Walter Steilberg left Spain at the end of March. The dismant-
ling was completed by July first. During the intervening time offi-
cials of the new Republican government threatened the completion of
the project. Byne wrote that it was then 'forbidden to ship a single
antique stone from Spain--even the size of a baseball.'[27] Dismant-
ling operations at Ovila were halted; but Byne's lawyer persuaded
the Minister of Labor to consider the work a 'partial solution to
the serious problem of Unemployment.'[28] So all the stones arrived
in San Francisco, where they were inspected by Steilberg and placed
in the largest warehouse in the city.

Julia Morgan and her staff were then perfecting the plans for
Wyntoon Castle, and Walter Steilberg would soon be preparing the
structural drawings. The chapter house from Ovila, Hearst decided,
should be an entrance hallway or vestibule. The refectory he origin-
ally intended for the library but soon thought that the room would
be more suitable for the 'armory,' where he would display his large
collection of armor. In an early sketch the monastery's church was
shown as the assembly hall--where Hearst would meet his guests be-
fore dinner. (This sketch shows a sitting room in the main apse,
another at the crossing, and a grand piano at the east end of the
nave.) Bedroom suites for guests were to be on the upper floors of
the castle; and Hearst's special domain was the tower over the en-
trance, the tallest part of the entire construction. There, on the
eighth floor (the top floor) was a single room of circular plan--the
study of Mr. Hearst, the Chief.

The plans, which mainly reflected Mr. Hearst's ideas, continu-
ally changed and became increasingly complex--and then were 'pulled
together' and simplified by Julia Morgan. Yet throughout the plan-
ning the monastery church remained a problem for Hearst. It was over
150 feet long and 50 feet tall--too capacious and too tall, he thought,
for an assembly hall. Finally the solution came to him: it would

house the swimming pool! The diving board would be at the west end
of the nave, where the 'plunge', as it was called, was to be eleven
feet deep, and the transept wings and apse, with water two, three,
and four and a half feet deep, could accommodate children and less
active swimmers. The north chapel then became the ladies' dressing
room; and all around the exterior of the apse (on a terrace, out-
of-doors) there would be a 'beach' with sand two or three feet deep,
for sun bathing.

When considering such disposition of the monastery's buildings
at Wyntoon one must bear in mind that Hearst, who was then in his
late sixties, intended the castle only for his temporary use. In
the words of Walter Steilberg, both Hearst and his architect Julia
Morgan were 'long-distance dreamers.'[29] Although they did not always
have the same dreams, they apparently both visualized Wyntoon Castle
as a medieval museum--a museum for architecture, not only for paint-
ings and for sculpture. And one becames aware, when studying the
plans for Wyntoon, that if the swimming pool were covered over with
flooring, the church building could become a handsome, spacious ex-
hibition hall, as could also the bowling alley (which was to have
sixteenth-century rib-vaulting) and the gymnasium or squash courts.

But this extravagant dream was not to be realized. Planning
continued until 1933. In July of that year a steam shovel was ready
to level land for the construction of the castle. Then suddenly Mr.
Hearst halted all work on the project. The Depression years and
taxes were bringing disaster to his huge organization of enterprises
and properties; and although he irrepressibly continued buying works
of art, he knew that it would be impossible to finance his magnifi-
cent castle.

Throughout the 1930s the monastery stones remained in a San
Francisco warehouse, accrueing storage fees of $5,000 per year. Many
of Hearst's operations were liquidated and properties were sold but
attempts to sell the monastery's stones were unsuccessful. In 1941
Mr. Hearst presented the stones to the city of San Francisco with
the understanding that the entire monastery would be reconstructed
as a museum near the De Young Museum in Golden Gate Park. City offi-
cials were enthusiastic; Museum Director Walter Heil wrote to Mr.
Hearst that this was the most thrilling news that ever had come to
him in his career as museum director. Even before the documents for
transfer of ownership had been prepared, Julia Morgan began research
for the reconstruction of the monastery and investigated possible
sites in Golden Gate Park.

As Miss Morgan's task was to use the monastery buildings as a
museum she made several possible layouts of the complex. In the
plan finally chosen by the city officials, the new site itself and
the intended use for each building determined the arrangement of
the buildings, which differed somewhat from the original layout in
Spain. But World War II interrupted the project. Soon after the

war, in 1946, city officials contracted with Miss Morgan to prepare drawings for the reconstruction of the monastery of Santa Maria de Ovila as a Museum of Medieval Arts and to make a scale model of the entire complex of buildings. The monastery as a museum was to be located near the De Young Museum and surrounded by landscaped park lands. It would have been a very handsome group of buildings, an outstanding cultural attraction, unique in the United States.

Unhappily in the following years attempts to raise money for the construction of the museum failed; and more tragic, the monastery's stones, which were stored outdoors in the park, were badly damaged by five fires. The last two fires, in 1959, clearly the work of arson, were catastrophic. Great damage was caused by the spalling and sudden quenching of the stones. After these last disasters architect Walter Steilberg was called upon again--this time to inspect the damaged stones and to determine whether any construction of the monastery buildings would be possible. In his report (1960) he stated that approximately half of the stones for the vaulting, the capitals, and the columns of the refectory and the chapter house had been salvaged, which indicated that these structures 'could be rebuilt substantially as they were at the time of their construction in the twelfth and thirteenth centuries.'[30]

A general belief in the hopelessness of the task prevailed, and no funds were raised for the reconstruction. Nevertheless, in 1964-65 the Museum Society raised $40,000 for the re-erection of the portal of the sixteenth-century church of Santa Maria de Ovila. It is now the principal decoration of the museum's central exhibition hall, which has been named Hearst Court.

Now, twenty years after the disastrous fires, returning interest has led to a new investigation of the state of the monastery stones. In March of 1980, through a generous grant from the Hearst Foundations, we began the work of identifying and segregating the carved stones of the chapter house, which was the finest of the buildings of the monastery. It has been tremendously encouraging and gratifying to find that at least 50% to 60% of the pieces still exist, confirming Walter Steilberg's earlier estimate. For some parts that figure is closer to 80%; and a large quantity of the building's facing stones (for walls and vaults) exists as well. There is indeed now a possibility that a reconstruction of a part of the monastery of Santa Maria de Ovila could become a reality.

De Young Museum
San Francisco, California

NOTES

*This study was presented in slightly different form at the Conference on Cistercian Studies, Fourteenth International Congress on Medieval Studies, 1979.

1. Francisco Layna Serrano, *El Monasterio de Ovila* (Madrid: 1932) p. 6.
2. Letter from Arthur Byne to W. R. Hearst, December 27, 1930. Letters referred to in this paper are among the Hearst Monastery documents in the M. H. de Young Memorial Museum, San Francisco. Many are the original letters, others are carbon copies of the original.
3. Layna, p. 121.
4. Byne, letter of December 27, 1930.
5. In addition 300 tons of plain blocks of limestone were later purchased. These were to be re-cut and used for wall-facing in the reconstruction of the rooms at Wyntoon Castle.
6. Letter from Arthur Byne to Walter Steilberg, April 20, 1931.
7. Layna, pp. 7ff.
8. Letter from Arthur Byne to Julia Morgan, January 25, 1931.
9. Layna, p. 35, Fig. 5.
10. See plans of Cistercian monasteries in Fr. M.-Anselme Dimier, *L'Art cistercien, France,* La Nuit des temps 61, 2nd ed. (*La Pierre-qui-vire:* 1974) p. 41; in Marcel Aubert, *L'Architecture cistercienne en France* (Paris: 1947) 2: fig. facing p. 1; and in Wolfgang Braunfels, *Monasteries of Western Europe: the Architecture of the Orders* (London: 1972) p. 75, fig. 61.
11. Letter dated March 10, 1931.
12. Layna, pp. 48f.
13. Aubert 2:54.
14. Style of this triple archway is typically thirteenth century (cf. Mortemer, 1220-30, and l'Epau, c. 1250-60, in Aubert, 2:69, figs. 379-80). Reconstruction of the archway in the sixteenth century, noted by Layna, may have been mainly masonry repairs.
15. Letter from Walter Steilberg to Julia Morgan, March 10, 1931.
16. Letter to Julia Morgan, March 12, 1931.
17. Cablegram from Julia Morgan to Arthur Byne, June 3, 1931.
18. V. Lamperez y Romea, *Historia de la arquitectura cristiana española en la édad media* (Barcelona: 1906) 2:476; Layna, p. 87.
19. 'Era "suntuosísima, de tres naves y cinco capillas, mucho más (suntuosa) que agora es."' Layna, p. 39, quoting manuscript in Salazar Collection, Academia de la Historia, Madrid, 0-3, folios 313ff.
20. Leopold Torres Balbás, 'Inventaire et classification des monastères cisterciens espagnols,' *Actes de Congrès d'histoire de*

l'art (Paris, 1921) (Paris: 1924) 2:121f.

21. Aubert, 1:108.
22. Letter to Julia Morgan, March 10, 1931.
23. Letter from Arthur Byne to W. R. Hearst, June 3, 1931.
24. Layna, p. 47.
25. Valbuena, whence came the original community of monks at Ovila, and the Cathedral of Sigüenza, whose bishop took special interest in the construction at Ovila, remaining there during the spring and summer of 1213 and presiding at the consecration of the church in that year. (See: Fr. Toridio Minguella y Arnedo *Historia de la diócesis de Sigüenza y de sus obispos* (Madrid: 1910) 1: ch. IX. For a plan of Valbuena see Elie Lambert, *L'Art gothique en Espagne* (Paris: 1931) p. 107, fig. 40; for the Cathedral of Sigüenza see Lamperez y Romea, 2:200, fig. 225.
26. Letter to Julia Morgan, March 30, 1931.
27. Letter to Walter Steilberg, March 30, 1931.
28. Letter to Walter Steilberg, May 28, 1931.
29. Interview with Walter Steilberg, in S. Riess, ed., *The Julia Morgan Architectural History Project* (Regional Oral History Office, Bancroft Library, University of California) (Berkeley: 1976) 1:61.
30. Report to Charles Griffith, City Architect, San Francisco, August 30, 1960.

THE CISTERCIANS IN ENGLAND AND WALES:
A SURVEY OF RECENT ARCHEOLOGICAL WORK 1960-1980

Lawrence Butler

The work of Père Dimier has been an inspiration to all who have worked upon Cistercian problems. In showing us the wide range of architectural motifs within the basic unity of the order, and in stressing how susceptible the movement was to regional variation in styles while remaining unmistakably Cistercian in ethos, he has given both food for thought and insight into the medieval spirit.

The range of Cistercian topics that has been tackled in the British Isles from the architectural and archeological approach have been varied and in many ways complementary. Yet few scholars have brought together the range of work and sought to impose a sense of order upon it. The study by R. Gilyard-Beer (1958) is the most valuable in that he looks at the buildings and sites that remain and sees the diverse developments from foundation to dissolution within all the monastic houses in England and Wales. Other seminal works are the contributions of Knowles (1963, 196-206), and particularly his survey with Dr. St. Joseph (1952). This latter is a commentary upon the sites as they now are and also a brief summary of the earlier investigative work, especially in the appraisal of Calder and Robertsbridge.

It is the good fortune of Britain that it possesses a comprehensive Ancient Monuments Service: most of the architecturally important sites are in state care (England and Wales: nineteen sites, 17%; Scotland: seven sites, 58%) and the majority of the remainder are protected from random destruction, either by development or by excavation, through being 'scheduled' (England and Wales: forty-two sites, 38%; Scotland and Isle of Man: five sites, 42%). Those outside this protective network are the sites where little or nothing is visible on the ground, where the monastery was incorporated into a great landowner's mansion, or where the church was transferred to parochial use (four sites) and the precincts used as a cemetery. The largest category outside the limited protection of scheduling are the sites of early monasteries (twenty-four sites) from which the communities moved to found a more congenial residence. These 'short-stay' sites are a precious source of information not yet investigated.

Out of the total number of houses in England and Wales (seventy-six) archeological work has been conducted upon twenty-five of them in the last two decades. Obviously these excavations have varied both in extent of ground examined and in the quality of the investigation. Only at one site, Vale Royal, has the work formed part of a larger research program (Thompson 1962); the remainder have been

tackled from three main motives. In the first, and largest, category
are those subjected to clearance and tidying as part of the Ancient
Monuments Department's improvement of the visual appearance of the
site and provision of an enhanced understanding of the ruin for visi-
tors. This has occurred within at least eleven abbeys (and probably
more), and raises important questions of excavation practice. In
many cases the stimulus has been the production of a new scholarly
guide; archeological work has been adequately co-ordinated and direct-
ed to this end. These guides provide a substantial corpus of histor-
ical and architectural literature. A few provide the only authorita-
tive study of an abbey, but the majority expand the work of the earli-
er generation of scholars such as St. John Hope, Brakespear and Peers.
The only new guides have been J. G. Coad, *Hailes Abbey* (1969), R. Gil-
yard-Beer, *Fountains Abbey* (1970) and L. A. S. Butler, *Neath Abbey*
(1976), though all three draw upon the work of earlier excavators.
Two guides have been totally recast: those by C. A. Ralegh Radford
for *Strata Florida Abbey* (1936) and *Valle Crucis Abbey* (1953), both
as a result of recent historical and archeological research: J. Bev-
erley Smith and W. G. Thomas, *Strata Florida Abbey* (1977) and J. Bev-
erley Smith and L. A. S. Butler, *Valle Crucis Abbey* (forthcoming).
A similar enterprise sponsored by the Manx Museum has been excavation
at the only Cistercian house on that island: L. A. S. Butler, *Rushen
Abbey* (1978). One new departure has been J. K. Knight, *Tintern Abbey
and the Romantic Movement* (1977).

The second category of investigation has been the excavation con-
ducted in advance of destruction through site development, often upon
already disturbed abbeys or portions of the precinct. Fortunately few
sites fall into this category though work at Maenan (Butler and Evans
1980) and St. Mary Graces, London, is of this nature.

The third and most varied category is the local amateur investi-
gation, often inadequately financed, poorly directed and erratically
conducted. These destructive efforts are generally imperfectly pub-
lished and seldom understand the potential of their evidence. When
well organized, however, with a clear objective and under firm direc-
tion, useful work can result, as at Bordesley, Boxley and Newminster.

It would be impossible here to examine and appraise each of the
twenty-five excavations. Instead it is proposed to take specific
themes and evaluate the archeological contribution. These themes
will be pursued in a predominantly chronological sequence; the wider
implications of the evidence upon trade, land use and the exploita-
tion of the economy will be followed later.

The adoption of the Bernardine or Fontenay plan throughout Eur-
ope has stimulated argument into the mechanics of church construc-
tion. Two particular points emerge. The principal theme is whether
there was a common formula governing the ideal proportions of ground
plan (and elevation) as proposed by Hahn (1957) and modified by Di-
mier (1966); the other is whether the first stone church was preceded

by any timber buildings. The question of ideal proportions has been
examined in Ireland at Mellifont (de Paor 1969; Stalley 1975) and
shown to be a valuable formula, though not to be accepted uncritical-
ly or without any variation caused by difficulties of the terrain.
One site, excavated *ab initio* from beneath the gardens of a post-
Dissolution mansion, is Rufford in Sherwood Forest (Gilyard-Beer
1965). This had a church of 1147 to which Hahn's formula seems em-
inently applicable. Similar evidence is forthcoming about Boxley
(Tester 1974) and has come from the re-excavation of Newminster (Har-
bottle and Salway 1964). It seems clear that the conflict between
the 'Benedictine' apse and the 'Bernardine' straight presbytery was
not fought on this island. Instead the difference of emphasis ex-
plored by Esser (1952), Eydoux (1953), Esser (1954) and Dimier (1966,
1967, 1974) has passed England by.

The clarity of the Bernardine formula identified with Fontenay
was lost after the hiatus in new foundations which followed the Gen-
eral Council of 1152 and the death of St. Bernard in the following
year. There is little evidence of it in the churches of later foun-
dation such as Aberconway I of ca. 1190 (Butler 1964), Valle Crucis
of 1201 or Whalley of 1330-80. These later building plans need to
be seen not only within the narrow confines of Cistercian architecture
and influence, but also within the broader canvas of the architecture
created by the Benedictines and the secular canons within these isl-
ands.

Intriguing questions yet to be answered are whether there was on
any site a wooden church constructed before the choir and presbytery
of the stone church were completed, whether there were temporary build-
ings on the site for the lay brothers to inhabit before the founding
band of monks came 'to establish their new citadel for Christ' and
whether one should seek an earlier wooden phase for those buildings
beyond the cloister, such as the infirmary, the guest houses and the
barns. So far the answers are both tentative and tantalizing. No
church has yet been found constructed in wood, in contrast to the
growing body of evidence that wooden parish churches were not uncom-
mon in eleventh-century England (briefly summarized by Taylor 1979,
107). The architectural evidence of the west range at Byland sug-
gests that the lay brothers were building their lodging there in
stone from the very first, but this was a community long in gesta-
tion and more interesting evidence might come from Waverley or Furness.
Excavation at Valle Crucis (Butler 1977, 115-6) showed that structural
timbers were being re-used as footing material below the south range
and these point to temporary lodgings elsewhere on the site. Similar
evidence came from Bordesley where timbers were re-used in the night-
stairs before its late twelfth-century replacement in stone (Rahtz
and Hirst 1976). There is possible evidence of a wooden structure
beneath the nave from the current excavations at Fountains (see al-
so Gilyard-Beer 1968, 314). At Kirkstall (Pirie 1967, 36) the found-

ations of a timber hall were found east of the east range. The pur-
pose suggested for this hall was to house the first band of monks;
a similar building would be needed for the lay brothers when they
came from Barnoldswick in 1152 to clear the site ahead of the main
community. However its position more probably indicates an earlier
phase of the infirmary; the structural evidence is that the stone-
walled hall was built in about 1200 and a fifty-year life for the
timber structure is quite probable.

Although the role of Geoffrey of Aigny as the architect emissary
of St Bernard at Fountains and Clairmarais is well known, it is uncer-
tain whether this was sufficiently rare an occurrence to be worthy of
mention in chronicles. Adam, later abbot of Meaux, advised in simi-
lar fashion the planning of three houses in eastern England, but still
more needs to be known about how the Cistercians assembled the neces-
sary expertise in masoncraft to enable them to erect their houses and
particularly their churches. In later centuries abbeys, through their
patrons, could call upon established master masons as happened at Vale
Royal (Thompson 1962) or at Royaumont (Bruzelius 1979, 90-110). The
sketch-book of Villard de Honnecourt shows the format of church and
cathedral plans and vaults, but the mathematical knowledge, the influ-
ence of 'Golden Numbers' or the principle of canonic design is still
a matter of debate. Similarly the units of precise measurement have
not been established, though Esser (1953) and Walsh (1980) have drawn
attention to this problem which has tantalized architectural historians
concerned with the cathedrals of northern France.

Another related question concerns the quarry organization. Some-
times there is clear evidence that an individual house has relied
principally upon the stone available on its own lands; at Fountains,
Furness and Roche the valleys in which the abbeys stand have been
quarried into steeper profiles. Work has yet to be done on the
sources of building stones for each abbey (e.g. Cymmer: Neaverson
1949, 281) and it has yet to be determined whether the rebuilding of
abbey churches in the thirteenth and fourteenth centuries was in part
caused by the need to replace a decaying structure in local stone by
a grander structure in a finer quality stone from a more distant
source. This certainly seems to be the case at Neath (Butler 1976)
where the poor quality Coal Measures sandstones are used in the mid-
twelfth-century west range and the finer quality carboniferous lime-
stone from Sutton on the Glamorgan coast is used for the ashlar fac-
ing of the monastic church, rebuilt by Adam of Carmarthen in the last
quarter of the thirteenth century. Insufficient work has been under-
taken on mortar analysis to assist the more conventional dating by
sculptural or architectural features.

The relative rarity of total rebuilding has been commented upon
by Gilyard-Beer (1958, 49). Total replacement at Tintern was partly
alongside the earlier church and the same succession may be expected
at Neath. Generally there was minor modification in the transept

chapels as is shown at Furness and Bordesley, but it is only at the
latter that excavation (Rahtz and Hirst 1976) has been sufficiently
detailed to show the minutiae of floor replacements or even to indi-
cate the ritual paths evident in the patterns of wear upon the tile
pavements. Similar information may be recoverable from the tile
pavements at Warden (Webster and Cherry 1975, 233) and Meaux (Eames
and Beaulah 1956). The enlargement of the eastern arm, as at Foun-
tains and Rievaulx, has encased beneath its floor an earlier simple
plan and this sequence may be anticipated at Furness and Margam. If
Furness imitated Vaux-de-Cernay (Dickinson 1965, 11) then the earli-
est transepts there would have been apsidal. Comparative examples
are given in Beuer (1957), Dimier (1967) or van der Meer (1965). Crox-
den in 1179 followed its mother-house of Aunay (Baillie-Reynolds 1964)
with a full chevet; this illustrates well the conflict between two of
the *differentiae* (Knowles 1963, 197), those of regional architectural
design and of the influence of filiation. The third difference in
plan and appearance was the social motive, adapting features in the
plan for greater comfort or convenience within the community; some
examples are considered later. In Benedictine houses in England
there was a general replacement of apses in the thirteenth century
either because of difficulties in roof and vault maintenance or be-
cause of fashionable dictates for an enlarged east window, an attach-
ed altar and a permanent piscina.

The monasteries of late foundation sometimes adopt a plan of ra-
diating chapels in chevet around the eastern arm, but detailed work
at Hailes and Vale Royal has revealed a simpler apsidal termination
preceding the full-fledged ring of chapels. At Vale Royal (Thomp-
son 1962) where it was anticipated that the employment of royal ma-
sons might have influenced the design, some practical details were
found concerning the surveying and setting out of the new work of
the mid-fourteenth century. Although such plans need to be seen in
the European Cistercian context, they should not be divorced from
parallel developments within the English Gothic.

Abbeys of new foundation were affected just as much as the early
twelfth-century pioneers with the contraction in choir numbers and
the loss of lay brothers in the later middle ages. The details of the
consequent modifications in ritual can only be traced by excavations
conducted to the highest standards. Even then the finer details may
be lost through severe disturbance caused by post-Dissolution stone-
robbing or by Victorian treasure-hunting such as to acquire decorated
floor tiles to enrich country gentlemen's cabinets of curiosities;
the Rutland collection in the British Museum was assembled from such
cabinets. The architectural purist tends to concentrate upon the
initial concept of the church and to ignore the minor sub-divisions
made to the structure when the community was in decline and its mor-
al fiber weakened. The archeologist cannot see the vault, except
where an ornate foliage boss has crashed through the pavement. How-

ever he can see the disheartening modifications; these are the par-
titioning of the empty transepts as at Valle Crucis and Rushen, the
shortening of the nave, as has been argued for Sawley (Kitson 1909)
and the blocking of the aisles, as at Strata Florida (Smith and Thom-
as 1977). Instances of this contraction in other monastic orders has
been discussed by architectural historians, though in some cases due
to pilgrim revenue a frenetic rebuilding and adornment took place in
the sixteenth century even as the storm-clouds of the Dissolution
gathered on the horizon.

Excavation has also clarified the last acts in the abbey's life:
the hearths where the roof and window lead was melted down into read-
ily transportable pigs, the crucibles where the bronze taps and fin-
ials were rendered shapeless, the bonfires where the unsaleable tim-
ber laths and shingles were burned and the scrap heap where the glass
was thrown before being collected as cullet. Such evidence may occur
in the transept as at Rushen, in the churchyard as at Llanthony or in
the guesthouse as at Kirkstall. Other examples visible in the fabric
have been noted (Gilyard-Beer 1958, 50).

The problems of the cloister and its ranges have seldom claimed
as much attention as those of the church. However quite drastic
changes in cloister size could occur, as at Furness and at the Clu-
niac Faversham, with repercussions upon one or more surrounding rang-
es. The main questions posed in the cloister alleys are the transi-
tion from a wooden cloister arcade to a stone one, when the 'lane'
was abandoned and what was the route of the water supply. It has been
possible to recover details of an early arcade at Newminster and evi-
dence of tracery of high quality in the fourteenth century arcade at
Bordesley (Walsh 1979), but it is not yet possible to say whether the
monks of Fountains replaced a wooden arcade by a stone one. Details
of water supply have been recovered in various houses, such as the
conduit at Kirkstall, the minor drains at Valle Crucis and the lead
piping from Tintern. Unfortunately no English Cistercian house pos-
sesses a water supply drawing such as survive from Canterbury Cathe-
dral Priory and the London Charterhouse. A well-directed program of
geophysical survey would enable the entire drainage system to be re-
covered; this is now being undertaken at Kirkstall and is under con-
sideration for the Gilbertine houses in eastern England.

Although each of the three cloister ranges prompts problems of
initial planning and subsequent alteration for comfort or demolition,
it is the south range that has attracted the most attention from ar-
cheologists because here are found, near the refectory and kitchen,
the fullest evidence of pottery and animal bone. The excavations at
Kirkstall (Owen 1955; Mitchell 1961; Pirie 1967) and Valle Crucis
(Butler 1977) have shown how satisfactorily this evidence from all
periods may be exploited. The appearance of specialist items, such
as the pottery ink stand at Byland (Dunning 1961), the bone dip-pen
and the ivory stylus at Bordesley and the slate writing tablets from

Strata Florida, is to be set alongside the altar cruets and the
pottery urinals. The latter may have collected an ingredient for
use in alchemy and monastic participation in this science is indi-
cated by the glassware from the Cluniac priory of Pontefract and the
the Augustinian house of Selborne as well as pottery from Byland,
Kirkstall and Hailes (Moorhouse 1972). The concealed coins in the
west range at Neath and in the main drain at the Augustinian Mucka-
more suggests that the vow of poverty might be loosely interpreted.

The evidence for diet which comes from animal, fowl and fish
bone may be supplemented under favourable circumstances by evidence
of seeds from waterlogged deposits. The bone from Kirkstall (Ryder
1961) and from Valle Crucis (Barker 1977) has been subjected to de-
tailed scrutiny to supplement the general surveys (Trow Smith 1957;
Chaplin 1971; Hughes et al 1973). The effects of that diet upon
the inmates has not yet been correlated from the skeletal material
in the monastic cemeteries of the order in Britain. Sometimes ex-
cavators have noted unusual features such as secular gravegoods at
Rushen or the ritual of placing branches over the corpses at Bordes-
ley (though at Lund this practice was interpreted as an attempt to
prevent the dead from walking among the living by spelling the runic
symbols in hazel twigs).

Another area where archeological work has been profitably under-
taken has been the outer precinct. There the buildings received
less architectural embellishment, were more frequently replaced and
were seldom incorporated into post-Dissolution mansions. In those
abbeys now in state care (Byland, Fountains, Furness, Rievaulx, Tin-
tern) excavation has been initiated to ascertain the lay-out of
buildings such as the meat kitchen, the guest-houses, the brewhouse,
the mill and the forge. At Kirkstall recent excavation has preced-
ed urgent conservation work on the guest house, while at Garendon
excavation followed the demolition of the mansion built out of the
abbey ruins. At the major abbeys, excavation has been linked to site
consolidation and visitor interpretation centers, usually displaying
the ruined walling at the latest surviving monastic building, often
removing any evidence of post-medieval re-use whether industrial as
at Neath or 'romantic' as at Hailes.

Concern with the industrial exploitation of the monastic pre-
cinct, allied to the skilful interpretation of air photographs, has
enabled a wide range of water management to be identified by field
work. These have included fisheries, mill-ponds and forge-hammer
ponds at Bordesley (Aston 1972), Byland (McDonnell and Everest 1965)
and Rievaulx (Weatherill 1954). 'Our knowledge of monasteries as
economic units rather than architectural masterpieces could be con-
siderably increased with detailed surveys of precinct areas, identi-
fying features indicating water-control and utilisation, tracing
boundary banks or walls of precincts and locating outlying buildings'
(Aston 1972, 136). Since then details of the precinct boundary and

the lesser gatehouse have been excavated at Stratford Langthorne and Robertsbridge respectively, but the major excavation of such complexes has been at the Augustinian house of Thornholme by G. Coppack and at the Templar preceptory of South Witham by P. Mayes.

Further from the monastic precinct research has paid attention to the monastic tile kiln with the excavation of North Grange, Meaux (Eames 1961) and to the importance of monasteries as customers at the commercial tile kilns, such as Danbury, Nuneaton and Penn. Fieldwork and limited excavation has taken place at the predominantly a-grarian granges (Platt 1969) and surveys have been made of settlements deserted as a result of the Cistercians' aggressive desire for isolation (Barley 1957; Beresford and Hurst 1971, 4-6; Donkin 1978).

Such surveys look beyond the immediate precinct of the monastery but this work does highlight two broad questions which have yet to be satisfactorily answered. The first concerns the primary state of the landscape before the monastery was founded: what type of cultivation (if any) was practised, what habitat did the monks find, and how did they change or tame their environment. On the larger scale this can be illustrated by the pollen analysis from the bogs near Strata Florida (Turner 1964, 81-4) and the woodland at Dieulacres (Tinsley 1976); on the smaller scale it might be illustrated from the soil layers buried beneath boundary banks, fish-pond upcast and artificial terracing thrown up to secure level ground for church or cloister ranges.

The second major deficiency is the lack of any excavation at a site of an early monastery which experienced a site transfer after economic or political difficulties had made life intolerable. Although sixteen houses in England and Wales transferred after less than ten years stay (perhaps housed in temporary buildings as at Fountains), there are a further seven which moved after more than thirty years at the initial site; at none of these has any significant excavation taken place to discover what permanent structures were erected. Although these abbeys occasionally reverted to life a as a grange, they do offer the prospect of sites whose terminal dates as a monastery are well chronicled. The information gained from them would provide valuable evidence to date developments of uncertain periods elsewhere. They might throw light on the forms of the early chapter houses before enlargement became necessary or fashionable; they might illumine the problem of the re-siting of the day stairs or upon the re-alignment of the refectory at right-angles to the cloister.

In conclusion the archeological investigation of the buried remains has yielded considerable new evidence in the past twenty years. Where the highest standards of excavation and publication prevail, then work in this country can bear comparison with the best in Germany, Denmark and Ireland. However, there is still a grey area of amateur effort where it is desirable for professional assistance

in interpretation and publication to be sought. Also in the case of state-sponsored work, publication of the excavation results solely in the form of a Guide, where the architectural and archeological evidence is not presented in full, must be deplored. An example is Hailes where there is little continuity in the conduct of the work. Far better is the publication by Dickinson (1967) to set alongside his Guide (1965) or that by Saunders (1978) of St Augustine's, Canterbury.

There is far less opportunity in England for pioneer architectural studies of the type excellently shown by Bruzelius (1979) at Longport, Kinder (1976) at Maubuisson or Krönig (1973) at Altenburg. There has been some re-appraisal of the late twelfth-century Cistercian architecture by Fergusson (1970, 1971, 1973), though some of his observations at both Roche (Parsons 1974) and Dundrennan need correction. Probably the way forward lies in the study of specific structures such as multi-sided chapterhouses, as at Dore, Garendon and Margam (and the Furness kitchen), or in the development of the refectory and its pulpit. One example of this approach has discussed cloister lavatories as free-standing structures (Godfrey 1952). Similarly the design history of those churches with radiating chevet chapels (Croxden, Beaulieu, Hailes, Vale Royal) has yet to be studied as developments in their own right in the context of English Gothic rather than as a pale imitation of French Cistercian inventiveness. The Dissolution of the Monasteries cut short any hopes of grandiose rebuilding as occurred in the Catholic provinces of Europe. Instead of a destructive refashioning in the Baroque of St Paul's Cathedral in London or in the papery 'Gothick' of Dunfermline Abbey, there are only four challenging centuries of architectural development readily available for study in 'the bare ruined choirs' and the silent parlors.

University of Leeds
Leeds, England

BIBLIOGRAPHY

Aston 1972 M. Aston, 'The Earthworks of Bordesley Abbey,
 Redditch, Worcs,' *Medieval Archaeology* 16
 (1972) 133-6.

Baillie-Reynolds 1964 P. K. Baillie-Reynolds, 'Croxden Abbey,' *Ar-
 chaeological Journal* 120 (1964) 278.

Barker 1977 G. W. Barker, 'Diet and Economy at Valle
 Crucis: The Report on the Animal Bones,'
 Archaeologia Cambrensis 125 (1977) 117-26.

Barley 1957 M. W. Barley, 'Cistercian Land Clearances in
 Nottinghamshire: Three Deserted Villages and
 Their Moated Successor,' *Nottingham Medieval
 Studies* 1 (1957) 75-89.

Beresford and Hurst 1971 M. W. Beresford and J. G. Hurst, *Deserted
 Medieval Villages* (London: 1971)

Beuer 1957 H. V. Beuer, 'Evolution du plan des églises cis-
 terciennes,' *Citeaux in de Nederlanden* 8 (1957)
 269-89.

Bruzelius 1979 C. A. Bruzelius, 'Cistercian High Gothic: The
 Abbey Church of Longpont and the Architecture
 of the Cistercians of the Early Thirteenth
 Century,' *Analecta Cisterciensia* 35 (1979)
 3-204.

Butler 1964 L. A. S. Butler, 'An Excavation in the Vicar-
 age Garden, Conway, 1961,' *Archaeologia Cam-
 brensis* 113 (1964) 97-128.

Butler 1976 L. A. S. Butler, *Neath Abbey* (London: 1976).

Butler and Evans 1980 L. A. S. Butler and D. H. Evans, 'The Cistercian
 Abbey of Aberconway at Maenan, Gwynedd: Excavation
 in 1968' *Archaeologia Cambrensis* 129 (1980), 37-63

Butler 1977 L. A. S. Butler, 'Valle Crucis Abbey: An Ex-
 cavation in 1970,' *Archaeologia Cambrensis*
 125 (1977) 80-116.

Butler 1978 L. A. S. Butler, *Rushen Abbey* (Douglas: 1978).

Chaplin 1971 R. E. Chaplin, *The Study of Animal Bones from
 Archaeological Sites* (London: 1971).

Coad 1969 J. G. Coad, *Hailes Abbey* (London: 1969).

de Paor 1969 L. de Paor, 'Excavations at Mellifont Abbey,
 Co. Louth,' *Proceedings of Royal Irish Academy*
 68C, No. 2 (1969) 109-64.

Dickinson 1965 J. C. Dickinson, *Furness Abbey* (London: 1965).

Dickinson 1967 J. C. Dickinson, 'Furness Abbey--An Archaeologi-
 cal Reconsideration,' *Transactions of Cumberland
 and Westmoreland Archaeological Society* 67 (1967)
 51-80.

Dimier 1966 A. Dimier, 'Eglises cisterciennes sur plan
 bernardin et sur plan benedictin,' in P.
 Gaillais et Y.-J. Riou, *Mélanges offerts à
 René Crozet* (Poitiers: 1966) 2:697-704.

Dimier 1967 M.-A. Dimier, *Receuil de plans d'églises
 cisterciennes* (Paris: 1967), Supplement,
 2 volumes.

Dimier 1974 M.-A. Dimier, *L'Art cistercien* (La Pierre-
 qui-Vire: 1974), 2nd ed.

Donkin 1978 R. A. Donkin, *The Cistercians: Studies in the
 Geography of Medieval England and Wales*
 (Toronto, 1978).

Dunning 1961 G. C. Dunning, 'A Medieval Pottery Inkstand
 from Byland Abbey,' *Medieval Archaeology* 5
 (1961) 307.

Eames 1961 E. S. Eames, 'A Thirteenth-century Tile Kiln
 Site at North Grange, Meaux, Beverley, Yorks,'
 Medieval Archaeology 5 (1961) 137-68.

Eames and Beaulah 1956 E. S. Eames and G. K. Beaulah, 'The Thir-
 teenth-century Tile Mosaic Pavements in the
 Yorkshire Cistercian Houses,' *Cîteaux in de
 Nederlanden* 7 (1956) 264-77.

Esser 1952 K. H. Esser, 'Die Ausgrabungen der romanischen
 Zistersienserkirche Himmerod,' *Das Munster*
 5 (1952) 221-3.

Esser 1953 K. H. Esser, 'Uber den Kirchenbau des Hl.
 Bernard von Clairvaux. Eine kunstwissenschaft-
 liche Untersuchen aufgrund der Ausgrabung der
 romanischen Abteikirche Himmerod,' *Arckiv fur
 Mittelrheinische Kirchengeschichte* 5 (1953)
 195-222.

Esser 1954 K. H. Esser, 'Les Fouilles à Himmerod et le
 plan bernardin,' *Mélanges à St Bernard* (Dijon:
 1954).

Eydoux 1953 H. P. Eydoux, 'Les Fouilles de l'abbatiale
 d'Himmerod et la notion d'un plan bernardin,'
 Bulletin monumental 111 (1953) 29-36.

Fergusson 1970 P. J. Fergusson, 'Early Cistercian Churches
 in Yorkshire and the Problem of the Cistercian
 Crossing Tower,' *Journal of the Society of
 Architectural Historians* 29 (1970) 211-21.

Fergusson 1971 P. J. Fergusson, 'Roche Abbey: the Source and
 Date of the Eastern Remains,' *Journal of the
 British Archaeological Association* 34 (1971)
 30-42.

Fergusson 1973 P. Fergusson, 'The Late Twelfth-Century Re-
 building at Dundrennan Abbey,' *Antiquaries
 Journal* 53 (1973) 232-43.

Gilyard-Beer 1958 R. Gilyard-Beer, *Abbeys* (London: 1958).

Gilyard-Beer 1965 R. Gilyard-Beer, 'Rufford Abbey, Nottingham-shire,' *Medieval Archaeology* 9 (1965) 161-3.

Gilyard-Beer 1968 R. Gilyard-Beer, 'Fountains Abbey: the Early Buildings 1132-50,' *Archaeological Journal* 125 (1968) 313-9.

Gilyard-Beer 1970 R. Gilyard-Beer, *Fountains Abbey* (London: 1970).

Godfrey 1952 W. H. Godfrey, 'English Cloister Lavatories as Independent Structures,' *Archaeological Journal* 106 (1952) Supplement, 91-7.

Hahn 1957 H. Hahn, *Die Fruhe Kirchenbaukunst der Zister-zienser* (Berlin: 1957).

Harbottle and Salway 1964 B. Harbottle and P. Salway,''Excavations at Newminster Abbey, Northumberland, 1961-63,' *Archaeologia Aeliana* 42 (1964) 85-171.

Hughes et al 1973 R. E. Hughes, J. Dale, L. Ellis-Williams and D. I. Rees, 'Studies in Sheep Population and Environment in the Mountains of North-West Wales,' *Journal of Applied Ecology* 10 (1973) 113-32, esp. 113-9.

Kinder 1976 T. N. Kinder, 'Blanche of Castile and the Cis-tercians: an Architectural Re-evaluation of Maubuisson Abbey,' *Cîteaux in de Nederlanden* 27 (1976) 161-88.

Kitson 1909 S. D. Kitson, 'Salley Abbey,' *Yorkshire Ar-chaeological Journal* 20 pt. 4, 454-60.

Knight 1977 J. K. Knight, *Tintern Abbey and the Romantic Movement* (London: 1977).

Knowles 1963 D. Knowles, 'The Monastic Buildings of England,' *The Historian and Character, and Other Essays* (Cambridge: 1963) 179-212.

Knowles and St. Joseph 1952 D. Knowles and J. K. S. St. Joseph, *Monastic Sites from the Air* (Cambridge: 1952).

Krönig 1973 W. Krönig, *Altenburg und die Baukunst der Zisterzienser* (Altenburg: 1973).

McDonnell and Everest 1965 J. McDonnell and M. R. Everest, 'The "Waterworks" of Byland Abbey,' *The Ryedale Historian* 1 (1965) 32-40.

Mitchell 1961 C. M. Mitchell (ed.), *Kirkstall Abbey Excava-tions 1955-1959*, Thoresby Society Publications 48 (1961).

Moorhouse 1972 S. Moorhouse, 'Medieval Distilling Apparatus of Glass and Pottery,' *Medieval Archaeology* 16 (1972) 79-121.

Neaverson 1949 E. Neaverson, 'The Building Stones of Harlech Castle and Cymmer Abbey,' *Archaeologia Cam-brensis* 100 (1949) 280-1.

Owen 1955 D. E. Owen (ed.), *Kirkstall Abbey Excavations 1950-1954*, Thoresby Society Publications 43 (1955).

Parsons 1974 D. Parsons, 'A Note on the East End of Roche Abbey Church,' *Journal of British Archaeological Association* 37 (1974) 123.

Pirie 1967 E. J. E. Pirie (ed.), *Kirkstall Abbey Excavations 1960-1964*, Thoresby Society Publications 51 (1967).

Platt 1969 C. P. S. Platt, *The Monastic Grange in Medieval England* (London: 1969).

Radford 1936 C. A. R. Radford, *Strata Florida Abbey* (London: 1936).

Radford 1953 C. A. R. Radford, *Valle Crucis Abbey* (London: 1953).

Rahtz and Hirst 1976 P. A. Rahtz and S. Hirst, *Bordesley Abbey, Redditch: Excavations 1969-73*, British Archaeological Reports 23 (Oxford: 1976).

Ryder 1961 M. L. Ryder, 'Report on the Animal Remains' in Mitchell 1961 (see above), 41-54, 67-77, 98-100, 130-2.

Saunders 1978 A. D. Saunders, 'Excavations in the Church of St Augustine's Abbey, Canterbury 1955-1958,' *Medieval Archaeology* 22 (1978) 25-63.

Smith and Butler, forthcoming J. Beverley Smith and L. A. S. Butler, *Valle Crucis Abbey* (London).

Smith and Thomas 1977 J. Beverley Smith and W. G. Thomas, *Strata Florida Abbey* (London: 1977).

Stalley 1975 R. Stalley, 'Mellifont Abbey: Some Observations on Its Architectural History,' *Studies* (Dublin) 64 (1975) 347-67.

Taylor 1979 H. M. Taylor in H. Christie, O. Olsen and H. M. Taylor, 'The Wooden Church of St Andrew at Greensted, Essex,' *Antiquaries Journal* 59 (1979) 92-112.

Tester 1974 P. J. Tester, 'Excavations at Boxley Abbey,' *Archaeologia Cantiana* 88 (1974) 129-58.

Thompson 1962 F. H. Thompson, 'Excavations at the Cistercian Abbey of Vale Royal, Cheshire, 1958,' *Antiquaries Journal* 42 (1962) 183-207.

Tinsley 1976 H. M. Tinsley, 'Monastic Woodland Clearance on the Dieulacres Estate,' *North Staffordshire Journal of Field Studies* 16 (1976) 16-22.

Trow-Smith 1957 R. Trow-Smith, *A History of British Livestock Husbandry to 1700* (London: 1957).

Turner 1964 J. Turner, 'The Anthropogenic Factor in Vegetational History: 1, Tregaron and Wixall Mosses,' *The New Phytologist* 63 (1964) 73-90.

Van der Meer 1965 F. Van der Meer, *Atlas de l'ordre cistercien* (Paris-Brussels: 1965).

Walsh 1979 D. A. Walsh, 'A Rebuilt Cloister at Bordesley Abbey,' *Journal of the British Archaeological Association* 132 (1979) 42-9.

Walsh 1980 D. A. Walsh, 'Measurement and Proportion at Bordesley Abbey,' *Gesta* 19 pt. 2 (1980) 109-13.

Weatherill 1954 J. Weatherill, 'Rievaulx Abbey,' *Yorkshire Archaeological Journal* 38 (1954) 333-54.

Webster and Cherry 1975 L. Webster and J. Cherry, 'Medieval Britain in 1974,' *Medieval Archaeology* 19 (1975) 220-60, esp. 233 and Pl. XVII.

Lawrence Butler's work on the excavations of Rushen Abbey was presented at the Eleventh Conference on Cistercian Studies, Kalamazoo, 1981.

THE CHANGING FORM OF THE CHOIR AT THE
CISTERCIAN ABBEY OF ST MARY, BORDESLEY

David A. Walsh

At Bordesley Abbey (Worcestershire) an extensive excavation of a Cistercian monastic complex in the English West Midlands is being undertaken by the Universities of York and Reading in England and the University of Rochester, New York. Bordesley was almost certainly founded in 1138, and the community had a varied history of building and decay until its final surrender in 1538 during the Dissolution of the monasteries under Henry VIII.[1] Much of the archeological investigation of the past twelve years has centered on the church; the presbytery, choir, and the south arm of the transept have been completely excavated, and a second major report is forthcoming.[2] The remains of this structure may seem scant to the architectural historian since only the foundations and the lower walls, to slightly over two meters maximum height, are still standing. Yet these stubs of walls convey substantial information about the construction and building modification throughout the abbey's history. Indeed, central to the following account, the floors of the eastern portion of the church with over a meter of stratification present a continuous record of a variety of monastic activities within these walls.

The focus of this paper is the monastic choir at Bordesley. The site, with its deep stratification, allows us to study the changes in the choir during nearly 400 years of use: changes in architectural design, in floor surfaces and church furniture. More important, we can understand the interrelation of floors and walls so that the changing arrangement of choir stalls, for instance, can be related to the changing aspect of the walls that surround them. Thus, a vivid picture is emerging of the most liturgically and architecturally significant part of the monastery.

The conclusions of this study will be tentative, for the portions of the choir to the west and some ancillary areas of the church have not been excavated, and the investigation of comparable material from sites elsewhere has just begun. The richness of the archeological remains and, in particular, the chronological sequence of the choir elements make it possible to establish the basic pattern of change here. From an archeological standpoint, I hope this account will show that more can be seen and understood if a site area is excavated and studied as a whole rather than by a selective examination through traditional trenching. For art historians, I wish to demonstrate the value of recovery and careful examination of ephemeral features, which in so many cases are directly related to the form of the standing masonry.

Though the unusually deep stratification has preserved most features, not all of the choir area of Bordesley has escaped post-medieval disturbance. Stone robbing did not cease with the initial destruction of the walls at the Dissolution; robbing pits of succeeding centuries and, indeed, local tradition, support the notion that Bordesley's remains continued to be exploited into this century. The first clearly documented excavation by James Woodward in 1864 did not impinge seriously on the area of the choir, though the N.E. pier of the crossing was excavated from within and without in a futile attempt to find a foundation document. On Woodward's plan of the church (Fig. 1), a section of tiled pavement is indicated in the crossing as well as a set of choir stalls extending from the western crossing piers eastward to the middle of the presbytery.[3] There is no archeological evidence for the existence of stalls in this position and we must assume that these were conjectural additions to his plan.

The first phase of construction of the abbey church probably took place in the 1150s and is designated here as Period 1. Comparison of the plan and architectural articulation suggests that the work is approximately contemporary with the first period of construction at Kirkstall Abbey, though Bordesley does not derive from the Yorkshire group of Cistercian churches. The plan is of the 'Bernardine' type with a square-ended aisleless presbytery and a transept with three eastern chapels on each arm.[4]

The choir and crossing (taken together in this study) have had a most complicated structural history. The extensive series of transformations and modifications found here relate to a number of factors: changes of monastic population, liturgical requirements, and architectural styles, along with repairs and rebuilding necessitated by recurring structural failure.

The elements of this area exposed by present excavation are the crossing piers and the first piers of the nave arcade to the west and, of course, the floor levels of the eastern portion of the choir between these architectural members (Fig. 2). The crossing configuration of the first phase of construction can be determined with some precision (Fig. 3). While no single pier has escaped rebuilding, the whole of the S. E. unit remains, encased only on its western face by part of the later construction narrowing the entrance from the crossing into the south arm of the transept. The form of the pier shows that the designer wished to mark the transitions between the crossing and presbytery and from the crossing into the arms of the transept very strongly. On the side of this pier facing its analogue to the north, a central rectangular element flanked by two semicircular engaged shafts projects out from the presbytery wall (Fig. 4). Only fragments of the S. W. pier remain, embedded in many rebuildings. On its eastern side, a double-shafted face corresponding to the articulation of the west face of the S. E. pier can be assumed. Its northern face--that is, facing the choir--was certainly plain and unarticulated and is close in this

respect to the analogous pier at Kirkstall.[5] The west face seems to
have been flat as well. We cannot be sure of the foundations of the
western piers, tampered with in rebuilding; but the eastern pair,
with heavy north and south responds, have strong footings consisting
of cobble rafts with roughly cut but well joined slabs above suggest-
ing that the builders anticipated the kind of overburden that a stone
tower above would provide.[6]

We can imagine, then, the crossing at Bordesley was probably
marked on the upper level by a western crossing arch thrown across
the western piers and springing from corbels. For the eastern pair
there was likely to have been a similar arch whose responds extend
to the floor, resting on massive bases. On the lower level, the
transition between presbytery and crossing/choir is strongest, dif-
fering in this respect from Buildwas and the early schemes at Rie-
vaulx and Fountains, but like Kirkstall and Louth Park.[7] The first
pair of piers of the nave arcade match the western crossing piers in
their plain surfaces facing the crossing and across the choir. Their
western faces, however, have great semicircular responds which could
represent a transition to round piers to the west in the nave.[8]

The crossing/choir established in the first building had a dirt
floor corresponding to the ground surface in the south arm of the
transept.[9] No trace of footings for choir stalls was found, indicat-
ing that either no such structures existed or that the stalls were of
a temporary or movable nature.

The next phase of building, designated Period 2 and dating from
c. 1200 (Fig. 5),[10] transformed the choir area profoundly, for we see
here the first major provision for a substantial set of choir stalls
extending west from the crossing area probably through the second
nave arcade. These stalls can be traced in the pits, hollows, and
grooves in the floor surface, which was at this time tiled.[11] Back-
ings for the stalls were provided in the blocking walls (of undeter-
mined height) of the first two bays of the arcade west of the cross-
ing (Fig. 11). These blockings are composed of reddish sandstone ash-
lar; the blocks are larger and much more roughly dressed than the Per-
iod 1 masonry and, in light of the fine quality of Period 2 work else-
where, it must be assumed that the surfaces were not finished because
they were hidden behind the stalls. Period 2 is an important building
phase beyond the choir and includes new buttressing of the corners of
the east exterior of the presbytery, a new night stair replacing an
earlier wooden one in the south arm of the transept, and reworked
jambs narrowing the entrances to the south and north aisles from the
transept.

The next major program of building, Period 3A, involves the re-
construction of the north and east faces of the S. W. crossing pier
and, probably, the total replacement of the N. W. pier (fig. 6). The
eastern and northern sides of the S. W. pier are reworked, and these
faces correspond roughly in position and articulation to the form of

the Period 1 predecessor; its choir face is again plain and its
eastern face has a central rectangular element with flanking shafts.
The corners of the rectangular section are now chamfered and the
shaft bases are also modernized with base moldings whose profiles
suggest a date in the second half of the thirteenth century.[12] The
work may represent a rebuilding necessitated by structural failure,
perhaps caused by subsidence of soil beneath, since the new work
corresponds in size and position with what is replaced and varies
only slightly in detail. Structural problems are indicated by much
evidence elsewhere; the new N. W. crossing pier (Period 3A) was re-
placed later as we shall see, and there is other buttressing and
strengthening both before and after this period.[13]

 With the new piers comes the most extensive array of choir
stalls ever, extending nearly as far east as the eastern crossing
piers and west into the unrecorded area of the nave. The depth of
these stalls is over 2.5 meters, indicating that they must have been
of two tiers and probably backed against the western piers and block-
ing walls. The innermost rows of seats facing each other across the
choir rest on shallow timber foundations which run lengthwise.[14] The
back of the stalls evidently rested on red sandstone pads, some of
which have survived on the eastern ends. We may actually have a rem-
nant of a stall end from this phase (Fig. 7), made of oak and 1.01
meters in extant height with a sloping setting for a movable seat
on one side. This perfectly preserved piece was found below ground-
water in the construction trench for a new N. W. pier, rebuilt in
the second quarter of the fourteenth century.[15]

 Around 1300, the entrance to the south arm of the transept from
the crossing was modified (Period 3B). The west face of the S. E.
crossing pier was extended 1.2 meters and a corresponding but greater
extension of 2.3 meters was made from the east face of the S. W. pier
(Fig. 8). This new work, with multishafted splaying and elegantly
moulded bases, effectively narrows the entrance between transept and
choir.[16] Though the height of the entrance cannot be determined,
the overall result was to increase the expanse of wall from the east-
ern crossing pier westward, backing the choir stalls and curtailing
the flow of space between transept and aisle and the choir. It is
uncertain what the configuration of the choir stalls was at this re-
building which was mainly limited to the south side of the crossing.

 Sometime in the first few decades of the fourteenth century
there evidently was structural failure in the choir area with the
collapse of one or more of the crossing piers. A large section of
Period 3B masonry from the N. W. pier is embedded into the choir
floor just to the south of the original pier location (Fig. 9). That
this piece of still articulated masonry fell from considerable height
is clearly seen in the present depth of the lower edge of the fallen
mass; floor material and even a piece of choir stall were driven into
the subsoil below even the earliest floor levels. The depth of pene-

tration and the wholeness of the piece of pier indicate that the
ground into which it fell was not solid; surely it was, in fact,
the 'mushy' condition of the ground beneath that led to the col-
lapse.[17]

This disaster heralded another building period in the choir
area. A huge excavation pit was then dug on the site of the N. W.
pier and a massive plinth made up of courses of reused ashlar was
built as a foundation of the new work.[18] The fragment of the 3A pier
remained where it fell, the top being dismantled to the level of
the floor. The new construction of Period 3C resulted in the most
radical change in the configuration of the crossing/choir area. The
remodeled N. W. pier joins the Period 2 blocking on the west; but
on the east and south faces new triple-shafted responds on polygon-
al bases project boldly, reestablishing the importance of the en-
trance into the north transept arm and, more importantly, defining
a new relation between crossing and choir spaces, now distinct areas
(Figs. 8, 10). The analogues for the responds of the N. W. pier on
the south side of the choir introduce a bold articulation of bay
division into what has been an expanse of wall, including the flat
north face of the S. W. pier and its extension east as well as the
Period 2 blocking wall. The new addition to the S. W. pier is plac-
ed on a footing of reused material which is rather shallow compared
with the footing of the N. W. pier, this area presumably having been
structurally stable for some time. All of this work may date as
early as c. 1330.[19]

Though the configuration of the preceeding 3B choir stalls is
uncertain, those of 3C represent a positional change from all previ-
ous phases that can be traced. The shift is clearly related to the
architectural modification of the western crossing piers, and the
footings of the stalls are of a different construction and type than
we have seen before (Fig. 11). Now the stalls are set hard against
the blocking walls and begin immediately to the west of the new triple-
shafted responds of the western crossing piers. Their footings are
entirely of stone, perhaps as a measure of protection against the
moisture of the floor, and have the effect of a low supporting wall
of one course rising just above the floor. Projecting pads on the
short eastern ends and along the long inner sides may have been for
buttressing the wooden superstructure. These new stalls are two
meters deep, certainly indicating that the stalls continued to be
double tiered. The floor of this period was tiled; three wide 'aisles'
of diagonally set tiles ran the length of the choir and crossing.[20]
The floor surface of the crossing area clearly now became an open
space. Perhaps not very much later the whole N. E. crossing pier was
replaced.[21]

This basic stall configuration was retained until the Dissolu-
tion. The footings for the stalls in Periods 4B and 4C (probably fif-
teenth and early sixteenth century) rest upon those established in 3C.

Additional courses of stone were laid atop the earlier footings as
the floor level rose. Those of the latest phase, 4C, incorporated
numerous fragments of vaulting masonry, including rib sections and
a large roof boss decorated with intertwined vine leaves probably of
the later fourteenth century. The reuse of such material indicates
that vaulting in some major area of the complex had fallen by this
time. In Period 4C, the entrances of the two southernmost chapels,
the door on the south wall of the south arm of the transept, along
with cupboards and aumbries, were all blocked, indicating a cessation
of many if not all liturgical activities in the transept. While the
transept seems to be going out of use at this period, the last choir
stall phase of the choir is accompanied by a final refurbishing, in-
cluding a new tile floor in that area, probably not long before the
Dissolution in 1538.

 At Bordesley, perhaps the most important change in the choir
was the shifting of stalls from the crossing area. It would be easy
to see this as primarily related to decreasing numbers of choir monks
in the fourteenth century and the few relevant documents preserved
indicate that there was a fall of population by this time. A visi-
tation of 1332, no doubt very near the time of the rebuilding of Per-
iod 3C, indicates that the abbey had thirty-four monks, a novice,
eight lay brothers, and seventeen serving men,[22] probably consider-
ably less than the numbers in the preceeding century.[23] In his brief
consideration of the choir stalls in French Cistercian architecture,
Aubert indicates that, in the earliest period of the Order and ex-
tending into the thirteenth century, the easternmost stalls could be
positioned in all or nearly all of the crossing bay, a situation
necessitated by large numbers of lay brothers who occupied the west-
ern portions of the church. Later, stalls could start from the west-
ern crossing piers as the lay brother population decreased. Aubert
also suggests that the shift liberated the transept space for the
ringing of bells and the development of ceremonies.[24] This 'western
movement' which frees the crossing seems to fit the Bordesley pattern
well.

 It is difficult to obtain reliable information about ephemeral
features such as stalls, particularly from sites which are unexcavat-
ed or were subject to early and/or poor archeological investigation.
But even an uncritical examination of plans including stalls from the
corpus assembled by Dimier shows that stalls starting to the west of
the crossing are as frequently found as stalls starting within the
crossing. There are numerous examples of those in the latter loca-
tion not only in the thirteenth century but in later times as well,
thus seeming to belie Aubert's suggested pattern.[25] At Bordesley,
we have seen that Period 3C was a time of considerable rebuilding in
the choir, necessitated, no doubt, by the collapse of part or nearly
all of the crossing supports. But even if stimulated by the need
for rebuilding, the changes can be seen as part of a pattern estab-

lished earlier at Bordesley since there are efforts to wall off the
choir from the transept and aisle spaces during Periods 2 and 3B.

Shifting functions of neighboring areas of the church may also
be related. The south arm of the transept began to have an important
function as a place of burial starting with a few graves in the cen-
tral chapel which were joined by a few more in Period 3 and many more
in Period 4, the later graves clustering about the entrance to the
chapel. At the same time burials are found in the presbytery and,
indeed, an important interment, marked out by tiles, is introduced
into the eastern part of the crossing along the central axis of the
church, being cut into the dirt floor of Period 4B.

The changes of Period 3C have considerable architectural signi-
ficance for, as we have seen, the crossing space was cleared and re-
defined. Architecturally the cleared crossing space at Bordesley
follows somewhat belatedly a tendency begun, as Fergusson has shown,
in English Cistercian architecture of the second half of the twelfth
century to accentuate the crossing externally with a tower and intern-
ally with the necessary substantial crossing piers.[26] The general
preference for accentuated crossings is common enough in new Cister-
cian building of the succeeding centuries such as at Tintern, Hailes,
Vale Royal, and the rebuilt Melrose.[27]

We have seen that the changes in the choir at Bordesley Abbey
are complex and that many factors are involved in the rebuildings and
transformations. The amount of archaeological evidence at Bordesley
is unusual and we may ask to what degree this community's architecture
is typical in its changing forms. Conditions of preservation and lack
of archeological understanding of the record in other buildings have
made finding parallels difficult. At this point, however, some general
trends which relate to the picture elsewhere do emerge. More important,
we can formulate questions to ask when examining liturgical and archi-
tectural evidence of other Cistercian sites and documents.

University of Rochester
Rochester, New York

NOTES

1. *Victoria County History of the County of Worcestershire,* eds.
 J. W. Willis-Bund, William Page (London: Archibald Constable,
 1906) 2:151-4; and especially, Stephen J. Price, 'The Early
 History of Bordesley Abbey,' Diss. Birmingham University 1971.
2. A brief historical introduction, a field study, and an account
 of the excavation of the south arm of the transept are found in
 Philip Rahtz and Susan Hirst, *Bordesley Abbey, Redditch, Hereford-
 Worcestershire. First Report on Excavations 1969-1973,* British
 Archaeological Reports, No. 23 (Oxford: British Archaeological
 Reports, 1976). The second report, recording the work on the
 eastern portions of the choir and presbytery, will be published
 by British Archaeological Reports in 1982.
3. James M. Woodward, *The History of Bordesley Abbey* (London:
 Parker, 1866) pp. 38-54.
4. David A. Walsh, 'Measurement and Proportion at Bordesley Abbey,'
 Gesta 19/2 (1980 (109-13). A more complete analysis of the
 design and origins of the architecture of the first period of
 construction at Bordesley is forthcoming in the second report
 of the excavation.
5. John Bilson, 'The Architecture of Kirkstall Abbey Church with
 Some General Remarks on the Architecture of the Cistercians,'
 Transactions of the Thoresby Society No. 16 (1907) 124.
6. For the introduction of the crossing tower to Cistercian churches
 in England in the second half of the twelfth century, see Peter
 Fergusson, 'Early Cistercian Churches in Yorkshire and the Prob-
 lem of the Cistercian Crossing Tower,' *Journal of the Society of
 Architectural Historians* 29 (October, 1970) 211-21.
7. Fr. M.-Anselme Dimier, *Recueil de plans d'églises cisterciennes*
 (Grignan, Drôme: Abbaye Notre-Dame d'Aiguebelle, 1947) 2, pls.
 56, 246, 121, 167, 179.
8. The second pair of piers of the nave arcade are as yet unexcavat-
 ed; those further down the nave, uncovered briefly in 1968, are
 more complex and probably later in date. It has not been deter-
 mined whether the nave was finished quite a long time after the
 eastern portions or whether the western parts were rebuilt.
9. Rahtz and Hirst, pp. 62-4.
10. Rahtz and Hirst, pp. 79-80, 94, figs. 22-3.
11. A few impressions in the floor bedding indicate that the central
 area of the floor had diagonally set tiles.
12. The bases have a triple roll design with a 'hooked indent' below.
 Richard K. Morris, in communication with the author, suggests
 fairly close parallels in the base moulding of the double pis-
 cina in the gallery chapel of the north transept at Gloucester
 Cathedral (probably 1270s) and bases from the north transept
 triforium of Hereford Cathedral (1260s).

13. The exterior corners of the eastern projection and the north exterior wall of the presbytery were augmented respectively by corner buttresses and thickening of the wall. The east exterior wall of the south arm of the transept has a large crack through the center in the area of the southernmost chapel; here the wall was repointed and two new buttresses added in an unsuccessful effort to stabilize the sagging masonry.

14. The footing trench for the front of the stalls consists of a shallow depression running the length of the unit. Behind the depression, fragments of decayed timber sills were seen in a few places. Tiles in irregular placement backed this trough.

15. See below and note 18. The fragment was in the very bottom of the pit and must have been placed there as something to stand on in the mire.

16. Rahtz and Hirst, p. 97, pl. XIII, fig. 22.2. Dr. Morris suggests comparison with the bases of the sedilia of Exeter Cathedral of c. 1290-1300 and in the presbytery aisles of Ely Cathedral beginning in 1322. As the sub-base is circular rather than polygonal, a date c. 1300 seems to him to be most likely.

17. Sometime during the period of existence of the 3A work, walls were limewashed and painted with false jointing. The painted horizontal jointlines deviate consistently a few degrees from the true horizontal joints of the masonry on the 3A fallen fragment, suggesting that the pier was canted when it was painted.

18. Many blocks of Period 2 and 3A work were reused in this construction, the base of which measures 3.8 meters east-west.

19. The molding profile of this base is close to those of the westernmost Decorated piers of the nave of Worcester Cathedral of the 1320s or early 1330s. See Richard K. Morris, 'Worcester Nave: From Decorated to Perpendicular,' *Medieval Art and Architecture at Worcester Cathedral*, British Archaeological Association Conference Transactions No. 1 (Leeds: 1978) 118-20, fig. 2B.

20. The pattern of this floor is known from the mortar impressions made by the tiles; only a few tiles remained *in situ*.

21. This pier base is polygonal and differs in type and orientation from the constructions of all other phases. It seems to have been placed directly on Period 1 footings, though a 3C phase could have existed here, all traces of which have disappeared.

22. *Victoria County History, Worcestershire* 2:153.

23. Rahtz and Hirst, p. 19.

24. Marcel Aubert, *L.'Architecture cistercienne en France* (Paris: Vanoest, 1947) 2:316, n. 6.

25. Of the thirteenth and fourteenth century Cistercian churches having stalls which extend into the crossing, I cite the following from Dimier: Beaulieu (pl. 26), Hailes (pl. 140), Marienstatt (pl. 186), Orval I and II (pls. 214, 215), and Waverly II (pl. 328).

26. Fergusson, pp. 211-21.
27. Dimier, pls. 290, 140, 303, and 197.

David Walsh spoke on excavations at Bordesley Abbey at the Conference on Cistercian Studies, Kalamazoo, 1979 and Kalamazoo, 1981.

CISTERCIAN TILE MOSAIC PAVEMENTS IN YORKSHIRE:
CONTEXT AND SOURCES

Michael Cothren

During the past few decades, Cistercian art and architecture have been studied with renewed intensity.[1] Much of this inquiry has been focused on an attempt to recognize and to understand those features which distinguish Cistercian artistic production from that under different patronage, to explain what motivated the often striking homogeneity found in the diverse and widespread visual culture of a particular order. The traditional understanding of the Cistercian aesthetic as negative or reductive has been tempered by a search for its positive aspects. According to this new perspective, the formal imperatives of the order not only attempted to eliminate inappropriate visual forms, but also chose and imposed appropriate ones.

The analysis of the definition, the development, and the dissolution of the Cistercian aesthetic as expressed in the monastic complex itself has not considered Cistercian pavements, concentrating instead on studies of architecture and stained glass. On the other hand, Cistercian pavements have attracted considerable attention from specialists in medieval tiles.[2] This study intends to bridge this gap by serving as a brief introduction to the Cistercian context of Cistercian pavements through the examination of the well-preserved, well-documented, and well-known floors from a group of Cistercian abbeys in Yorkshire--Byland, Fountains, Rievaulx, Newbattle, and Meaux.[3] It will be seen that in both style and technique they are representative of an international movement in Cistercian pavements during the late twelfth and thirteenth centuries.

The portions of pavement still *in situ* in the south transept chapels of the abbey of Byland[4] (Fig. 1) provide the most spectacular evidence about the Yorkshire group. Like those in the related sites, the floor at Byland was covered with tile mosaic, the earliest type of decorated ceramic pavement employed by the English Cistercians.[5] In this technique, patterns were formed by arranging carefully shaped tiles in contrasting colors (Fig. 2). The individual components were cut from partially or fully dried sheets of clay following outlines which had been impressed, probably with the aid of templates, while the clay was still wet. Some of the tiles were covered with slip, and all were coated with glaze before firing. Though five colors were available to the medieval tiler through the simple manipulation of glaze and slip, the pavements at Byland and the other Yorkshire abbeys are composed almost exclusively of dark green and yellow tiles.[6]

The intact portions of tile mosaic pavement at Byland have pre-

served sixteen different patterns as exemplars of the possibilities
of the technique. More significantly, they provide an example of how
the patterns were arranged to create an overall design. This informa-
tion is important for the understanding of related Yorkshire pavements
which often survive only as disconnected tiles, but which are, however,
all but identical to those at Byland in both technique and design. The
floor at Byland was not composed of large areas of a single pattern.
Instead broad expanses were divided into sections and filled with vary-
ing geometric configurations. A monumental wheel or rose pattern was
placed prominently in front of the altar.

Knowledge about the pavement at Fountains is based primarily on
reports, drawings, and reconstructions of nineteenth-century observ-
ers.[7] Nothing remains *in situ*. From this information, however, it
can be determined that at least four of the patterns used at Fountains
are also used at Byland. Although less well preserved than that at By-
land, the Fountains pavement is certainly more explicitly documented.
The original church was built during the second quarter of the twelfth
century, but a new choir was started under Abbot John of York (1203-11)
and brought to completion under Abbot John of Kent (1221-47).[8] The
same chronicle which provides information about the chronology of the
new choir credits John of Kent with a new pavement as well--'addit et
novo operi pictum pavimentum.'[9]

There is less documentation but more concrete evidence about the
pavement from the abbey of Rievaulx. Tiles still exist *in situ* and
others, constituting eight patterns and including part of a wheel like
that in front of the altar at Byland, are now in the British Museum[10]
(Fig. 3). Three of the patterns find exact parallels at both Byland
and Fountains, and three others are found again only at Byland. The
building chronology is similar to that at Fountains, confirming a pos-
sible date in the first half of the thirteenth century for the group.[11]

Excavations between 1878 and 1898 at Newbattle Abbey uncovered
thirteen different designs,[12] many of which are matched at Byland (Fig.
4). Most impressive among the finds are two great wheel patterns (Fig.
6), both of which are similar to the wheels at Byland and Rievaulx,
but neither of which reproduces them exactly. The sole documentary
clue for the dating of this pavement is a reference to a dedication
in 1233 or 1234.[13]

The abbey of Meaux is the fifth of the Cistercian sites in York-
shire with evidence of tile mosaic.[14] Represented by forty-three dif-
ferent patterns, the Meaux pavement has a greater variety of preserved
motifs than the combined repertory of the four pavements discussed so
far (Fig. 7). Fortunately, there is documentary evidence which allows
the Meaux pavement to be dated with precision equal to that at Foun-
tains. A history of the abbey written around 1400 by its nineteenth
abbot, Thomas de Burton, credits the pavement of the church to the ab-
bacy of William of Driffield, 1249-69.[15] The consecration of the high
altar in 1253 makes a date in the early 1250's most probable, placing

this pavement somewhat later than those previously discussed. An ad-
vanced date is confirmed by certain significant differences between
Meaux and the other pavements. Although a considerable number of
field motifs (Fig. 7: patterns 1, 5-8, 12-15) and one of the wheel
patterns (Fig. 8a) at Meaux fall within the group defined by the
earlier pavements, the advanced complexity of another wheel (Fig.
8b) and the creation of equally as complex field patterns (Fig. 7:
patterns 2, 4, 9-11) with amazing technical virtuosity separate the
Meaux pavement from them, though the design principles are the same.
 The pavements of Byland, Fountains, Rievaulx, and Newbattle
form an obvious stylistic group. Their patterns are relatively sim-
ple, are formed of only two colors, and are drawn from the same re-
pertory of motifs. Similarities in style are matched by similarities
in technique.[16] Furthermore, the existence of documentary evidence
for the dating of Fountains, a certain confirmation in the building
chronology of Rievaulx, and the dedication date at Newbattle allow
the group to be dated to the years between 1220 and the 1240's. Two
of the pavements seem to have been inspired by architectural addi-
tions to the abbey churches, but the pavements at Byland and New-
battle were most likely intended to refurbish an existing structure
with a stylish floor decoration. The slightly later pavement at
Meaux, characterized by more elaborate patterns executed with an in-
crease in technical audacity, is best evaluated not as a distinct
venture, but as a somewhat more developed example of the type estab-
lished by the earlier group.
 It would be difficult to avoid the obvious conclusion. The Cis-
tercian affiliation of these abbeys must be involved in the stylistic
and technical homogeneity of this group of pavements. Moreover, in
this case, filiation is even closer than simple Cistercian associa-
tion would suggest. All but Byland are a part of the same sub-family
within the Cistercian order. Rievaulx and Fountains were founded
from Clairvaux in 1132.[17] Newbattle was founded in 1140 from Mel-
rose,[18] an 1136 foundation from Rievaulx, and Meaux was founded in
1151 from Fountains.
 The Rievaulx-Fountains family is even more extensive and wide-
spread than this, however. Published evidence, albeit more meager,
indicates that pavements in the same technique--though not perhaps
as closely related stylistically--were used in other daughter houses
of the family. Excavations in 1713 revealed the remains of what was
called a 'tesselated pavement' at Kirkstall,[19] an 1152 foundation
from Fountains. Similar remains have been discovered at Newminster,[20]
founded in 1138 from Fountains, and at Sawley,[21] founded in 1148 from
Newminster. Evidence of tile mosaic extends outside of northern Eng-
land (Fig. 9) to members of this monastic family at Revesby,[22] War-
den,[23] and Sawtry.[24] What is more, at Beaulieu, which like Byland
is not a part of the immediate family, tile mosaic similar to that
of the Yorkshire group formed a part of the pavement.[25] Clearly,

the pavements of the five Yorkshire abbeys should be seen as a well
preserved sub-group within a larger Cistercian movement in England.[26]
 Most students of English tile pavements, agreeing that the Cis-
tercian tile mosaics of Yorkshire are too sophisticated at their first
appearance to have been a spontaneous development, have posited an un-
identified source for them in northern France.[27] On the other hand,
an intermediary much closer to home has been proposed by Elizabeth
Eames and G. K. Beaulah.[28] Their suggestion is both more specific
and more provocative. Espousing the traditional view that the ulti-
mate origin of tile mosaic lies in the attempt, perhaps first in Nor-
mandy, to create ceramic imitations of similarly designed Italian
stone pavements, they cite an elaborate English example of *opus Alex-
andrinum* installed in the retrochoir of Canterbury Cathedral by Ital-
ian craftsmen between 1213 and 1220. Their conjecture is that it en-
gendered a local ceramic counterpart, citing the remains of a tile
mosaic pavement in the corona which they believe is contemporary with
the Italian pavement. Based on this evaluation of the evidence at
Canterbury, the seductive suggestion is tendered by Eames and Beaulah
that Abbot John of Kent, who was responsible for the Fountains pave-
ment, may have been aware of the pavement at Canterbury and may in
fact have been inspired by it to install a similar pavement at Foun-
tains after he became abbot in 1221. Having been brought in to exe-
cute one pavement, the workshop would then have been employed in oth-
er abbeys in the region.
 There are several problems with this neat and attractive scen-
erio, not the least of which are the uncertain date of the Italian
pavement at Canterbury[29] and the conjectural nature of its associa-
tion with the tile mosaic, based primarily on proximity of location.
Moreover, the patterns of the tile mosaic fragments at Canterbury
are more ordinary and less monumental than the fanciful and complex
field patterns of the Yorkshire abbeys.[30] Whereas it seems clear
that Italian pavements are the ultimate ancestors of the wheel pat-
terns on Cistercian floors, it is hard to imagine the elaborately in-
terlocking circles and squares of the Canterbury retrochoir pavement
as the immediate source. If the tile mosaic at Canterbury is too sim-
ple in comparison, the Italian pavement is too complex. Its design
is assembled from different components and arranged after totally dif-
ferent principles.
 I believe that there is an alternative and much more compelling
explanation for the appearance of tile mosaic pavement in Yorkshire
Cistercian abbeys, an explanation which relies more heavily on their
place within a larger Cistercian context. I have already shown that
the pavements of the Yorkshire abbeys are part of a broad movement in
Cistercian houses throughout England. The practice was even more
widespread.
 A series of thirteenth-century tile mosaic pavements in German
Cistercian abbeys follows the same principles of decorative design

used in English Cistercian examples.[31] A pavement at the abbey of
Walkenried in Lower Saxony[32] (Fig. 10), like its Yorkshire counter-
parts, employs petal shapes, curving as well as rectilinear geometric
forms, and small shapes inserted within larger tiles (cf. Figs. 4 and
5). The design of the Walkenried pavement finds striking correspon-
dences with those at other Cistercian abbeys in the area such as Do-
berlug, [33] just below Berlin, and both Heiligenkreuz and Zwettl in
Austria.[34] There is no precedent for this type of design in Germany
outside of a Cistercian context, even though there is an indigenous
tradition of ceramic pavement, including the use of tile mosaic.[35]
Evidence of Cistercian tile mosaic pavements can even be found as
far away from Yorkshire as the abbey of Wachock in Poland,[36] and a
pattern of this kind was drawn by Villard de Honnecourt at a Cister-
cian abbey in Hungary during his thirteenth-century grand tour.[37]

The use of tile mosaic pavements in Cistercian houses did not
bypass the homeland of the order in France. Although evidence about
their appearance is much more sketchy,[38] the French examples can be
dated somewhat earlier than their Yorkshire counterparts. Emile Amé
discovered three tile mosaic patterns in the radiating chapels of
the church at Pontigny during nineteenth-century excavations[39] (Fig.
11). Since a new chevet was begun at Pontigny around 1185 and fin-
ished between 1205 and 1210,[40] the chapel tiles probably date from
the first decade of the thirteenth century. The circle and lattice
interlace characteristic of two patterns at Pontigny is repeated in
another French Cistercian pavement at L'Ile-en-Barrois[41] (Fig. 12).
The latter pavement also included patterns with petals, more reminis-
cent of the pavements of Yorkshire. The church in which these tiles
were found was begun in 1162 and finished in 1202. In all probabil-
ity they date from the end of the twelfth or the beginning of the
thirteenth century.[42]

Whereas the appearance of this kind of tile mosaic in German
and English Cistercian abbeys is best explained through fidelity
to an international Cistercian type rather than as the continuation
of an indigenous tradition, in France there are local precedents for
Cistercian pavements. Although augmented and restored toward the
middle of the thirteenth century, the pavements of three chapels at
the Benedictine abbey church of Saint-Denis retained sections of
twelfth-century tile mosaic until Viollet-le-Duc's restorations at
the middle of the nineteenth century. Evidence which exists about
them indicates that they exemplified the sort of indigenous tradi-
tion which inspired the French Cistercian tilers.[43] The pattern
of interlaced circles and lattice from the Virgin Chapel (Fig. 13c)
is found at both Pontigny (Fig. 11c) and L'Ile-en-Barrois (Fig. 12).
An infinite petal pattern from the same chapel (fig. 13b) not only
finds a close parallel within France at L'Ile-en-Barrois (Fig. 12)
but also in the Yorkshire Cistercian pavement at Meaux (Fig. 7, no.
5).[44] Similarly, two patterns in a second chapel at Saint-Denis

(Fig. 14) prefigure the cut-out fleurs-de-lys of both Newbattle (Fig. 2) and Meaux (Fig. 7, no. 9) and match another pattern at Newbattle (Fig. 4, no. 8). Although the fleurs-de-lys at Saint-Denis and New-battle are not identical in detail, the technique of their construction and the principle of their design are the same.

Another French example (Fig. 15), while unrelated to known Cistercian floors within France, bears a similarly strong relationship with the Yorkshire pavements. Discovered in the 1950's at the Cathedral of Châlons-sur-Marne,[45] the floor has been dated to the middle of the twelfth century, contemporary with the pavements of the Saint-Denis chapels. It is composed of compartments of geometric field pattern into which two wheels have been set in a disposition very similar to Byland, but the overall design is not all that recalls Byland. The formation of the wheel patterns with concentric rings of decoration and their placement within a rectangular frame with corner fillers, are closer to the wheel patterns of Yorkshire than to those of any other pavement outside of the Cistercian group. It is probable that between Châlons and Yorkshire there were French Cistercian intermediaries which have been lost or which await excavation.[46]

In my alternative scenerio for the source of tile mosaic pavements in Yorkshire Cistercian abbeys, the French Cistercians would have adopted the local technique and design of tile mosaic pavement late in the twelfth century and subsequently exported it to other houses of the order throughout the thirteenth century, including the group under consideration here from Yorkshire. The proliferation of patterned tile pavements in a Cistercian context might seem inconsistent with the strict Cistercian regulations about the nature of decoration in their churches. Based on a simplistic interpretation of a number of textual sources, it has long been assumed that the Cistercians were opposed to the idea of decorative pavements, at least early in their history.[47] Evidence for uneasiness begins with the severe admonitions in Bernard of Clairvaux's *Apologia* to William of Saint Thierry.

> What sort of respect is shown for the saints by placing
> their images on the floor to be trampled underfoot?
> People spit on the angels, and the saints' faces are
> pummelled by the feet of passers-by. Even though its
> sacred character counts for little, at least the paint-
> ing itself should be spared. Why adorn what is so soon
> to be sullied? Why paint what is to be trodden on?
> What good are beautiful pictures when they are all dis-
> colored with dirt? Finally, what meaning do such things
> have for monks, who are supposed to be poor men and
> spiritual? It is, of course, possible to reply to the
> Poet's question in the words of the Prophet: 'Lord, I
> have loved the beauty of your house, and the place where
> your glory dwells.' Very well, we may tolerate such

things in the church itself, since they do harm only to
greedy and shallow people, not to those who are simple
and god-fearing.[48]

Although he clearly objects to the idea of expending energy and mater-
ials on any decoration of areas which will be walked on, Bernard re-
served his most vituperative language for the use of figural decora-
tion on floors. It is worth noting that his objection is focused on
monastic structures other than the church. Here he finds such orna-
mentation at least tolerable. All of the Cistercian pavements dis-
cussed here were found in monastic churches.

The spirit of Bernard's rhetorical admonition was translated into
legislation by the General Chapter of the order early in the thirteenth
century. Initially there were specific references to infractions at
individual houses. In 1205 the abbot of Pontigny was reprimanded for
the offensive pavements of his church and was ordered to remove and re-
place them.[49] In 1210 the abbot of Belbec in Normandy was placed on
slight penance for three days because his monks had been allowed to
construct pavements which exhibited levity and curiosity ('pavimenta
quae levitatem et curiositatem praeferunt') for persons outside of the
order. He was instructed both to prevent them from working for non-
Cistercian patrons and to prevent them from making pavements 'quae
maturitatem ordinis non praetendant.'[50]

These specific transgressions seem to have inspired the General
Chapter of 1213 to include a statement about pavements in their defi-
nition of artistic policy for all Cistercian houses.

It is hereby forbidden by authority of the General
Chapter that there be from henceforth in the Order
any pictures, sculpture--save for the image of our
Saviour--or any variegated floors [neque varietates
pavimentorum], or anything unnecessary in the way
of buildings or victuals.[51]

The same precept was repeated by the General Chapter in 1218.[52] In
1235 a specific infraction ('Pavimentum curiosum') was cited at the
abbey of Le Gard.[53] There was clearly a reason for their concern.

The coincidence of Cistercian proscriptive legislation with a
flourishing of the art of Cistercian decorated pavements obviously
creates a problem of interpretation. Two possible conclusions could
be drawn. The concern of the General Chapter could have been a re-
action against the inappropriateness of tile mosaic pavement. All of
the pavements I have discussed, therefore, would have been unorthodox,
if not scandalous. On the other hand, these pavements could repre-
sent the orthodox formula which was exported by the order in defer-
ence to some other and offensive type of pavement. For several rea-
sons the latter alternative is more logical.[54]

In the first place, there is a relationship between the patterns on Cistercian floors and orthodox Cistercian design in other media. At Pontigny, for example, the tiles discovered by Emile Amé confirmed a popular notion that the designs of the windows originally had been reproduced in the pavements,[55] asserting a sense of decorative homogeneity in the conception of the Cistercian abbey church with which the use of tile mosaic was directly involved. In addition to matching the recorded designs of lost windows from Pontigny, one of Amé's reconstructed patterns (Fig. 10b) can still be seen in a fragment of a window from the Cistercian abbey of La Bénisson-Dieu. The interlace designs of the tile patterns at Pontigny and L'Ile-en-Barrois are used in windows at Obazine and La Bénisson-Dieu. The motifs of the pavements, then, are within the repertory permissible in the windows.[56]

If the patterns of known tile mosaic pavements were acceptable for Cistercian usage, then some other indiscretion must have qualified the 'varietates pavementorum' or 'pavimentum curiosum' for condemnation by the Cistercian fathers. Pontigny is important in this respect because the pavement there, about which there is considerable evidence, was ordered removed by the General Chapter in 1205. If Amé's drawings can be trusted, the Pontigny tile mosaic deviated from practice in other Cistercian pavements through its use of as many as four colors for one pattern. Four colors were easily available to the ceramic paver in the twelfth and thirteenth centuries through variations in the use of slip and the chemical composition of the glaze; but whereas three or four colors were normally used in twelfth-century French tile mosaic pavements like Saint-Denis, standard practice in Cistercian pavements, notably those in Yorkshire, was the use of only two—green and yellow. 'Varietas' is a word used insistently by the General Chapter for what the Cistercians were to avoid in their pavements. Considering the deviant nature of the Pontigny tile mosaic and the description of the objectionable pavement of Pontigny as 'superfluitate' and 'curiosa varietate', it may have been the motley nature of this pavement which transgressed the boundaries of Cistercian propriety.[57] It is an attractive possibility, then, that in a more general way the concern of the General Chapter was elicited neither by the use of decorated pavements as such, nor by the geometric and interlace patterns with which tile mosaic pavements were designed, but instead by the number of colors which were used to compose them.[58] More than two colors may have been considered both curious and superfluous variety. It would have been in Cistercian windows.[59]

Evidence suggests that the impressive relics of what would have been even more impressive pavements in the Cistercian abbeys of Yorkshire can be identified as examples of a Cistercian style of tile mosaic pavement, used by the order over a broad geographic area in the thirteenth century. The basis for both the style and technique of these pavements can be found in French tile mosaic of the twelfth

NOTES

1. The active forum on Cistercian art organized and nurtured by Meredith Lillich each spring, at the Cistercian Conferences held with the Conferences on Medieval Studies at Western Michigan University, has been part of this investigation. My study was first presented in a slightly different form at the Sixth Cistercian Conference in 1976. Without Professor Lillich's example and encouragement, my study would neither have begun nor been completed. I would also like to express my thanks to Constance Cain Hungerford and especially Susan Lowry who read this article and offered many helpful suggestions.

2. Almost every general work on medieval floor tiles includes a section on the Cistercians. Most recently see E. S. Eames, *Medieval Floor Tiles: A Handbook* (London: 1968); H. Kier, *Der mittelalterlich Schmuckfussboden, unter besonderer Berücksichtigung des Rheinlandes* (Düsseldorf: 1970); H. de Morant, 'Les carreaux de pavage du moyen-âge,' *Archéologia* 38 (1971) 66-73; and J. A. Wight, *Medieval Floor Tiles* (London: 1975).

3. For this group see the excellent article by E. S. Eames and G. K. Beaulah, 'The Thirteenth-Century Tile Mosaic Pavements in the Yorkshire Cistercian Houses,' *Cîteaux in de Nederlanden* 7 (1956) 264-77. I am indebted to the work of these English specialists for much of my raw information about the Yorkshire pavements. The abbey of Newbattle is actually in Scotland, but for convenience I will follow the example of Eames and Beaulah by using the geographic label of 'Yorkshire' for the whole group.

4. For Byland see C. Peers, *Byland Abbey* (London: 1952); N. Pevsner, *Yorkshire: The North Riding* (Harmondsworth: 1966) pp. 94-101; and P. Fergusson, 'The South Transept Elevation of Byland Abbey,' *Journal of the British Archaeological Association* 38 (1975) 155-76.

5. Only the first phase in the history of Cistercian ceramic pavements will be discussed here. During the second half of the thirteenth century and throughout the fourteenth century, the Cistercians adopted the more economical and more expedient method of inlaying white slip decoration into red tiles of modular, most often square, shape. The question of the distinctiveness of these later Cistercian pavements is not within the mandate of the present study, but I hope to address it at a later time.

6. The best discussion of technique can be found in Eames and Beaulah, *Cîteaux*, pp. 264-5, 271-3. For the most expansive treatment of tile mosaic as a type see Wight, pp. 75-102.

7. W. Fowler, 'Principal Patterns of Roman Floors at Fountain Abbey near Rippon Yorks,' (a single engraving dated 1800 and published by subscription in the series Fowler entitled *Engravings of the Principal Mosaic Pavements which have been discovered in the*

Course of the last and present Centuries in various Parts of Great Britain). J. B. Gass, 'Tile Pavement, High Altar, Fountains Abbey,' *The Building News* 29 (November 26, 1875) 586. Gass includes a drawing of the patterns as they were installed in 1875.

8. The chronology of and literature on the early church is discussed in P. Fergusson, 'Early Churches in Yorkshire and the Problem of the Cistercian Crossing Tower,' *Journal of the Society of Architectural Historians* 29 (1970) 214-17. See also N. Pevsner and E. Radcliffe, *Yorkshire: The West Riding*, 2nd ed. (Harmondsworth: 1967) pp. 203-10.

9. Eames and Beaulah, *Cîteaux*, pp. 276-7. Their information is based on W. Dugdale, *Monasticon Anglicanum*, 5:286, n. f.

10. Illustrated in Wight, fig. 28, p. 78.

11. The original, twelfth-century church was altered around 1225 with the beginning of a new choir. Pevsner, *Yorkshire: The North Riding*, pp. 301-3.

12. J. S. Richardson, 'A Thirteenth-Century Tile Kiln at North Berwick, East Lothian, and Scottish Medieval Ornamented Floor Tiles,' *Proceedings of the Society of Antiquaries of Scotland* 63 (1928-9) 287-92.

13. D. E. Easson, *Medieval Religious Houses: Scotland* (London: 1957) p. 65.

14. G. K. Beaulah, 'Paving Tiles from Meaux Abbey,' *Transactions of the East Riding Antiquarian Society* 26 (1929) 116-36. E. Eames, 'A Thirteenth-Century Tile Kiln Site at North Grange, Meaux, Beverly, Yorkshire,' *Medieval Archaeology* 5 (1961) 137-68.

15. Eames and Beaulah, *Cîteaux*, p. 276. The *Chronica Monasterii de Melsa* upon which this information is based is published in *Rerum Britannicarum Medii Aevii Scriptores (Rolls Series)*, 43, part 2: 119. The word pavement is not used in the reference--'totaque ecclesia asserum testudine caelata et tegulis in fundo cooperta.'

16. The most obvious conclusion from this evidence--that the tiles were produced at one site and exported for the pavements of the four abbeys--has been disproved by Eames and Beaulah. The actual fabric and glaze of the tiles are different in each pavement, indicating that they were in all probability produced on site, perhaps by the same itinerant workmen, and perhaps using the same templates. One kiln, that from the abbey of Meaux, has been discovered at the site of a pavement in Yorkshire. Eames and Beaulah, *Cîteaux*, pp. 271-6.

17. Information on filiation and date of Yorkshire abbeys is based on D. Knowles and R. Hadcock, *Medieval Religious Houses: England and Wales* (London: 1953).

18. Melrose also had an elaborate pavement which by strict definition could be classified as tile mosaic, although individual

components are embossed with decoration in a technique which, divorced from mosaic composition, would replace tile mosaic as the means for creating patterns on Cistercian floors by the middle of the fourteenth century. (See n. 5 above.) As such, it is better seen as a transitional monument, more important for the understanding of later Cistercian pavements than it is for those under consideration here. For this pavement see Richardson, *Proceedings of the Society of Antiquaries of Scotland* (1928-1929) pp. 293-7.

19. J. Nichols, *Examples of Decorated Tiles, Sometimes Termed Encaustic* (London: 1845) p. vii.
20. Wight, p. 79.
21. Ibid.
22. Ibid. N. Pevsner and J. Harris, *Lincolnshire* (Harmondsworth: 1964) p. 341. The thirteenth-century pavement was found in the nave where it formed strips of ten different patterns including six-pointed stars and lilies. Like the Yorkshire pavements it was executed in only two colors, green and buff, although there is mention of black tiles as well. Revesby was an 1142 foundation from Rievaulx.
23. Wight, p. 80. She reports on the extensive tile mosaic discovered in excavations carried out during the 1960's. The section of the Warden pavement illustrated in J. Godber, *History of Bedfordshire* (Bedford: 1969) pl. 14b, equals in complexity the field patterns at Meaux without reproducing them exactly. There are remains, however, of a wheel pattern composed of interlacing arcades almost identical to those of a wheel at Meaux (my fig. 8b). Godber dates the pavement to the fourteenth century, but a date near the middle of the thirteenth, contemporary with Meaux, seems more likely. Other tiles from Warden in a technique she calls 'pseudo-mosaic', are published by E. S. Eames, 'Medieval Pseudo-Mosaic Pavements,' *Journal of the British Archaeological Association* 38 (1975) 81-9. Warden was founded in 1135 from Meaux.
24. Wight, p. 80. Sawtry was an 1147 foundation of Warden.
25. W. St. John Hope and H. Brakespear, 'The Cistercian Abbey of Beaulieu in the County of Southampton,' *Archaeological Journal* 63 (1906) 181.
26. Tile mosaic seems to have been principally a Cistercian phenomenon in England during the first half of the thirteenth century. Its use in churches outside of the order at this time is so rare as to be almost insignificant. The only two examples known to Eames and Beaulah are the Cathedrals of Canterbury and Rochester (*Cîteaux*, p. 265). None of the patterns at these two sites approach the complicated design of the Yorkshire motifs. Only one uses a curved component. Most are created with simple

triangles, lozenges, or squares in alternating colors. The Canterbury pavement is not as insignificant in their analysis as it is in mine.

27. A. Lane, *A Guide to the Collection of Tiles (Victoria and Albert Museum)* (London: 1960) pp. 27-8. Eames, *Medieval Archaeology*, p. 137.

28. Eames and Beaulah, *Cîteaux*, pp. 265, 276-7.

29. Eames and Beaulah base their date on the study of N. Toke, 'The *opus Alexandrinum* and sculptured stone roundels in the retrochoir of Canterbury Cathedral,' *Archaeologia Cantiana* 42 (1930) 193-8. A date of 1268-78 (contemporary with the Italian pavement at Westminster) is proposed by E. Hutton, *The Cosmati. The Roman Marble Workers of the XIIth and XIIIth Centuries* (London: 1950) p. 26.

30. The Canterbury tile mosaic pavement, which survives only in a limited area at the north edge of the corona, has not been adequately published. Square areas of small scale, geometric pattern are enclosed by strips of border. All of the motifs are created with square or triangular tiles which are green (possibly black), yellow, or red. One area is covered with incised square tiles in a technique Eames has called 'pseudo-mosaic' (*British Archaeological Association*, 1975, pp. 81-9). None of the Canterbury patterns figure prominently in the Yorkshire pavements.

31. German Cistercian pavements deserve a thorough study as a group, but for a solid introduction to them, placed into the context of contemporary non-Cistercian pavements in Germany, see Kier, *Die mittelalterlich Schmuckfussboden*.

32. Kier, pp. 137-8. The pavement was uncovered in a twentieth-century excavation and has been dated to a building campaign in progress between 1240 and 1290.

33. Kier, p. 93 and figs. 256-7.

34. Ibid., pp. 98-99, figs. 244-54 (Heiligenkreuz); pp. 142-3, fig. 255 (Zwettl).

35. Ibid., pp. 35-9. Some German Cistercian pavements follow local traditions. In the Rheinland, for example, tile mosaic developed as a ceramic version of local eleventh-century stone mosaic pavements, using the same fairly consistent design. A wheel pattern composed of radiating acute triangles was placed directly on a checkered ground without the square frame used in Yorkshire. The Cistercian abbey of Walberberg was paved in this manner (c. 1197), but the design was not used in Cistercian houses outside of the region.

36. K. Białoskórska, 'L'abbaye cistercienne de Wachock,' *Cahiers de civilisation médiévale* 5 (1962) 335-50. (See 349-50 and fig. 11).

37. H. Hahnloser, *Villard de Honnecourt*, 2nd ed. (Graz: 1972) pp. 73-5, 393-6, pl. 30. The identification of the tiles drawn by

Villard with those of a particular Cistercian abbey in Hungary
(Pilis) was made by L. Gerevich, 'Villard de Honnecourt magyaros-
zágon,' *Muvészettörténeti Ertesito*, Adadémi Kiadó (1971) 81-105.
Only one pattern was composed of tile mosaic. The others were
formed from square tiles with incised decoration, another tech-
nique used frequently in Cistercian pavements elsewhere.

38. For example, only fragmentary evidence remains of tile pave-
ments from two important sites--Clairvaux and Cîteaux. 1) P.
Jeulin, 'Quelques découvertes et constatations faites à Clair-
vaux depuis une vingtaine d'années,' *Bulletin de la société na-
tionale des antiquaires de France* (1960) 114-15. Jeulin dis-
cussed brown and yellow triangles of various sizes presumably
from a tile mosaic pavement. 2) Although the technique is dis-
tinct (incised designs on monochrome, modular tiles), the pave-
ment at Cîteaux employed motifs which are consistent with the
repertory used in Cistercian tile mosaic. Particularly inter-
esting is a square tile which, when used in groups of four, form-
ed a circle of radiating, interlaced arches much like those cre-
ated by tile mosaic in a wheel pattern at Meaux (my fig. 8b).
For the Cîteaux tiles see most recently M. Pinette et al, *Les
Carreaux de pavage dans la Bourgogne médiévale* (Exhibition cata-
log, Autun, Musée Rolin, 1981) nos. 84-8.

39. E. Amé, *Les Carrelages émaillés du moyen-âge et de la renaissance*
(Paris: 1859) pp. 100-1. Amé also reconstructed two other pat-
terns from tiles found among debris over a vault, but informa-
tion about them is much too conjectural to include them in the
discussion here. Knowledge about the patterns in the chapels
is based totally on Amé's drawings. I expended considerable
energy and was aided by Terryl Kinder (who is preparing a study
of the architecture of Pontigny) in an attempt to locate any
trace of the original tiles, but neither tiles nor information
about them was discovered.

40. M. Aubert, *L'Architecture cistercienne en France* (Paris: 1947)
1: 187-9. R. Branner, *Burgundian Gothic Architecture* (London:
1960) p. 163.

41. M. Maxe-Werly, 'Etudes sur les carrelages au moyen-âge,' *Mémoires
de la société nationale des antiquaires de France* 53 (6ᵉ sér. III)
(1892) 260-5.

42. The dating of the Ile-en-Barrois pavement is controversial.
Maxe-Werly (pp. 264-5) believed that since excavation reports
claimed that the tiles extended under the walls of the cloister,
they were used in the eleventh century to pave a church which
was destroyed in 1162 and replaced with a new building between
1162 and 1202. His presentation of the evidence does not con-
vince me that the tiles are that early, but his argument has
been adopted by Dom J. Coquet and added to the evidence for his

controversial, seventh-century date for the tile mosaic pavement
of the abbey of Ligugé. See J. Coquet, 'Les Carrelages vernissés
du VII^e siècle à l'abbaye de Ligugé,' *Revue Mabillon* 201 (1960)
109-44. A group of tiles from a Cistercian abbey, Les Châtelliers,
has been grafted to his argument and consequently dated to the
seventh century since they are from a pavement identical to the
one at Ligugé. Coquet's early group presents problems too com-
plex to address in detail here, where my primary concern is a
group of pavements in Yorkshire, but for a variety of reasons,
not the least of which is the similarity between these pavements
and other Cistercian examples, I find both Coquet's seventh-century
date for Ligugé (and consequently for Les Châtelliers) and Maxe-
Werly's eleventh-century date for the Ile-en-Barrois pavement dif-
ficult to accept. It is a more tempting suggestion that the Les
Châtelliers floor was installed after 1163, when this site became
Cistercian, in an attempt to transform an existing church into a
Cistercian abbey through orthodox decoration. It could also have
been added in the thirteenth century when the choir was increased
in size, although a more impressive pavement with inlaid designs
in a tile mosaic format (similar to Melrose and Jervaulx across
the channel) is generally associated with the thirteenth-century
architectural campaign. For the later Les Châtelliers pavement
see B. de Montault, 'Les Carrelages de l'église abbatiale des
Châtelliers au moyen-âge et à la renaissance,' *Mémoires de la
société des antiquaires de l'ouest* 14 (1891) 341-96; 15 (1892)
617-40.

43. The chapels are those dedicated to the Virgin and to Saints Hil-
aire and Cucuphas. The pavements now in these chapels were pro-
duced during Viollet-le-Duc's restoration, and although they are
based on the designs of the original floors, there were altera-
tions to suit nineteenth-century sensibilities. Knowledge about
their original design is based on drawings made by Charles Perci-
er in 1794 and on the documentation produced by Viollet-le-Duc
himself who discovered remains of the medieval pavement under an
early nineteenth-century floor. Based on the heraldic, inlaid
tiles of the altar platform, he first dated the whole pavement
to the thirteenth century: 'Carrelages de l'église de Saint-
Denis,' *Annales archéologiques* 9 (1849) 73-7. He reconsidered
this dating, however, and eventually proposed that the tile mo-
saic was from the twelfth century but that the pavement had been
restored and the altar platform made during the thirteenth-century
project which overhauled the chevet and built the nave: 'Carrelage,'
*Dictionnaire raisonné de l'architecture française de XI^e au XVI^e
siècle* (Paris: 1854-68) 2:260-3. Kier, p. 38, prefers a thirteenth
century date, contemporary with the pavement at Pontigny, but the
recent, excellent study of the Saint-Denis pavements by Christo-
pher Norton has secured a twelfth-century date for the portions

which concern me here. He includes a detailed discussion of all
of the surviving evidence: 'Les Carreaux de pavage du moyen-
âge de l'abbaye de Saint-Denis,' *Bulletin monumentale* 139 (1981)
69-100.

44. An interesting, but more complex, relationship between the pave-
ments at Saint-Denis and Cistercian tile mosaic is encountered
in a comparison of a third pattern from Saint-Denis (fig. 13a)
and an almost identical pattern at Newbattle (fig. 5b). Norton,
pp. 77-9, has dated this portion of the Saint-Denis pavement to
the middle of the thirteenth century, raising the possibility
that influence or interchange of pattern and technique was not
restricted to the early part of the thirteenth century. French
pavements may have been more than just the source for the wide-
spread use of tile mosaic by the Cistercians. With pavements,
as with other architectural arts, new developments in France may
have been absorbed periodically by the order and transmitted
along its international monastic network.

45. See 'Découvertes à la cathédrale de Châlons-sur-Marne,' *Les Monu-
ments historiques de la France* 2 (1956) 50. Another twelfth-
century example is the pavement at Saint-Quentin (Amé, pp. 118-21)
which has been cited in relation to Villard's drawing (Hahnloser,
Villard, p. 74) but which is even closer to the pavements at
Meaux and Walkenried.

46. Although it is modest, the evidence about the relationship be-
tween Cistercian and non-Cistercian tile mosaic in Normandy is
tantalizing in its potential importance. P. Oliver, 'Les Car-
relages céramiques de Jumièges,' *Jumièges. Congrès scientifique
du XIII^e centenaire* (Rouen: 1955) pp. 537-49, asserts that the
fragmentary remains of a pavement from the Benedictine abbey of
Jumièges confirms the often repeated but unsubstantiated thesis
that British Cistercian pavements have their source in Normandy.
(See n. 27 above.) He identifies prototypes for the Yorkshire
wheel patterns and illustrates other fragments of patterns with-
in the perimeters of the design principles used in Yorkshire.
He mentions remains of related tile mosaic from the Norman Cis-
tercian abbey of Mortemer. Recent excavations, still in progress,
have revealed more tile mosaic at Mortemer, some of it still in-
stalled. Although there are petal shaped tiles and segments of
circles, most of the tiles uncovered in the recent excavations
have been rectilinear--squares, rectangles, triangles, lozenges,
and hexagons. The designs, some of which are arranged in strips,
may have been composed of three colors--green, yellow, and red.
Definite conclusions about Mortemer must await a careful study
of all of the evidence, but there can be no doubt about the use
of tile mosaic pavement in Normandy and its relationship to other
French and English sites. I do not, however, think that French
influence on the development of this kind of pavement must or can

be limited to Normandy, as Oliver suggests. In fact, considering
the reprimand by the General Chapter of the abbot of Belbec (lo-
cated not far from Mortemer or Jumièges) because he was allowing
his monks to create pavements for non-Cistercians, Oliver's con-
clusion about influence may be inverted. Norman Cistercians could
have influenced the pavement of Jumièges, if they did not actually
make it. The improprieties at Belbec will be discussed presently.

47. For example, Aubert, 1: 313, considered only those plain pave-
 ments 'sans dessin ni figure' to be orthodox and believed decor-
 ated pavements were contrary to the rule, though he admitted that
 infractions were frequent.
48. Bernard of Clairvaux, 'Apologia to Abbot William,' tr. M. Casey,
 The Works of Bernard of Clairvaux: Volume I, Treatises I (Shannon,
 Ireland: 1970) p. 66.
49. 'Statuta selecta capitulorum generalium ordinis Cisterciensis,'
 E. Martène and U. Durand, *Thesaurus novus anecdotorum* (Paris:
 1717) 4: col. 1301.
50. Ibid., col. 1308.
51. This translation (published with the original Latin) is from
 W. Braunfels, *Monasteries of Western Europe* (Princeton: 1970)
 p. 243.
52. Martène and Durand, 4: col. 1322.
53. Ibid., col. 1362.
54. Peter Fergusson has studied a group of monuments faced with a
 similar problematic relationship to the proscriptions of the
 General Chapter. P. Fergusson, *Society of Architectural His-
 torians*, 1970, pp. 211-21. Fergusson's study stands as a warn-
 ing against hasty conclusions based on a summary reading of Cis-
 tercian statutes and without a sufficient exploration of all of
 the actual evidence, notably the works of art themselves. He
 proves convincingly that the naive assumption that all crossing
 towers violated aesthetic rules is untenable. The prescribed
 annual visitations to daughter houses precluded the possibility
 of a wholesale disregard for the established artistic guidelines.
 It was not the use of towers as such, he contends, but the kinds
 of towers which were built which was important to the Cistercians.
 Single story crossing towers were permissible. The situation
 with regards to tile pavements, I believe, was not dissimilar.
 Whereas decorated pavements were not illegal, certain kinds of
 decorated pavements certainly were.
55. Amé, pp. 100-101.
56. The relationship between patterns in Cistercian windows and tiles
 has been discussed by H. Zakin, *French Cistercian Grisaille Glass*
 (New York: 1979) pp. 120-5. She illustrates all of the windows
 referred to here.
57. This hypothesis rests on the assumption that the pavement found
 by Amé was that condemned by the General Chapter in 1205. This

is by no means certain, but it is supported by the unique multi-color nature of the Pontigny pavement as published by Amé.

58. Christopher Norton, in agreement that the Cistercians were not opposed to decorative pavements as such, has suggested that the objections were directed against stone pavements--both incrusted slabs and mosaic--because of their costliness and the richness of the designs they created. See *Les Carreaux de pavage dans la Bourgogne médiévale*, 10.

59. For Cistercian proscriptions about stained glass see Zakin, 1979, pp. 4-7.

60. Ibid., pp. 85-116. Also see H. Zakin, 'French Cistercian Grisaille Glass,' *Gesta* 13 (1974) 17-28.

GRISAILLES FROM THE FORMER ABBEY CHURCHES OF OBAZINE AND BONLIEU

Catherine Brisac

In our time, the most beautiful examples of Romanesque grisailles, and probably the oldest along with those of La Bénisson-Dieu, are in the center of France, more specifically in the Limousin, and in the neighboring provinces.[1] Since 1134, the statutes of the order of St Bernard forbade the monks to decorate their churches with painted glass: 'Vitrae albe fiant et sine crucibus et pictur-is,'[2] a rule renewed several times in the course of the twelfth century.[3] This regulation gave birth to a colorless and non-figural type of glazing characterized by an economy of means which exploited to the fullest the ornamental effects of interlace or floral motifs.[4] Today the study of these grisailles is fraught with difficulties; the authentic panels are rare, and often very restored; the historical and physical analysis has often been done only superficially. Hence a new historical, technical, and stylistic investigation of the most celebrated examples of Romanesque grisailles, those of Bonlieu and Obazine, is necessary.

The grisailles of those two former abbeys were 'discovered' and published in the middle of the nineteenth century by Abbé Texier, then the parish priest of Dorat, an indefatigable Limousin scholar to whom homage should be paid.[5] His pioneering works still serve as important references, even if certain of the propositions which he enunciated have become out-dated on the material as well as on the historical level. His publications on the subject which concerns us here are indispensable. His testimony is, in fact, essential for the panel from the former abbey church of Bonlieu (Creuse), near Aubusson,[6] since this glass has disappeared,[7] and since Abbé Texier gave a complete and detailed description of it (Fig. 1).[8]

At the time of the Revolution, the abbey of Bonlieu was sold as the property of the French government, and was purchased by a family from the Bordeaux region.[9] Bonlieu had been founded in 1119 by Géraud de Sales, a follower of Robert d'Arbrissel and the founder of the abbey of Dalon. Géraud de Sales had, for several decades, served as the head of the order for a congregation of hermetic inspiration in the Limousin and neighboring provinces.[10] Concerning the construction of Bonlieu, it is known that in 1141 the bishop of Limoges consecrated an altar there.[11] As was proved by the archeological study of the monument, which was difficult to make because of the state in which it was found, the building was far from finished in 1141.[12] When Abbé Texier 'discovered' the grisaille panel in 1845, it was found behind the main altar, probably at the place where it had originally been installed.[13] That fact permitted the Limousin scholar to state that it had been put into place on the occasion of the con-

secration in 1141, and that it was a question then 'du plus ancien
vitrail conservé en France à dates précises,'[14] a judgment which to-
day appears somewhat exaggerated. A consecration of an altar, even
that of the main altar, does not prove that a religious building has
been finished, and caution is advised concerning this matter.

In 1162-1163, Bonlieu was affiliated to the order of Bernard of
Clairvaux at the same time as Dalon.[15] Because Bonlieu was growing
very rapidly and housed a significant number of monks, the estab-
lishment enlarged its church, which was consecrated only in 1232 by
the bishop of Limoges, Guy de Clauzel.[16] In the absence of any ar-
chival documentation, it is reasonable to concede that this grisaille
panel could be evidence of the first Cistercian work at this site.
It could only have been installed in the years 1160-1170, and not be-
fore the middle of the twelfth century as Abbé Texier had stated.
Moreover, we will prove that technical and formal analogies make
this work comparable to the grisailles of Obazine, the execution of
which is also to be dated after 1150.[17]

As we indicated at the beginning of this essay, the Bonlieu
panel has disappeared since Abbé Texier studied it. As long ago as
1919, the learned Albert Lacrocq mentioned its loss in his inventory
of the glass of the Creuse, without giving the reasons for it.[18] Was
it destroyed or sold? The first hypothesis seems the most plausible.
Sections of the eastern parts of the former abbey church were pulled
down in 1870, causing serious damage.[19] Today only a part of the
apse and the north arm of the transept, which has been transformed
into a chapel by the present owner, remain standing. A few years
ago, at the time of the auction at the Hôtel Drouot of the collec-
tion of old glass brought together by the painter-glazier Michel
Acezat (24-25 November 1969), a panel similar to the one from Bonlieu
was sold.[20] We have been able to see and to examine this panel re-
cently: the dimensions agree. An informed eye is needed to recog-
nize that it is a forgery: certain pieces have been cut from old
glass; and other modern pieces have been shaded with grisaille paint
in order to appear authentic, but the design and the cutting differ
in certain details from the drawings published by Abbé Texier. It
should be admitted that this is a good copy made in the nineteenth
century as was often the case.

An analysis of authenticity is also of prime importance for
the study of the grisailles of the former abbey church of Obazine
(Corrèze). It is amazing that, since the nineteenth century, it
has not been done in spite of the numerous publications on the pan-
els,[21] particularly because inspection of the restoration records
kept at the Archives des Monuments Historiques gives important infor-
mation on this problem.[22] We will not review the history of this
monastic establishment, since Bernadette Barrière has just published
it;[23] the history of the abbey church, on the other hand, interests
us. The church was begun about 1156.[24] Its construction was rather

advanced in 1176, the date when a consecration took place.[25] It
would appear that the monument was completely finished about 1190.[26]
Originally the nave included six bays, a projecting, wide transept
to satisfy the liturgical needs of the community, and a polygonal
choir.[27] In the eighteenth century the building was at the point
of ruin and the three western bays of the nave were demolished in
1757 (Fig. 2).[28]

Under the Restoration, the bad state of the former abbey church,
which had become the parish church, preoccupied the civil and eccle-
siastical authorities of the Corrèze, and even the authorities in
Paris.[29] The architect Abadie was appointed to draw up a report on
the urgency of work to be carried out. An estimate and plans were
then sent to the Administration des Cultes which did not consider
it expedient to proceed any further because the commune was too poor
to pay its share of the cost. Almost every year from 1852 to 1875,
the Conseil général of the Corrèze sent a detailed report to Paris
concerning the state of disrepair of one of the most prestigious
monuments of the department. In 1875, one fact seems to have played
a determining role in obliging the central Administration des Cultes
to intervene: the leading citizens of the commune of Obazine were
accused of having sold the glass and the objects belonging to the
church. Naturally they denied the charge:

> ...as the glass existing today fills almost entirely
> three bays on the north side and part of other bays,
> all of it in a deplorable state and at the point of
> ruin; and as the missing parts of the original
> glass have fallen from old age and from accident into
> a state where repair is completely impossible.[30]

How is this ambiguous text to be interpreted? Three windows,
those of the north aisle of the nave, the best protected in all
respects, still possessed their original glass, which was in a bad
state, but repairable. On the other hand, for two other windows,
those of the north arm of the transept, the decay had gone so far
that restoration could no longer be envisaged. This interpretation
is confirmed by the notes and drawings that an English traveler made
from these grisailles, which we have just discovered at the Biblio-
thèque des Monuments Historiques.[31] The watercolor drawings of the
three grisailles of the windows of the north aisle show the same
motifs and the same composition as today; on the other hand, for
the window of the north arm of the transept, the conception is slight-
ly different, proving that the original design was not respected at
the time of the restoration, which took place some years later (Fig.
3). Examination of the report of the Inspecteur général E. Boes-
willwald, which was written after the investigation opened by the
Administration des Cultes on the possible sale of the glass or

objets d'art belonging to the former abbey church, leads to similar conclusions:

> With regard to the glass dating from the epoch of the construction and which was said to have been sold by the commune, I believe that I ought to assure you, Minister, that this glass still occupies the four windows of the aisle and of the north transept. But the leads of the transept window are so worn-out that the glass falls from its settings.[32]

In concluding, Emile Boeswillwald asked that something be done as soon as possible, and he designated Nicolas Coffetier to carry out this intervention. Boeswillwald's recommendations were not followed. It was only in 1876 that Anatole de Baudot was officially charged with the repairs of the former abbey church.[33] He was assisted, at the site, by the architect Louis Bonnay, who had the glass restored, not by Coffetier, but by Oudinot in the 1880s.[34] This lapse of time was hardly beneficial for the grisailles, in particular for that of the north arm of the transept, the design of which was changed; for the others, it was necessary to remake numerous parts, but their original conception was respected.

In 1910, the architect of the Monuments Historiques, Chaîne, had the other windows of the church filled following an archeologically questionable decision: the motifs of the old grisailles were re-copied, but arranged differently in order 'to vary the compositions.'[35] This procedure, customary in the nineteenth century and at the beginning of the twentieth century, has led specialists to be, with just cause, severely critical with regard to the glazing of this church. Nevertheless, our present investigation, which physical analysis confirms, shows that the conception and some of the glass of the three grisailles ornamenting the windows of the north aisle of the nave should be regarded as authentic; we are much more cautious about the grisaille panels in the first western window of the north arm of the transept (Figs. 4-7).

Before beginning the formal study of these works, it is appropriate to supply some technical details. The Cistercian rule specifies the use of white glass, 'Albe vitrae,' that is to say, having a large percentage of soda salts, which originally produced greenish tones. These glasses, under effects of corrosion, have become pitted and darkened, and therefore are less translucent. In the nineteenth century, the master glaziers did not know how to clean and treat these glasses, and they replaced the darkened pieces almost automatically with modern glass.

The cutting of the glass is characterized by another technical peculiarity. For economy, the painters of these grisailles have used a particular process which completely accounts for the drawing

of the Bonlieu panel published by Abbé Texier (Fig. 1). The dotted
lines do not indicate a supplementary cut; on the contrary, in order
to avoid cutting, a half-lead has been used, a single flange of which
has been given the desired form. This piece has then been dipped in
a bath of tin so that it stays rigid, then soldered onto the glass
at several points. Finally, these grisailles carry no painting; only
the outline of the leads determines the forms. At the end of the
twelfth century, we see traces of paint used in crosshatching to animate
the backgrounds, as at Noirlac (Fig. 8).[36]
 A similar principle of composition governs these works, whether
they are of vegetal or geometric type. A central axis distributes
the motifs into two symmetrical zones. The first type is construct-
ed from stylized vegetal elements: for example, the lost grisaille
of Bonlieu is composed of a pattern of palmettes in heart-shaped
frames locked together and fastened by bands or flat knots. At Oba-
zine, the same vegetal motif has been used: the palmette is formed
from five wide lobes. In the latter example, the lower lobes form
an appendage partially covering the vine enclosing the design unit.
This particular arrangement is also seen in certain manuscripts from
Saint-Martial at Limoges, notably those executed by the painter of
a lectionary produced at the end of the tenth or at the beginning
of the eleventh century, and today preserved in Paris at the Biblio-
thèque Nationale (MS. lat. 5301).[37]
 The choice of such an archaizing ornamental repertory should
not be surprising. Very pertinent relationships between these gri-
sailles of the vegetal type and Islamic transennas have been estab-
lished by Eva Frodl-Kraft,[38] between that of Obazine with palmettes
enchâssées, and a transenna from the Umayyad castle of Qasr-el Heir
al-Gharbi (about 727-750), today reconstructed at the National Muse-
um in Damascus,[39] and with a plaque, probably of Syrian origin, re-
used over a tomb in San Marco in Venice.[40] Our grisailles belong
to the same formal ambiance as the Islamic transennas. It is evi-
dent that there is no question of direct contact, but rather of the
revival of an old ornamental vocabulary, common to the entire Medi-
terranean basin, which finds vitality and popularity at certain mo-
ments. Does not one discover analogous examples among the transennas
still preserved in the Visigothic churches of Asturias? At San Sal-
vador de Val de Dios (Fig. 9), this decoration of pierced stone pre-
sents formal analogies with one of the grisailles from Obazine (Fig.
4);[41] at San Juan de Baños, a stucco claustra has a simple twisted
cord for a border, as at Obazine.[42] The constant relations between
Spain and these regions allow one to assume that these stucco or
stone screens, which have the same architectural function as the
grisailles, could have more of an effect on the choices of the Cis-
tercians than the Islamic prototypes.
 The second type of grisaille imagery is geometric, constructed
on the theme of interlace. German scholars have sometimes questioned

the use of this term for our grisailles, preferring the expression 'geometricized lattice.'[43] Clearly the design does not form compli- cated and irregular knots as in Irish art, but is rigorously organ- ized as the analysis of one of the grisaille motifs from Obazine shows. Each motif is broken up into two concentric circles bound to each other by a network, with four loops on the axis, and two on the sides (fig. 10). It is a perfectly organized geometric figure, the antecedents of which were known since antiquity. The Carolingian world revived it again, in particular, in the world of sculpture;[44] this ornamental tradition has continued during the following centur- ies.[45] Often, with just cause, the first Cistercian grisailles have been compared with pre-Romanesque plaques or capitals decorated with interlace.[46]

On the other hand, the formal relationship between this type of grisaille and the *fenestellae*, several pre-Romanesque and Romanesque examples of which have survived, has not been noted. This method of covering windows goes back to Antiquity, and is continued during the early Middle Ages.[47] It has stayed in use in regions of soft stone so long that the size of the windows has remained of little import- ance. It is certain that *fenestellae* and glass closures have often had a parallel development, the glass being a precious material which was reserved for prestigious buildings. At Lyon, the basilica of Patiens, constructed about 470, was ornamented with glass having geo- metric designs;[48] it is possible that they had an effect comparable to that of the grisailles in the Corrèze. For the less important mon- uments, a system of stucco or stone window screens was very frequently retained.

An inventory, which does not pretend to be exhaustive, shows that several stone window screens dating from the eleventh and twelfth cen- turies are preserved in the regions neighboring Obazine. It was, then, a type of window closure still widely used in the west of France during the Romanesque period. The *fenestellae* of the Charentaise church of Fenioux (Fig. 11) have been well known since the publications of Viol- let-le-Duc[49] and Enlart (Fig. 12).[50] Of the seven recorded in the nineteenth century, there remain today only three, one of which is in- complete.[51] The analysis of the architectural context in which they are found proves that they date from the eleventh century.[52] The an- alogies which they present with our grisailles are more on the level of general composition than in the choice of motifs. The stone ribbon is always the same width; the relationships between the solids and the voids produce an impression similar to that of the play of pieces of glass in the grisailles.

Other *fenestellae* offer even clearer correspondances with the ob- jects of our study: one example, because of its geographic proximity with the Corrèze abbey, and the others, because of their formal simi- larities. The first window screen has been inventoried by the photo- graph library of the Centre d'Etudes Romanes de Poitiers. It decorates

a small church of the Vienne, that of Saint-Rémy-sur-Creuse, near
Châtelleraut[53] (Fig. 13). Very badly damaged, in part blocked by
modern plaster, it could date from the twelfth century, which is
of interest for our investigation.
 The second example is found in the Bordelaise church of Gironde.[54]
Its upper part is truncated, as is the preceding example, having been
hidden by rough plaster. The lower loop is still legible, a circle
cut by four arcs forming secant and regular loops, with a design rath-
er similar to our grisaille 'à entrelacs' at Obazine.
 The last example is found at the church of Verrie (Maine-et-
Loire), a monument studied not long ago by Abbé Plat, precisely be-
cause of these claustra.[55] Our example has passed unnoticed up until
the present, since it is incomplete and blocked (Fig. 14). It is easy
to see that its composition is related to those of the preceding ones,
with two concentric circles cut by a network of four knots, and also
by diagonals, resulting in a strong formal relationship among all these
works. *Fenestellae* and Romanesque grisailles, then, depend upon the
same formal system, and this is especially to be noted because evolu-
tionary processes must be considered, in so far as it is possible,
through similarities in their use. In our case, this statement seems
particularly justified since it is a question of the transcription of
a design from one material to another which had the same function in
the monument. The stone and stucco examples, the present rarity of
which one can only deplore, have probably helped the Cistercians to es-
tablish the decorative vocabulary of their first windows, even if the
materials used were different. The choice of stone was no longer pos-
sible because of the enlargement of the windows, and because of the
role which light had at this epoch: the glass transforms the light
whereas the stone, even pierced, filters it. With the *fenestellae* we
could have one of the formal origins of the first grisailles, although
up until now this relationship has not been considered.
 The rarity of the extant authentic panels does not permit estab-
lishing a definite conclusion regarding this relationship, except for
the fact that the Cistercians, doubtless because of their concern for
economy, never sought to innovate in this area, and they were content
to return to an ornamental vocabulary in use since Antiquity.

Musée des plans-reliefs, Paris

NOTES

I would like to thank Mme M.-M. Gauthier, Maître de Recherche at the Centre National de la Recherche Scientifique, and Mme M. Vieillard-Troiekouriff, Chargée de Recherche at the Centre National de la Recherche Scientifique, for the help they have given me.

1. L. Bégule, *Les Vitraux du moyen âge et de la renaissance dans la région lyonnaise* (Paris: 1911), pp. 106-7; and M. Aubert, *L'Architecture cistercienne en France*, 2nd ed. (Paris: 1947) 1: 311.
2. *Statuta capitulorum Generalium Ordinis cisterciensis*, ed. J.-M. Canivez (Louvain: 1933) 1: 31.
3. Renewed in 1159 and 1182, ibid., pp. 70 and 91.
4. L. Grodecki (with the collaboration of C. Brisac and C. Lautier), *Le Vitrail roman* (Fribourg: 1977), pp. 40-1, 277, and 285.
5. Abbé J. Texier, 'Histoire de la peinture sur verre en Limousin,' *Bulletin archéologique et historique du Limousin* 1 (1846) 20-9 and 94-148; and Abbé J. Texier, 'Origine de la peinture sur verre; système inconnu de vitraux romans,' *Annales archéologiques* 10 (1850) 81-9.
6. Commune de Peyrat-la-Nonière, canton de Chénérailles.
7. A. Lacrocq, 'Les vitraux de la Creuse,' *Mémoires de la société des sciences naturelles et archéologiques de la Creuse* 21 (1919-21) 503-4.
8. Texier, 'Limousin,' p. 94.
9. A. Lacrocq, 'L'Abbaye de Bonlieu,' *Mémoires de la société des sciences naturelles de la Creuse* 23 (1925-27) 327-32.
10. J.-M. Canivez, 'Dalon,' *Dictionnaire d'histoire et de géographie ecclésiastiques* 14 (Paris: 1960), cols. 38-40.
11. *Gallia Christiana*, 2, province de Bourges, cols. 623-624; hereafter cited as GCh.
12. Lacrocq, 'Bonlieu,' p. 328.
13. See above, note 9.
14. Ibid.
15. GCh 2, col. 624.
16. Ibid.
17. Grodecki, p. 285.
18. Lacrocq, 'Creuse,' p. 502.
19. Lacrocq, 'Bonlieu,' p. 329.
20. *Catalogue de la vente après décès de l'ancienne collection de vitraux anciens de M. Acezat* (Paris, Hôtel Drouot, 24-25 novembre 1969) no. 13, pl. 11.
21. See in particular Texier, 'Origine,' pp. 81-9; L. Bonnay, 'Vitraux du XIIe siècle de l'église d'Obazine,' *Bulletin de la société scientifique et archéologique de la Corrèze* 2 (1879) 199-202; Aubert, 1: 311; H. J. Zakin, 'French Cistercian Grisaille

Glass,' *Gesta* 13 (1974) 17-9, figs. 2-3 and 7-8; and Grodecki, pp. 40-41 and 285.

22. Paris, Archives de monuments historiques, église d'Obazine (Corrèze), ancienne abbatiale, refection et restaurations, I (1852-1901), and II (1901-29).

23. B. Barrière, *L'Abbaye cistercienne d'Obazine en Bas-Limousin* (Tulle: 1977).

24. J. Poulbrière, 'Sur la date de construction de l'église d' Obazine,' *Bulletin de la société scientifique, historique et archéologique de la Corrèze,* 2 (1879) 213-220.

25. GCh 2, col. 635.

26. Ibid., col. 636; A. Banchereau, 'L'Eglise d'Obazine,' *Congrès archéologique de France* 84 (1921) 347-8.

27. Ibid., pp. 347-50.

28. J. De Ribier and E. Lajugie, 'Sur les travées de l'abbatiale d'Obazine,' *Bulletin de la société des lettres, sciences et arts de la Corrèze* 74 (1970) 213-5.

29. Paris, Archives de Monuments Historiques, église d'Obazine, I. (This information is furnished by the later documents such as the deliberations of the Conseil Municipal of Obazine asking for the refurbishing of the building after 1852)

30. 'Que les vitraux existants à ce jour consistant dans trois travées du côté nord, presque entiers et partie d'autres travées, le tout dans un état déplorable et menaçant ruine et que le manquant des vitraux primitifs est tombé de vétusté et accidentellement dans un état où la réparation est tout à fait impossible.' (Report of the Conseil Municipal of Obazine, 4 mars 1876, ibid.)

31. C.-H. Purday, *Croquis* (1873-4) 4, pls. 8-9 (Paris, Archives des monuments historiques, ms. 4, 1844).

32. 'En ce qui concerne les vitraux datant de l'époque de la construction et que l'on affirmait avoir été vendus par la Commune, je crois devoir vous assurer, M. le Ministre, que ces vitraux occupent encore les quatre baies du collatéral et du transept nord. Mais les plombs de la baie du transept sont usés au point que les verres s'échappent de leurs sertissures,' (Report of E. Boeswillwald, 12 avril 1876, Paris, Archives des Monuments Historiques, eglise d'Obazine, I.)

33. Paris, Archives des Monuments Historiques, église d'Obazine, I, report of 12 avril 1879.

34. There is relatively little information on the restoration itself; it is necessary to refer to the article of Bonnay, 'Vitraux du XIIe siècle de l'église d'Obazine.'

35. Report and estimate of 9 décembre 1910, Archives des Monuments Historiques, église d'Obazine, II.

36. R. Crozet, *L'Abbaye de Noirlac* (Paris: 1932) pp. 35-6 and figs. 12-3; *Vitraux de France, Paris, Musée des Arts décoratifs*, catalogue (Paris: 1953) no 13 bis; Zakin, *Gesta* p. 19, fig. 6.

37. D. Gaborit-Chopin, *La Décoration des manuscrits à Saint-Martial de Limoges en Limousin* (Paris: 1969) pp. 56-7 and 206.

38. E. Frodl-Kraft, 'Das "Flechtwerk" der frühen Zisterzienserfenster,' *Wiener Jahrbuch für Kunstgeschichte* 20 (24) (1965) 8-12, fig. 11.

39. S. Abdul-Hak, 'La Reconstitution d'une partie de Ksar al-Heir al-Gharbi au Musée de Damas,' *Annales archéologiques de Syrie* 1, no. 1 (1951) 5-70; S. Abdul-Hak, *Les Trésors du Musée national de Damas* (Damas: n.d.) p. 26, pls. XLVIII-L.

40. O. Demus, 'Zwei Dogengräber in San Marco-Venedig,' *Jahrbuch der Österreichischen byzantinischen Gesellschaft* 5 (1956) 41-61.

41. For the last word on this question, see J. Fontaine, *L'Art préroman hispanique* (La Pierre-qui-Vire: 1973) pl. 132.

42. Ibid., fig. 55.

43. On this question see most recently C. Nordenfalk, 'Corbie and Cassiodorus,' *Pantheon* 32 (1974) 225-31.

44. Th. V. Bogvay, *Zum Problem der Flechtwerksteine in karolingischer und ottonischer Kunst* (Wiesbaden: 1957) pp. 262-76; and J. Hubert, in *L'Empire carolingien* (Paris: 1968) pp. 31-7 figs. 270-71.

45. J. Hubert, *L'Art pré-roman* 1st ed. (Paris: 1938) pp. 162-4, figs. 187a and b.

46. These relationships have been mentioned above all by Zakin, *Gesta* pp. 24-5, figs. 18-23.

47. See in particular Abbé J. Plat, *L'Art de bâtir en France des Romains à l'an 1100* (Paris: 1929) pp. 97-100; and Hubert, p. 121.

48. Sidoine Apollinaire, *Lettre à Hesperius* II, 10, ed. E. Baret (Paris: 1887) p. 150; Sidoine Apollinaire, *Lettres (Livres 1-4)*, ed. A. Loyen (Paris: 1970) 2: 65.

49. Viollet-le-Duc, 'Fenêtre,' *Dictionnaire raisonné de l'Architecture française* (Paris: 1856-64) 5, pp. 370-9, fig. 4.

50. C. Enlart, *Manuel d'archéologie française, architecture religieuse* (Paris: 1927), 1, p. 335, fig. 144.

51. F. Eygun, 'L'Eglise paroissiale de Fenioux et la lanterne des morts,' *Congrès archéologique de France* 104 (1956) 306; R. Crozet, *L'Art roman en Saintonge* (Paris: 1971) p. 34, pl. Vc.

52. Ibid.

53. There is no study on this building which has nevertheless been the object of a photographic campaign by the Centre d'études romanes de Poitiers.

54. J. A. Brutails, *Les Eglises de la Gironde* (Bordeaux: 1912) p. 207.

55. Plat, p. 99.

Translation by Helen Zakin.
This study was first presented at the *102e Congrès national des Sociétés Savantes (Limoges, 1977, archéologie)* (Paris: 1979).

CISTERCIAN GLASS AT LA CHALADE (MEUSE)

Helen Jackson Zakin

Among the least known of all French Cistercian houses is La
Chalade (Meuse), the only abbey in Lorraine to have remains
of its medieval glazing.[1] La Chalade was founded in 1128
by monks from Trois-Fontaines, in the filiation of Clair-
vaux.[2] St Bernard himself wrote a letter congratulating Henry of
Winchester, Bishop of Verdun, on this new Cistercian foundation,
and asking him for guarantees of protection.[3] A chapel was conse-
crated here by Albéron of Chiny, Bishop of Verdun, in 1136.

The La Chalade glass, dated in the early fourteenth century,
is unlike that of the more well-known French Cistercian twelfth cen-
tury sites such as Bonlieu and Obazine.[4] The earlier sites have
white, blankglazed windows; their glass is decorated with foliate
and geometric motifs defined by the leading alone. At La Chalade,
vegetal imagery is painted on the glass, and colored glass appears
in the borders and the centers of the panels.

The glazing at La Chalade has been heavily restored. Neverthe-
less, it is worthy of study because it is beautiful, and because it
provides evidence for the evolution of one distinctive Cistercian
art form, grisaille glass. This discussion of the La Chalade glass
will focus on three areas: (1) a description of the glass, prefaced
by a short description of the architecture; (2) a stylistic analysis;
and (3) a proposal for the dating based on heraldic evidence.

DESCRIPTION

La Chalade was in the diocese of Verdun; it was within the
county of Clermont, which after 1132 was a fief of the Count of
Bar.[5] He in turn held it from the bishop of Verdun, who paid hom-
age for it to the Emperor. According to *Gallia Christiana* the abbey
placed itself under the protection of the Count of Bar as early as
1183.[6]

The abbey church of La Chalade has an aisled, two bay nave; a
square crossing; one straight choir bay; a polygonal apse; and a
transept, each arm of which has two bays (Fig. 1).[7] The east aisles
of the transept arms were no doubt intended to be used for individ-
ual chapels, although the bays are not separated from each other as
was customary in earlier Cistercian plans. There is also one aisle
bay on the west side of the north transept.[8]

The polygonal apse is pierced on all five sides by double, tre-
foiled lancets with a trilobe above (Fig. 2). Windows in the aisles
of the transept arms and in the aisles of the nave consist of two

trefoiled lancets crowned by a quadrilobe. The clerestory windows
have a trilobe over two trefoiled lancets. In the end wall of the
north transept is a large four-light window. Here a trilobe is
placed above each pair of lancets, the whole topped by a quadrilobe.[9]

In 1928 André Ventre, the architect charged with the post-World
War I restoration, wrote a short statement explaining that his work-
men had found a box containing a large number of fragments of old
glass. The box had been filled with glass before the war and placed
in one of the aisles. Ventre said that the glass found in the box
matched some of the glass still in the windows in 1928.[10] This memo-
randum was appended to his estimate detailing the costs for restor-
ing the glass and included a plan which showed how the remains of
the old glass in the nave and clerestory windows would be consolidat-
ed in the choir and transept east aisle windows. He planned to put
old glass in windows nII, nIV, nV, NIV, nVI, sII, sIV and sV (Fig. 1).
Ventre did not explain how the glass found in the box was to be fit-
ted together with that found in the windows. It is important to
stress, however, that there was a considerable amount of old glass
here in 1928. Some of that old glass survived World War II, was re-
stored by the firm of J.-J. Gruber in Paris, and has again been re-
installed in the windows of La Chalade.

There are now two grisaille lancets in the central window of
the choir. The left lancet (Fig. 3) is filled with quarries which
are painted with rather naturalistic foliage. Each quarry has its
own independent motif; the foliage does not trail over several quar-
ries. The ground is left clear, without crosshatching, and the fil-
lets are leaded on one side only. There is a series of quatrefoils
down the center of the window, perched on the irons. The center part
of each quatrefoil is yellow pot-metal painted with an oak leaf pat-
tern and is surrounded by red fillets and blue lobes. Unpainted blue
glass alternates in the border with pieces decorated with ivy-like
foliage picked out in white against a black ground. Red fillets frame
the borders.

There are only scattered fragments of old glass in this lancet.
The panels which have the greatest amount of old glass are those
which are third, fourth, seventh, eighth, eleventh and twelfth from
the bottom; panels 1, 9, 10, and 13 have none. There are a number
of old border pieces, particularly in panels 3, 4, 5 and 6. Before
World War II there were two lancets which had this pattern at nII
(Fig. 9). These two lancets were probably combined when the glass
was restored by Gruber.

The right choir lancet is a little different (Fig. 4). Here
one finds quarries varied by two vertical, undulating fillets. Natu-
ralistic foliage, painted on the clear ground, resembles that of a
strawberry plant, the vine wandering under fillets and across lozen-
ges. Red and blue quarries and half quarries are set down the center

and sides of this panel. The borders, now installed upside down
as are the panels, are decorated with a symmetrical pattern which
includes two kinds of leaves. The present border undoubtedly com-
prises fragments of borders from the two lancets originally placed
to the right of the axial window.

This window is slightly better preserved than its mate. Panels
4, 5, 8, 9, 10, 11 and 12 are made up of at least one half old glass
(panels 1 and 13 have none). Panels 2, 3, 4, 5, 8, 9, 10, 11 and
12 have old border pieces.

The trilobe at the top of this window, bearing the arms of Na-
varre, is very important for the dating of the glass (Fig. 5).
About one half of the pieces in this coat of arms are old, as are
many pieces in the trilobe panel in which it is set. A few frag-
ments of the lovely murrey border also appear to be old.

There are bits and pieces of old glass in the chapel windows
on the east side of the transept. Beginning with window nV, two
trilobes are decorated with a somewhat richer foliage, a variant of
the 'cabbage leaf style' (Fig. 6). These veined leaves are set
against a hatched ground, surrounded by red and blue fillets, and
decorated with red, yellow, and blue accents. The right trilobe
has more old glass than the left. Some of the border is old as are
some of the accent pieces.

According to Ventre's 1928 *devis*, the trilobes to be placed
here would come from the westernmost south nave clerestory window
(SVI), and the east clerestory window from the adjoining north tran-
sept bay (NII).[11] The clerestory windows all have trilobes above
the lancets (unlike the aisle windows which have quadrilobes).

In the adjoining north transept aisle window (nIV) there are
two old lancets whose imagery is quite unusual in French glass paint-
ing (Fig. 7). These are basically lozenge windows with colored bor-
ders and bosses. The painted design consists of monsters--grotesques
with human or animal heads and leafy bodies, placed on crosshatched
grounds. Though the left lancet has more old glass than the right,
only two sets of these strange grotesque heads are preserved: those
in the bottom panel of the left lancet, and those in panel 3 of the
right lancet. Many border pieces in the left lancet are old, as
well as bits and pieces of several bosses.

Here Ventre planned to put the lancets from the clerestory win-
dow directly above this aisle window (NII).[12] Assuming that these
plans were carried out, we can postulate that one of the trilobes in
the adjoining north transept aisle windows was originally used above
these two lancets.

Window sIV in the south transept aisle is now filled with two
lancets with yet another design (Fig. 8). Here a circular fillet
is inscribed within the square panel; the circle is then sliced up
by the lozenge fillets. Again there are colored rosettes in the

center of the windows, and very thin 'block borders'. The ground is hatched and the foliage, which trails under the fillets, seems to grow from a central stem. (The foliage actually grows upward; the panel is illustrated right side up, although presently it is up side down in the window.) The fillets are leaded on one side in this lancet, the other side painted with a double line.

There are five panels which have old glass in these two lancets; the rest is completely new. Panels 1, 2, and 4 in the left window are partly old, as are panels 2 and 3 in the right window. There are many old border and rosette pieces.

Ventre's *devis* is only partially helpful here. His plan indicates that he planned to put panels here from the clerestory window on the west side of the north nave aisle, and from a north transept east clerestory window (NIII; Fig. 1).[13] That one of these windows came from the north transept east clerestory window need not be doubted, but the other could not have come from 'the clerestory window on the west side of the north nave aisle,' because there never was a window at that spot.

The remaining fragments, rather homely, are placed in the aisle window of the southernmost chapel of the south transept (sV).[14] These fragments were obviously once at the top of the smaller lancets. The pattern resembles that seen in the nV fragments, that is, heavily painted leaves on a crosshatched ground with thin, red borders. There are two of these fragments in sV, but the left one has more old glass.

Again Ventre is not very helpful. According to his plan these fragments came from 'the west side of the south nave aisle clerestory.'[15] There are no clerestory windows on the west side of the south nave aisle, just as there are no clerestory windows on the west side of the north nave aisle.

Combining the evidence of the extant glass with information gleaned from nineteenth century descriptions, pre-World War I photographs, and Ventre's restoration *devis*, one can reconstruct the pre-1914 appearance of this glass. In 1850 Barthélemy said there was fifteenth century glass behind the altar representing saints under canopies, and that there were grisaille lancets to either side of these colored ones. He also reported the coats of arms of France, Bar, and Champagne above the apse windows.[16]

Jadart, writing in 1894, commented on the grisaille lancets on either side of the axial apse window (which he said was filled with a modern scene of the Presentation in the Temple) and also mentioned the coats of arms in the apse.[17] A photograph possibly taken about 1910 (Fig. 9) shows figural glass in the axial apse windows, probably the nineteenth century Presentation. The remnants of canopy figures are also visible above this scene. The grisaille windows described by both Barthélemy and Jadart appear on either side of the axial window. The colored lancets in the apse have now disappeared,

and the four grisaille lancets have been consolidated to make the
two grisaille lancets presently in the axial window.

Barthélemy mentioned that there were fragments of old glass in
a transept chapel[18] while Jadart said there were colored fragments
in the lateral chapels, but that specific scenes were not recogniz-
able.[19] Colored fragments of a canopy window are clearly discerni-
ble in another old photograph, also about 1910.[20] Ventre did not
reuse any old glass from the transept chapels in his 1928 restora-
tion campaign; evidently all the old glass from these chapels--
colored and otherwise--had disappeared by then.

Neither Barthélemy nor Jadart mentioned any glass in the clere-
stories, but all the glass which Ventre planned to put in aisle win-
dows came from clerestory windows. Furthermore, all the glass which
Ventre found in these clerestory windows was grisaille glass. One
might tentatively conclude that the clerestory had always been glaz-
ed with grisaille.

STYLE

The La Chalade glass is stylistically anomalous within the con-
text of French Cistercian glazing. The glass now in nIV (Fig. 7),
for example, is decorated with leafy, grotesque creatures which would
have been forbidden by the Cistercian statutes.[21] The connection is
not to French but to German Cistercian glass, notably Altenburg where
such dragons and monsters make their appearance with the transept
campaign.[22] Grotesques also appear in a group of early fourteenth
century German Cistercian manuscripts studied by Ellen Beer.[23]

There are a few fragments of glass at La Chalade painted with
rich foliate decoration on a hatched ground (Fig. 6) which also show
some similarity to German Cistercian glass at Altenberg.[24] The type
of foliage seen at La Chalade is quite different, but thickly painted,
rather naturalistic leaves and hatched grounds appear at both sites.
This Altenberg glass is in the choir chapels, and can be dated in the
fourth quarter of the thirteenth century.[25] The Heiligenkreuz clois-
ter glass,[26] datable between 1220 and 1250, can also be mentioned here.
Again, however, the vegetal motifs are quite different.

Some of the La Chalade grisailles have connections with thirteenth
century, non-Cistercian glass. A pattern similar to that in the right
chevet lancet at La Chalade (Fig. 4) occurs at Evreux[27] and in a gri-
saille window at St-Urbain de Troyes (Fig. 10), probably from the
1270s.[28] The St-Urbain foliage is somewhat stiffer and is organized
along a vertical stem. The combination of vertically undulating fil-
lets and foliage growing from a central stem is typical of late thir-
teenth century grisailles.[29] At La Chalade the central stem itself
is missing but the foliage does seem to have its origin along the axis
of the window.

Certain connections with another St-Urbain window can be seen in

the left chevet lancet at La Chalade, where colored quatrefoils are placed on a field of quarries (Fig. 3).[30] The quatrefoils in the center of the La Chalade lancet resemble those at St-Urbain, but the La Chalade quatrefoils are really used quite differently. They are smaller, deeply colored, and placed on the irons rather than in the center of the panels. The border pattern in this La Chalade window shows some connection with the St-Urbain border, a widespread motif in eastern France in the early fourteenth century.[31]

Clearly none of these comparisons are totally satisfactory. There is really very little extant glazing in northeastern France for comparison. None of the Orbais (Marne) grisailles are relevant here; they are probably much earlier. Furthermore, there is no similar grisaille extant in Reims, although some of the glass at St-Nicaise, now destroyed, may have been related to that at La Chalade.[32]

The La Chalade glass is handsome and of fine quality. The chevet grisailles, in particular, are beautifully painted. It is difficult to rationalize the refined painting and the tasteful use of color with the isolated location of this abbey. One must therefore postulate relatively sophisticated sources of patronage.

DATE

There are no extant documents which refer to the construction or glazing of La Chalade. On the basis of stylistic evidence, however, the architecture can be conservatively dated in the first decade of the fourteenth century.[33] La Chalade is an example of the Rayonnant or Court Style phase of French Cistercian architecture. Unfortunately Cistercian building in France had slowed considerably by the end of the thirteenth century and there are relatively few examples of this French Cistercian 'court style'.

The abbey church of Altenberg, the German Cistercian house near Cologne, is one of the few buildings which shows a close architectural relationship with La Chalade, and Altenberg was influenced in turn by the French Cistercian abbey church of Royaumont (Seine-et-Oise).[34] The tracery pattern used at La Chalade for the apse windows (Fig. 2) is a slightly modified version of that found in the clerestory of the Altenberg hemicycle; the rather complex tracery pattern in the north transept at La Chalade is similar to that of the Altenberg straight bay choir clerestory.[35] The choir arcade of Altenberg and the nave arcade and crossing at La Chalade are supported by columnar piers; the Altenberg choir capitals resemble, to a certain extent, those seen at La Chalade.[36] The east end of Altenberg was finished, except for the glass, by 1275.[37]

Some of these details can be found in buildings closer to La Chalade. Columnar piers and ring capitals occur in a number of buildings in the Mosan region, such as Ste-Catherine in Verdun, begun ca. 1290-1310.[38]

The aisle and clerestory tracery patterns found at La Chalade both have Court Style origins ultimately, but both are widespread by the end of the thirteenth century. The quadrilobe above two tre-foiled lancets was found on the facade of St-Nicaise in Reims, and was, according to Branner, a very popular tracery pattern in eastern France in the second half of the thirteenth century.[39] The trilobe above two trefoiled lancets, another common motif, can be seen in Paris c. 1235 as well as in Burgundy c. 1270.[40]

Perhaps the most useful tool for dating the La Chalade glass is that of the coat of arms in the apse window (Fig. 5). In the nine-teenth century there were three coats of arms in the apse.[41] In 1850 Barthélemy said that the Champagne arms were on the left, the Bar arms on the right and the Capetian *fleur-de-lis* in the center.[42] The Navarre arms (gules, a cross saltire and double orle of chains, linked together or), borne after 1234 by the counts of Champagne, are the only arms extant, and they are now in the center trilobe.[43]

This heraldic combination of France, Bar, and Navarre could not occur here before 1301 since the counts of Bar and the counts of Champagne had had a very stormy relationship in the latter part of the thirteenth century. In 1268 King Louis IX had arbitrated a quar-rel between them.[44] La Chalade was located on the troubled border close to the town of Ste Menehould, where Countess Blanche of Cham-pagne had established a fortress early in the thirteenth century.[45] The border disputes became much more serious after 1285 when Philip the Fair became King of France; Philip had married Jeanne of Navarre, Countess of Champagne, in 1284. Having the count of Champagne for a neighbor was uncomfortable for the counts of Bar, but having the king of France nibbling on their territories was unacceptable.

As early as 1273 the monks of Montfaucon-en-Argonne, a Benedic-tine abbey in the territory of the count of Bar, had sought the pro-tection of the king of France. In 1290 Count Thibaut II was fined 10,000 *livres* by the Parlement in Paris because he refused to appear before it to answer the complaints of this abbey. Thibault appealed to the king of France to resolve the dispute, thereby acknowledging the authority of the king and French Parlement over what was really Barrois territory.[46]

Thibaut's son Henri III married the daughter of King Edward I of England, with whom he joined in a pact against Philip the Fair. In 1297 Henri attacked the abbey of Beaulieu-en-Argonne, which had also sought the protection of the king of France. Philip, occupied in Flanders, sent Gaucher de Châtillon, who defeated the count of Bar and took him prisoner. By the Treaty of Bruges, signed in 1301, Henri was forced to do homage to the king of France for all of his allodia, or freely held lands, west of the Meuse. Henri died in 1302, at which time his son Edouard I (1295 or 1296 - 1336) was six or seven years old.[47] Edouard, who gained control of his territor-ies in 1311, was reared in Paris at the court of Philip the Fair.[48]

Obviously neither Thibaut II nor Henri III would have donated glass to La Chalade with the arms of Champagne or of France. The young Edouard is the only likely patron, and he undoubtedly made this donation after 1301.

Edouard may have given the glass in 1307: in that year Louis le Hutin, eldest son of Philip the Fair and Jeanne of Navarre, was crowned king of Navarre.[49] As count of Champagne, Louis was Edouard's western neighbor; as eldest son of Philip, Louis was Edouard's future suzerain. In 1306, a marriage was contracted between Edouard and Marie of Burgundy, who was Louis's sister-in-law and a granddaughter of St Louis.[50] Evidently the house of Bar wished, at this time, to establish amicable relations with the Capetians.

At the very least, one can say that Edouard probably commissioned the La Chalade glass between the years 1307 and 1314. By 1314, when Louis became King of France, the relationship between the two doubtless would have deteriorated. Margarite, Louis's wife and Edouard's sister-in-law, had been imprisoned for adultery earlier that same year. She died in prison early in 1315, and Louis married Clemence of Hungary in August, 1315. The La Chalade glass, with its coats of arms of Navarre, France and Bar, must predate these events.

State University of New York at Oswego

NOTES

1. Research for this paper was funded by the Research Foundation of the State University of New York. An earlier version was read at the Cistercian Studies Conference held at Western Michigan University, in 1978. The present version was prepared during a 1980 Summer Seminar funded by the National Endowment for the Humanities, at Syracuse University. I would especially like to thank: Professor Meredith Lillich, the Director of that NEH Seminar, for her many helpful suggestions; Professor Elizabeth A. R. Brown, who originally suggested to me that Edouard might have donated this glass at the time of Louis's coronation as king of Navarre; and Norman Schlesser, for his help with historical information.

2. For information about the foundation and history of this abbey, and for additional bibliography about these subjects see: M. Aubert, *L'Architecture cistercienne en France*, 2nd ed. (Paris: 1947) 1: 74-5; J.-M. Canivez, 'Chalade (La),' *Dictionnaire d'histoire et de géographie ecclésiastiques* 12 (Paris: 1953) p. 266; Abbé Clouet, *Histoire de Verdun et du pays Verdunois* (Verdun: 1867) 1: 405-7, and 2: 238-42; M.-A. Dimier, *Recueil de plans d'églises cisterciennes* (Paris: 1949) 1: 96; N. Gauthier, 'L'Abbaye cistercienne de La Chalade,' *Horizons d'Argonne* no. 22 (1971) pp. 1-7; N. Robinet, *Pouillé du diocèse de Verdun* (Verdun: 1888) 1: 736-49; N. Roussel, *Histoire ecclésiastique et civile de Verdun* (Bar-le-Duc: 1864) 2: 252-3.

3. J.-P. Migne, *Patrologiae cursus completus, series latina,* 182 (Paris: 1862) Epistola 63, cols. 168-9; *The Letters of Bernard of Clairvaux,* trans. B. James (London: 1953) Letter 66, p. 90.

4. For discussion of the Bonlieu and Obazine glass see: C. Brisac, 'Romanesque Grisailles from the Former Abbey Churches of Obazine and Bonlieu,' in this volume; H. Zakin, *French Cistercian Grisaille Glass* (New York: 1979) pp. 13-23 and 44-52, pls. 1-9 and 50-4; and H. Zakin, 'French Cistercian Grisaille Glass,' *Gesta* 13 (1974) pp. 17-28.

5. M. Parisse, *La Noblesse Lorraine, XIe - XIIIe s.* (Paris: 1976) 1: 581.

6. *Gallia Christiana,* 13, 1320. There is a document dated 1247 which states that La Chalade had been placed under the protection of Count Thibaut of Bar: A. Lesort, *Les Chartes du Clermontois conservées au Musée Condé, à Chantilly (1069-1352)* (Paris: 1904) pp. 96-7.

7. For information about the architecture of this abbey see: Aubert, *L'Architecture cistercienne,* 1: 204, 273 et passim; E. de Barthélemy, 'Sur l'église et l'abbaye de La Chalade (Meuse),' *Bulletin monumental* 16 (1850) pp. 589-93; M.-A. Dimier, *L'Art cistercien:*

France, 2nd ed. (La Pierre-qui-vire: 1974) p. 57; Dimier, *Recueil de plans*, 1: 96 and 2: pl. 70; H. Jadart, 'La Chalade, la forêt, le village et l'ancienne abbaye, ses pierres tombales,' *Revue de Champagne et de Brie* 6 (1894) pp. 26-33; Roussel, *Histoire ecclésiastique* 2: 253-4.

8. For information about the restoration of the architecture and the glass see: Zakin, *French Cistercian Grisaille Glass*, pp. 69-70. The present abbey buildings, located on the south side of the church, were constructed in the early eighteenth century: J. Evans, *Monastic Architecture in France from the Renaissance to the Revolution* (Cambridge: 1964) p. 57. They are owned by the descendants of the family that purchased them in 1790. The abbey church is now used by the parish.

9. The La Chalade aisle, clerestory, and north transept windows are illustrated in Zakin, *French Cistercian Grisaille Glass*, pls. 79 and 80.

10. Dossier, Monuments Historiques (Meuse, La Chalade, 890).

11. Ibid.

12. Ibid.

13. Ibid.

14. Illustrated in Zakin, *French Cistercian Grisaille Glass*, pl. 91.

15. Dossier, Monuments Historiques (Meuse, La Chalade, 890).

16. Barthélemy, 'Sur l'église,' p. 591.

17. Jadart, 'La Chalade,' p. 29.

18. Barthélemy, 'Sur l'église,' p. 591.

19. Jadart, 'La Chalade,' p. 29.

20. Caisse Nationale des Monuments Historiques et des Sites, photograph MH 27.564.

21. J. Canivez, *Statuta capitulorum generalium ordinis cisterciensis ab anno 1116 ad annum 1786*, 1, *Ab anno 1116 ad annum 1220* (Louvain: 1933), p. 31 and 91; H. Séjalon, *Nomasticon cisterciense seu antiquiores ordinis cisterciensis constitutiones* (Solesmes: 1892), p. 287 and 395.

22. Hans Wentzel, 'Die Glasmalerei der Zisterzienser in Deutschland,' *L'Architecture monastique/Die Klosterbaukunst* (Numéro spécial, *Bulletin des relations artistiques France-Allemagne*, May 1951) pp. 175, 178 (ill.).

23. E. Beer, *Beiträge zur oberrheinischen Buchmalerei in der ersten Hälfte des 14. Jahrhunderts unter besonderer Berücksichtigung der Initialornamentik* (Basel: 1959), Abb. 27-39 and 46-7.

24. G. Panofsky-Soergel, *Rheinisch-Bergischer Kreis*, 2, *Klüppelberg-Odenthal*, Die Denkmaler des Rheinlandes (Düsseldorf: 1972), Abb. 244-7.

25. Ibid., p. 109.

26. E. Frodl-Kraft, *Die mittelalterlichen Glasgemälde in Nieder-Österreich*, Corpus Vitrearum Medii Aevi Österreich 2, pt. 1 (Vienna: 1972), p. 98 and Abb. 250-1, 255, and 284.

27. L. Day, *Windows: A Book about Stained and Painted Glass* (London: 1909) p. 156, fig. 135. Lafond dated this window in the third quarter of the thirteenth century: J. Lafond, 'Le Vitrail en Normandie de 1250 à 1300,' *Bulletin monumental* 111 (1953) p. 345.

28. M. Lillich, 'Three Essays on French Thirteenth Century Grisaille Glass,' *Journal of Glass Studies* 15 (1973) p. 76.

29. M. Lillich, 'A Redating of the Thirteenth-Century Grisaille Windows of Chartres Cathedral,' *Gesta* 11 (1972) p. 14.

30. L. Grodecki, 'Les Vitraux de Saint-Urbain de Troyes,' *Congrès archéologique* 113 (1955) p. 136, fig. 6.

31. Ibid., p. 137.

32. There was formerly a window in St-Nicaise, destroyed in the eighteenth century, which was donated by Thibaut II, Count of Bar, and his wife Jeanne of Toucy. This window is described in: L. Maxe-Werly, 'Les Vitraux de Saint-Nicaise de Reims,' *Bulletin archéologique de la comité des travaux historiques et scientifiques* no. 2 (1884) pp. 122-30. It is illustrated and also described in: C. Givelet, *L'Eglise et l'abbaye de Saint-Nicaise de Reims* (Reims: 1897) pp. 72ff. According to the illustration reproduced by Givelet, the St-Nicaise window was a canopy window.

33. Aubert dated the architecture of La Chalade c. 1320-1340 *(L'Architecture cistercienne* 1: p. 285); Dimier used the same dates *(L'Art cistercien,* p. 57); Van der Meer dated it c. 1310-1340 [F. Van der Meer, *Atlas de l'ordre cistercien* (Paris: 1965) p. 275]. Aubert dated the glass to the fourteenth century *(L'Architecture cistercienne* 1: 313).

34. C. Bruzelius, 'Cistercian High Gothic: The Abbey Church of Longpont and the Architecture of the Cistercians in France in the Early Thirteenth Century,' *Analecta Cisterciensa* 25 (1979) 136.

35. Panofsky-Soergel, *Rheinisch-Bergischer Kreis,* fig. 20 between pp. 104-5; and R. Branner, *St. Louis and the Court Style* (London: 1965) p. 134, fig. 14.

36. Panofsky-Soergel, *Rheinisch-Bergischer Kreis,* Abb. 229, 232-5, and 272-4; Aubert, *L'architecture cistercienne* 1: 275, fig. 149; 286, fig. 190.

37. Panofsky-Soergel, *Rheinisch-Bergischer Kreis,* p. 91.

38. L. Schürenberg, *Die kirchliche Baukunst in Frankreichs zwischen 1270 und 1380* (Berlin: 1934) pp. 218-9. Columnar piers and ring capitals are also found at Chaudardes (Aisne), northeast of Reims: E. Lefèvre-Pontalis, 'L'Eglise de Chaudardes,' *Congrès archéologique* 78, 2 (1911) pl. following p. 324, p. 326, and pls. following p. 326. The nave rib profile seen at Chaudardes (p. 327) is very similar to that of La Chalade (Aubert, *L'Architecture cistercienne* 1: 265, fig. 138). The choir chapels at Chaudardes, destroyed in World War I, were lit by double trefoiled lancets crowned by a trilobe (Lefèvre-Pontalis, 'L'Eglise de Chaudardes,'

pl. opposite p. 330), as is the apse of La Chalade (fig. 2).
Schürenberg dated the nave of Chaudardes c. 1300, and the choir
c. 1350 (*Die kirchliche Baukunst*, p. 221).

39. Branner, *St. Louis and the Court Style*, p. 82.

40. Ibid., pp. 46-7 and pl. 43; R. Branner, *Burgundian Gothic Archi-
 tecture* (London: 1961) pl. 30b. There are three tomb slabs,
 presently mounted upright in the south transept at La Chalade,
 which might be useful for dating the building. Their general
 format indicates that they can be dated in the late thirteenth
 or early fourteenth century. All three slabs are engraved with
 representations of knights, one of whom wears a flat heaume which
 is similar to that seen on a Flemish tomb slab dated c. 1280: F.
 Greenhill, *Incised Effigial Slabs: A Study of Engraved Stone
 Memorials in Latin Christendom, c. 1100 to 1700* (London: 1976)
 2: pl. 48, fig. 48a. The inscriptions on the tomb slabs were
 recorded by Jadart, 'La Chalade,' pp. 30-1.

41. Barthélemy, 'Sur l'église,' p. 591; Jadart, 'La Chalade,' p. 29.

42. Barthélemy, 'Sur l'église,' p. 591.

43. For the explanation of how the counts of Champagne came into
 possession of Navarre see: R. Fawtier, *The Capetian Kings of
 France: Monarchy and Nation (987-1328)*, trans. L. Butler and
 R. Adam (New York: 1969), pp. 127-9.

44. W. Jordan, *Louis IX and the Challenge of the Crusade* (Princeton:
 1979) pp. 200-1.

45. C. Hubert, 'Etudes sur les frontières septentrionales et orien-
 tales du comté de Champagne (936-1284),' *Positions des thèses
 de l'Ecole des Chartes* (1958) p. 48. La Chalade is located be-
 side a small river, the Biesme, which defined the border between
 Bar and Champagne. Today this river marks the boundary between
 the departments of the Marne and the Meuse.

46. R. Fawtier, *L'Europe occidentale de 1270 à 1328*, I, *De 1270
 à 1328*, Histoire du moyen âge, ed. G. Glotz, 6 (Paris: 1940)
 p. 365.

47. Grosdidier de Matons gave both 1295 and 1296 for Edouard's
 birthdate, but did not cite his source: M. Grosdidier de
 Matons, *Le comté de Bar dès origines au Traité de Bruges (vers
 950-1301)* (Paris: 1922) pp. 460 and 507.

48. Fawtier, *L'Europe occidentale*, p. 366.

49. Jeanne of Navarre, Louis's mother, died in 1305, but Louis was
 not crowned king of Navarre until 1307: *Les Grandes chroniques
 de France*, 8, ed. J. Viard (Paris: 1934) p. 255 and J. Lacarra,
 *Historia politica del reino de Navarra desde sus origenes hasta
 su incorporacion a Castilla*, 2 (Pamplona: 1972) p. 256.

50. Grosdidier de Matons, *Le comté de Bar*, p. 507 and E. Petit,
 Histoire des ducs de Bourgogne de la race capetienne, 7, *Regnes
 de Hugues V et Eudes IV mars 1306 à fevrier 1345* (Dijon: 1901)
 pp. 7, 453 and 476. Edouard and Marie were not actually married
 until 1310.

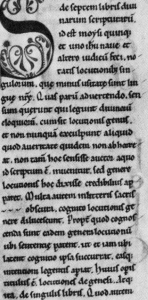

Zakin, Fig. 1. St Augustine, *Quaestiones et Locutiones in Heptateuchum*, Syracuse University, Smith MS. 1, folio 139r (the author)

Zakin, Fig. 2. St Augustine, *Quaestiones et Locutiones in Hepta-teuchum*, Syracuse University, Smith MS. 1, folio 139v (the author)

Zakin, Fig. 3. St Augustine, *Quaestiones et Locutiones in Hepta-*
 teuchum, Syracuse University, Smith MS. 1, folio
 60r, detail (the author)

Zakin, Fig. 4. St Augustine *et alia, Opera quaedam,* University of
 Pennsylvania, Latin 63, folio 37v, detail (the author)

Zakin, Fig. 5. St Augustine *et alia*, *Opera quaedam*, University of Pennsylvania, Latin 63, folio 43r (the author)

spe disciplíne effugiet fictum. Qui ergo uult habere spm scm ca
neat foris ab secta remanere. caueat in ea simulatus intrare. aut
si ū uult intrare caueat in eadē simulatione psistere. ut ueracit
contescat in arbore uite. Prolixum ihi librū direxi. et uult fo
raste occupationib; onerosum. Si ergo potuerit tibi ut par
tib; legi. Dabit tibi dñs intellectum. ut habeas quid respon
deas eis corrigendis atq; sanandis. quos etiā tibi ipsi tanquā
fideli filio mater eccta. ubi potueris. et quomodo potueris si
ue ipse loquendo. et respondendo. siue ad doctores eccte pdu
cendo. in adiutorio dñi corrigendos. sanandosq; commendat.
Expl lib sci augustini epi de correctione donatistarum. Incip
retractatio aureli augi epi in libro de fide et opibus.
Interea missa sunt m̄ a quibꝰdam fribus laicis quidem; si diuinorum e
loquiorum studiosis scripta quaedam; que ita distinguerent a bonis opi
bus xpianam fidem. ut sine hac non posse. sine illis aūt posse pue
niri suadetur ad eternam uitam. Quib; respondens librum scpsi;
cui nomen est de fide et opibus. In quo disputaui non solum
quemadmodum uiuere debeant gra xpi regeniati. uerum eti
am quales ad lauacrum regeniationis admitti; hic lib sic incipit;.
Expl retractio. Incip lib eiusdem de fide ⁊ opibus.
Quibusdam uidetur indiscrete oms admittendos
esse ad lauacrum regeniationis que est in xpo ihu dño nro.
etiam si malam turpemq; uitam facinorib; et flagitiis euidentissi
mis notam mutare noluerint. atq; in ea se pseueraturos aperta eti
am pfessione declarauerint. Verbi gra. Si quisquam meretrici
adheret. non ei prius pcipiatur ut ab ea discedat. et tunc ueniat ad
baptismum. si etiam cum ea manens mansurumq; se confitetur. si
ue etiam pfitens. admittatur et baptizetur. Nec impediatur fie
ri membrum xpi etiam si membrum meretricis esse pstiterit. si
postea doceatur quam sit hoc malum. iamq; baptizatus de mu
tandis in melius moribus instruatur. Prius enim putant atq;
pposterum prius docere quemadmodum debeat uiue xpianus.

Zakin, Fig. 6. St Augustine *et alia*, *Opera quaedam*, University of
Pennsylvania, Latin 63, folio 58v (the author)

Zakin, Fig. 7. St Augustine *et alia*, *Sermones*, Cambridge, Fitzwilliam Museum, McClean MS. 104, folio 1r (Fitzwilliam Museum, Cambridge)

Zakin, Fig. 8. St Augustine *et alia, Contra Felicem et opera alia,*
Cambridge, University Library, Add. 3576, folio 1r
(Cambridge University Library)

Serra, Fig. 1 Viterbo, San Martino al Cimino. Lateral portal.

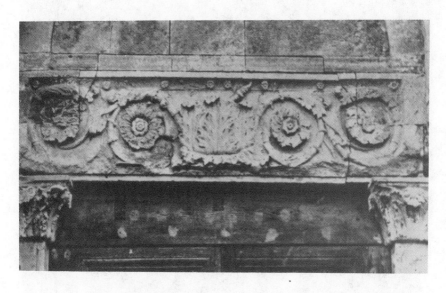

Serra, Fig. 2 Siena, San Galgano. Lintel of the main portal.

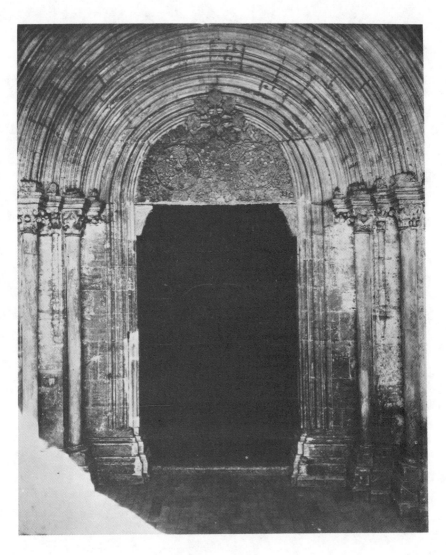

Serra, Fig. 3 Casamari, Portal of the facade.

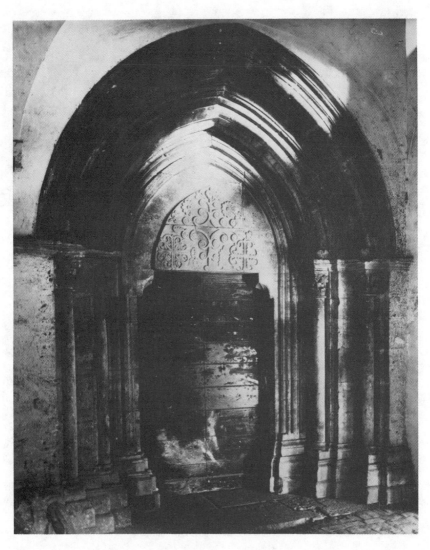

Serra, Fig. 4 Casamari. Portal of the atrium.

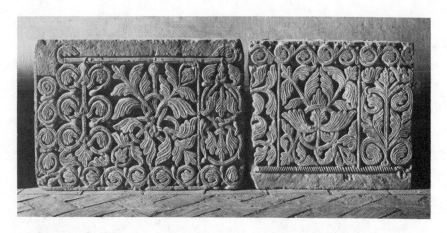

Serra, Fig. 5 Casamari. Marble transenna.
 (photo: Rome, Gabinetto Fotografico Nazionale)

Serra, Fig. 6 Casamari. Marble transenna.
 (photo: Rome, Gabinetto Fotografico Nazionale)

Serra, Fig. 7 Tarquinia, San Francesco. Altar relief.
(photo: Enzo Falleroni, Tuscania, Viterbo)

Serra, Fig. 8 Viterbo, Museo Civico. Relief.

Serra, Fig. 9 Capranica, Ospedale. Tympanum.

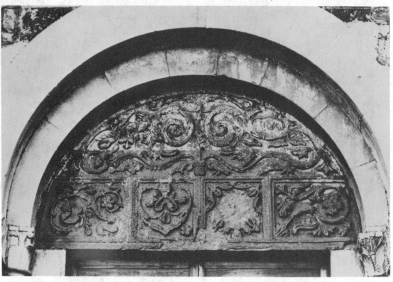

Serra, Fig. 10 Vetralla, San Francesco. Tympanum.

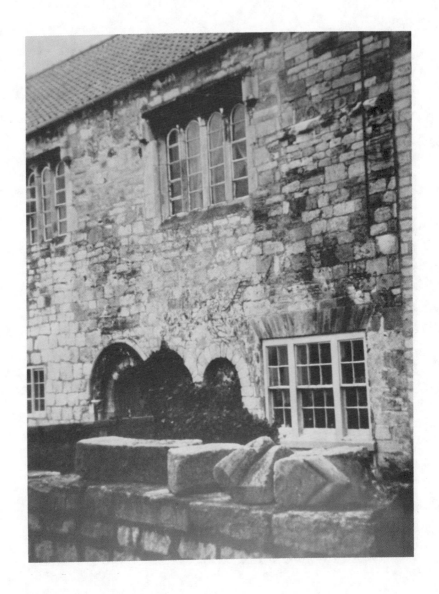

Nichols, Fig. 1 Sinningthwaite. North side of south range.

Nichols, Fig. 2 Sinningthwaite. Stone sink, ground floor, eastern-
most chamber.

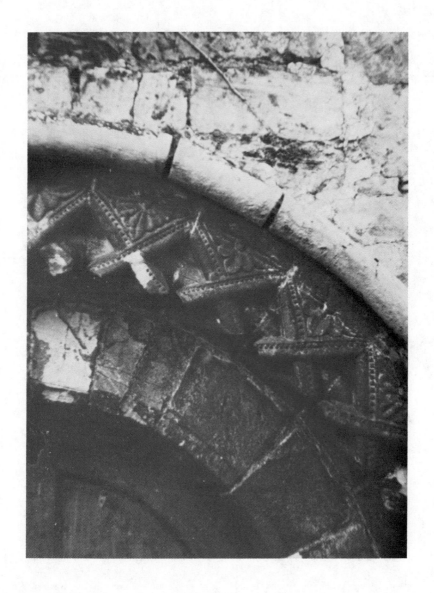

Nichols, Fig. 3 Sinningthwaite. Detail of arch, Norman doorway.

Nichols, Fig. 4 Sinningthwaite. Serpent's head on roll molding,
Norman doorway.

Nichols, Fig. 5 Sinningthwaite. Perpendicular windows, south side.

Nichols, Fig. 6 Sinningthwaite. Fragments of sculpted masonry.

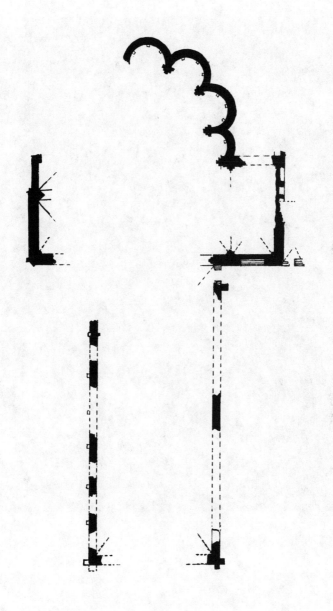

Gallagher, Fig. 1 Mortemer, plan (drawing: Roger Adams)

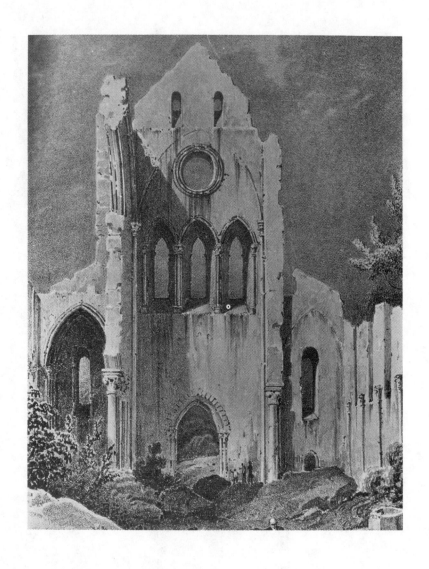

Gallagher, Fig. 2 Mortemer, facade interior (A. Joly, from Taylor-
Nodier, *Voyages pittoresques*, 1825)

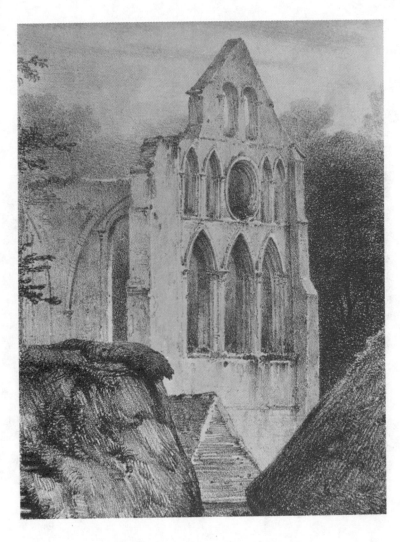

Gallagher, Fig. 3 Mortemer, facade from northwest (Enfantin, from
 Voyages pittoresques, 1825)

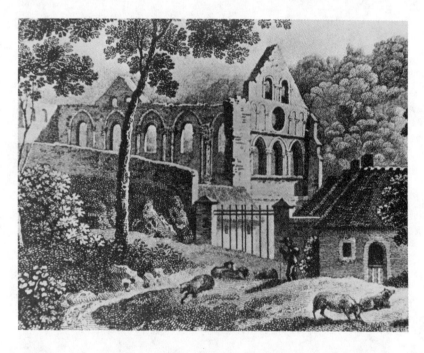

Gallagher, Fig. 4 Mortemer, facade from northwest (undated, from
Herval, *Beautés de la Normandie*)

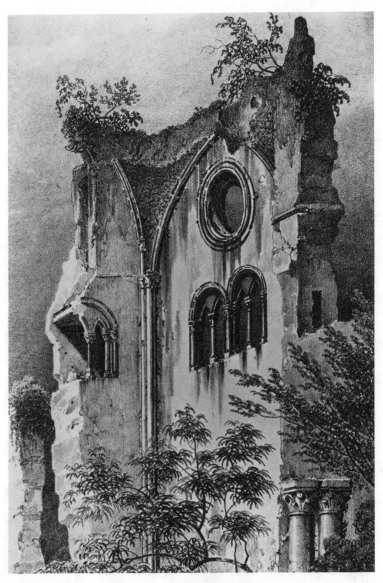

Gallagher, Fig. 5 Mortemer, northwest corner of transept (A. Joly, from *Voyages pittoresques*, 1825)

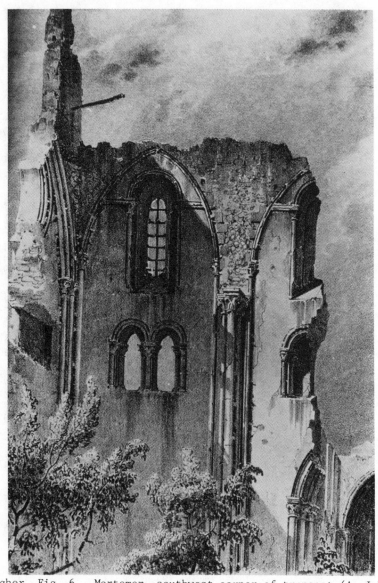

Gallagher, Fig. 6 Mortemer, southwest corner of transept (A. Joly,
from *Voyages pittoresques*, 1825)

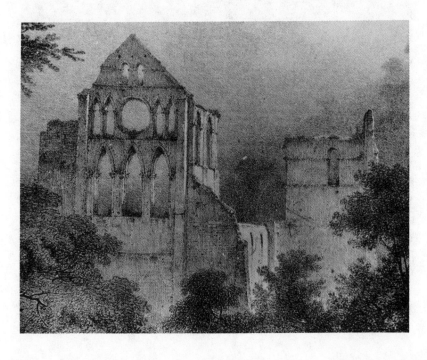

Gallagher, Fig. 7 Mortemer, facade from west (Enfantin, from *Voyages
 pittoresques*, 1825)

Gallagher, Fig. 8 Mortemer, west portal (J. Jorand, from *Voyages pit-toresques*, 1825)

Gallagher, Fig. 9 Mortemer, northwest corner of transept
(photo: author)

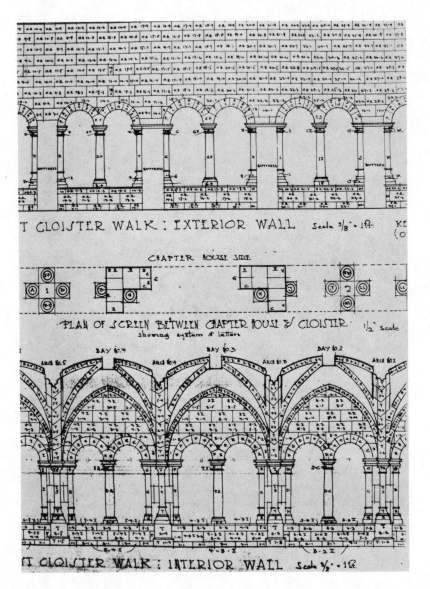

Sowell, Fig. 1 Sacramenia. Detail of one of the stone setting plans
 for the east cloister. (Made in Spain by Arthur Byne)

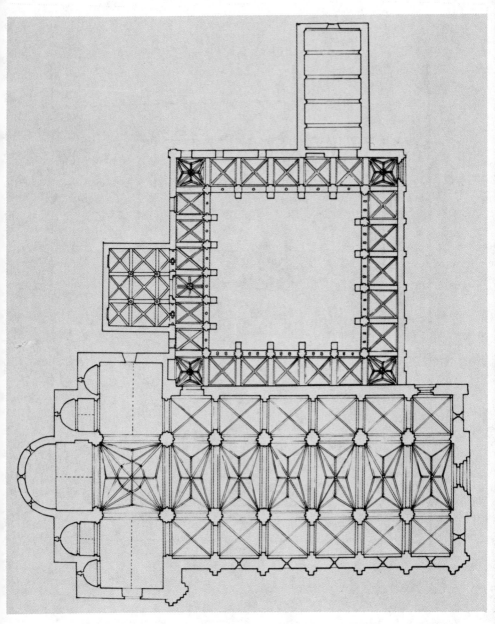

Sowell, Fig. 2 Sacramenia. Plan of the monastery buildings now
 reconstructed in Florida in their original relation-
 ship to the church which remains in Spain.

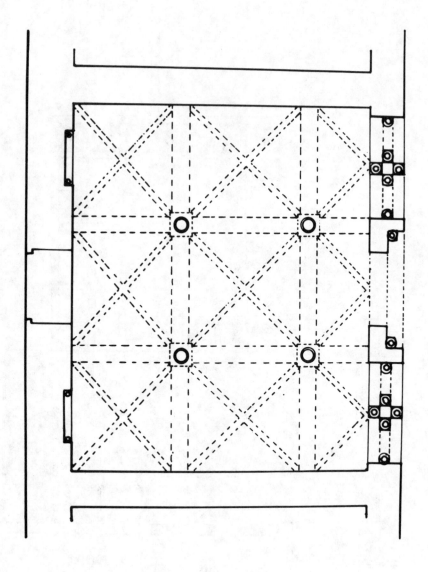

Sowell, Fig. 3 Sacramenia. Plan of the chapter house.

Sowell, Fig. 4 Sacramenia. North walk of the cloister as recon-
structed in Florida. (Photo: Rev. Bruce E. Bailey)

Sowell, Fig. 5 Sacramenia. East walk of the cloister as reconstruct-
ed in Florida. (Photo: Rev. Bruce E. Bailey)

Sowell, Fig. 6 Sacramenia. Refectory under construction in
 Florida (1953).

Sowell, Fig. 7 Sacramenia. Chapter house under construction in
 Florida (1953).

Sowell, Fig. 8 Sacramenia. Interior of the chapter house as re-
constructed in Florida. (Photo Rev. Bruce E. Bailey).

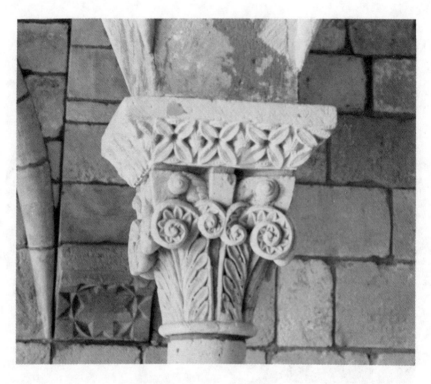

Sowell, Fig. 9 Sacramenia. Capital of the chapter house. (Photo: Rev. Bruce E. Bailey)

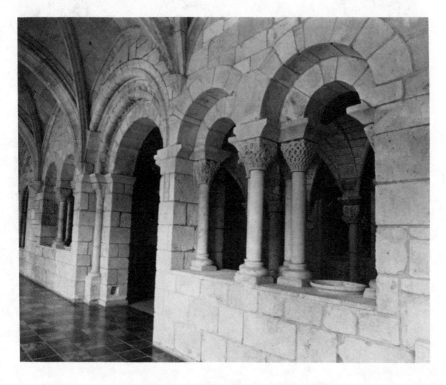

Sowell, Fig. 10 Sacramenia. East walk of the cloister showing the
chapter house entry. (Photo: Rev. Bruce E. Bailey)

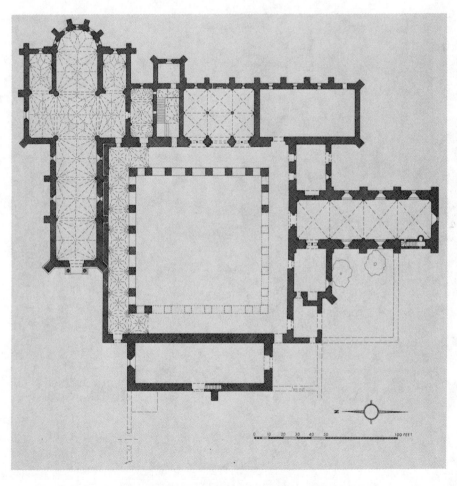

Burke, Fig. 1 Santa Maria de Ovila. Plan of monastery before
 1931. (Author)

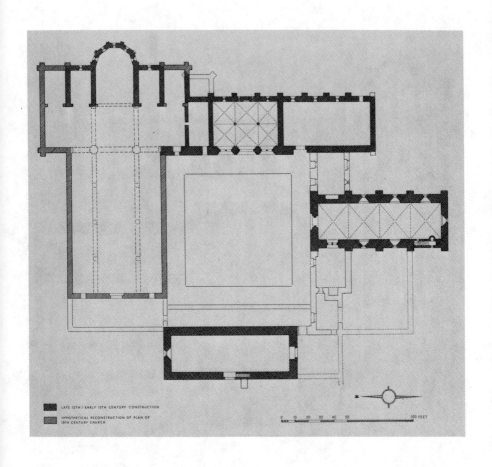

Burke, Fig. 2 Santa Maria de Ovila. Reconstruction of plan with
 thirteenth-century church. (Author)

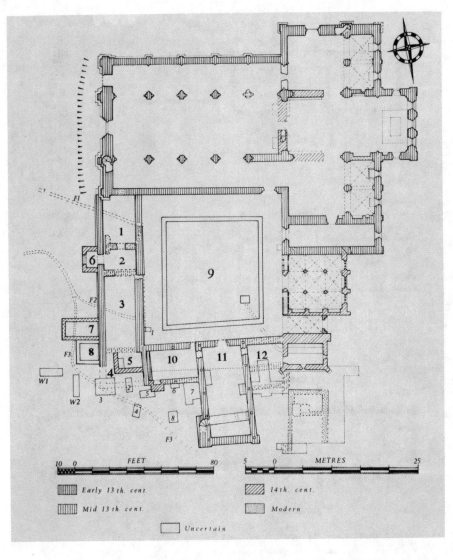

Butler, Fig. 1 Valle Crucis, Denbighshire, Wales. Excavations of 1970/71 revealing west range and south range.

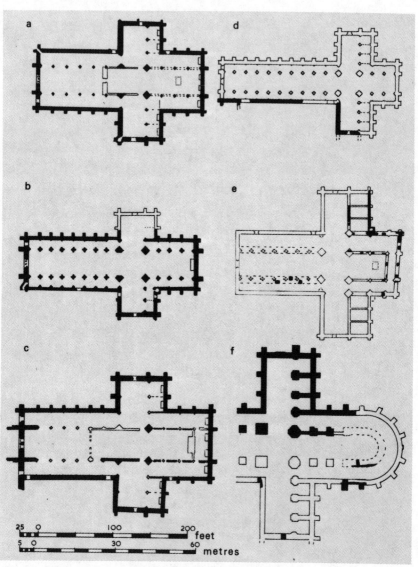

Butler, Fig. 2 Maenan (Aberconway II), Caernarvonshire, Wales.
Plan of the Abbey found in excavation (e) and
comparative plans of the late thirteenth century
from Tintern (a), Netley (b), Neath (c), Whalley
(d), Vale Royal plan of 1277, nave omitted (f).

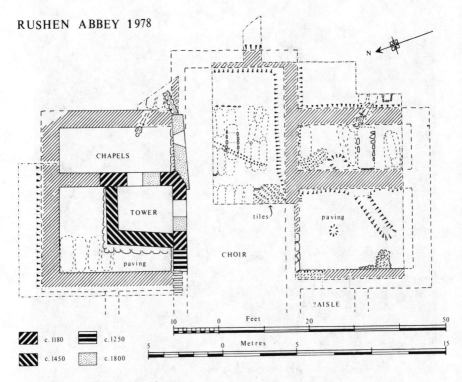

RUSHEN ABBEY 1978

CHAPELS

TOWER

paving

CHOIR

tiles

paving

?AISLE

N

c. 1180 c.1250

c.1450 c.1800

10 0 Feet 20 50

5 0 Metres 5 15

Butler, Fig. 3 Rushen Abbey, Isle of Man, plan of east end
of the church. Excavations of 1978/9.

Butler, Fig. 4 Carved head of Morus, probably forming corbel of
refectory pulpit, Valle Crucis Abbey. 1970.
(Copyright, National Museum of Wales)

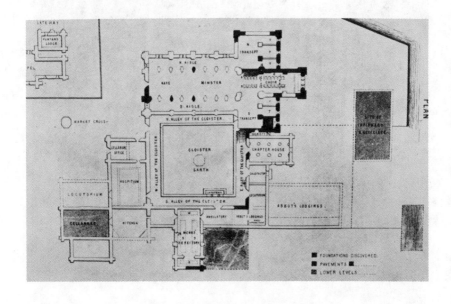

Walsh, Fig. 1 Bordesley Abbey. Plan of James Woodward, 1864
(after Woodward).

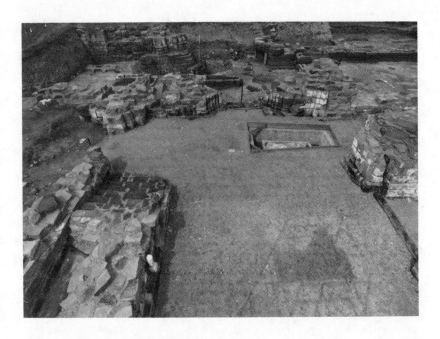

Walsh, Fig. 2 Bordesley Abbey. View of the crossing from the
 south wall of the south transept (photo: P. Rahtz).

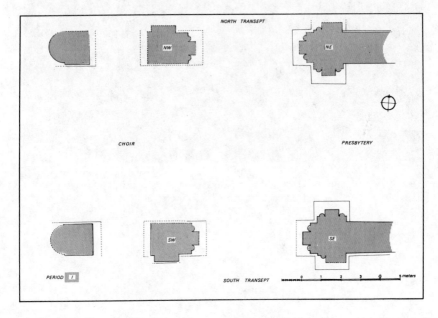

Walsh, Fig. 3 Bordesley Abbey. Plan of the choir as in Period 1
(drawing: author).

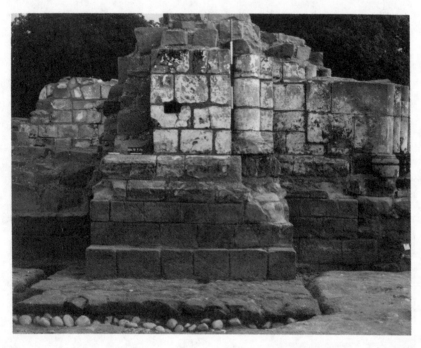

Walsh, Fig. 4 Bordesley Abbey. Southeast crossing pier of Period 1
viewed from the north (photo: P. Rahtz).

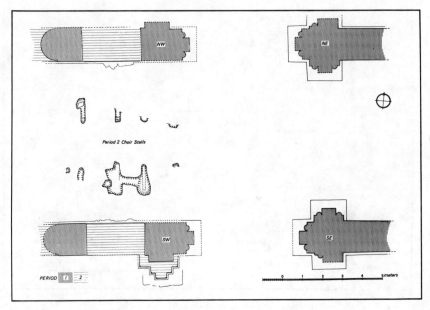

Walsh, Fig. 5 Bordesley Abbey. Plan of the choir as in Period 2
(drawing: author).

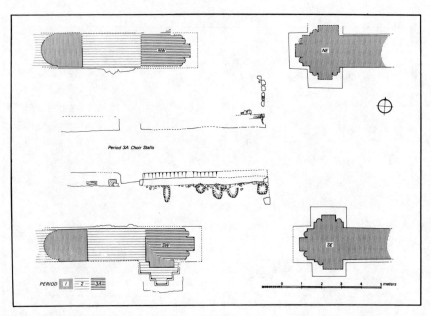

Walsh, Fig. 6 Bordesley Abbey. Plan of the choir as in Period 3A
(drawing: author).

Walsh, Fig. 7 Bordesley Abbey. Fragment of a choir stall
 (drawing: author).

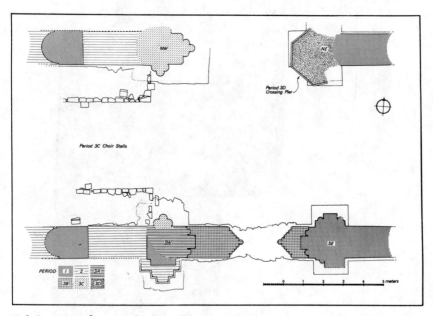

Walsh, Fig. 8 Bordesley Abbey. Plan of the choir as in Periods
 3B, 3C, and 3D (drawing: author).

Walsh, Fig. 9 Bordesley Abbey. Fragment of the fallen northwest
crossing pier of Period 3A (photo: P. Rahtz).

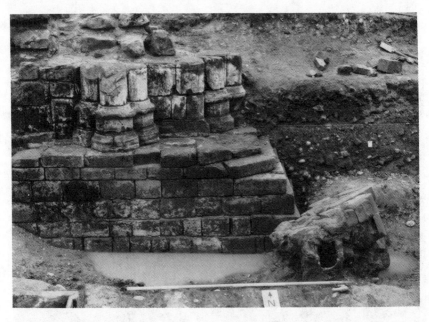

Walsh, Fig. 10 Bordesley Abbey. Northwest crossing pier of Period
 3C viewed from the south (photo: P. Rahtz).

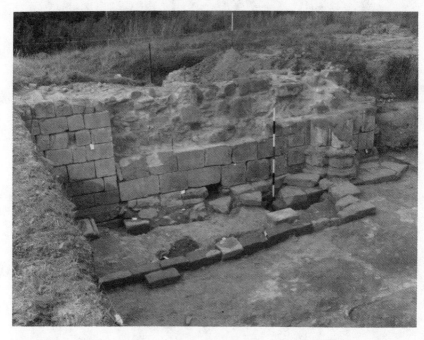

Walsh, Fig. 11 Bordesley Abbey. Period 3C choir stall footings of
the north side of the choir (photo: P. Rahtz).

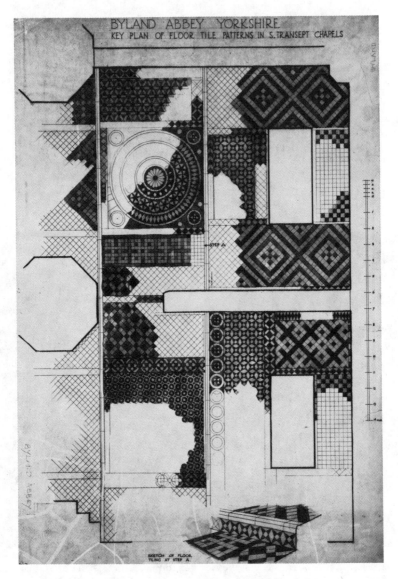

Cothren, Fig. 1 Byland, drawing of the tile mosaic pavement in the
 south transept chapels. (Photo: Crown Copyright--
 reproduced with permission of the Controller of Her
 Britannic Majesty's Stationery Office)

Cothren, Fig. 2 Newbattle, diagram of the composition of two tile mosaic patterns. (J. S. Richardson, *Proceedings of the Society of Antiquaries of Scotland*, 1928)

Cothren, Fig. 3 Rievaulx, tile mosaic patterns as reconstructed in the British Museum. (Photo: Trustees of the British Museum)

Cothren, Fig. 4 Newbattle, drawings of reconstructed tile mosaic
 patterns. (J. S. Richardson, *Proceedings of the
 Society of Antiquaries of Scotland*, 1928)

Cothren, Fig. 5 Newbattle, drawings of reconstructed tile mosaic
 patterns. (J. S. Richardson, *Proceedings of the
 Society of Antiquaries of Scotland*, 1928)

Cothren, Fig. 6 Newbattle, drawings of two reconstructed wheel
 patterns. (J. S. Richardson, *Proceedings of the
 Society of Antiquaries of Scotland*, 1928)

Cothren, Fig. 7 Meaux, tile mosaic patterns. (Beaulah photo in
Eames, *Medieval Archaeology*, 1961)

Cothren, Fig. 8 Meaux, drawings of two reconstructed wheel patterns.
 (Poulson, *History and Antiquities of Holderness*,
 1843)

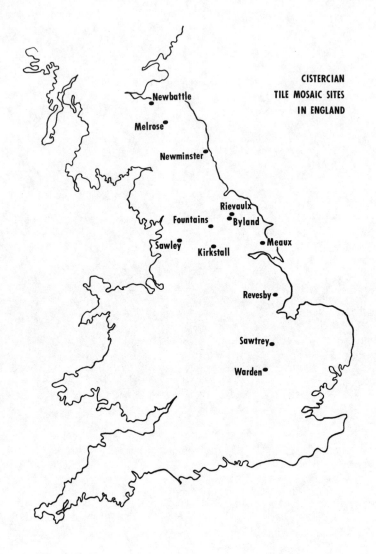

CISTERCIAN
TILE MOSAIC SITES
IN ENGLAND

Newbattle

Melrose

Newminster

Rievaulx

Fountains Byland

Sawley Kirkstall Meaux

Revesby

Sawtrey

Warden

Cothren, Fig. 9 Cistercian tile mosaic sites in England.

Cothren, Fig. 10 Walkenried, drawing of reconstructed tile mosaic
patterns. (From Pfeiffer, *Zeitschrift für Bau-
wessen*, 1914; photo courtesy of Dr. Hiltrud Kier)

Cothren, Fig. 11 Pontigny, drawings of tile mosaic patterns found
 in the choir chapels. (Amé, *Les Carrelages
 émaillés*, 1859)

Cothren, Fig. 12 L'Ile-en-Barrois, drawings of reconstructed tile
mosaic patterns. (Maxe-Werly, *Mémoires de la
société nationale des antiquaires de France*, 1892)

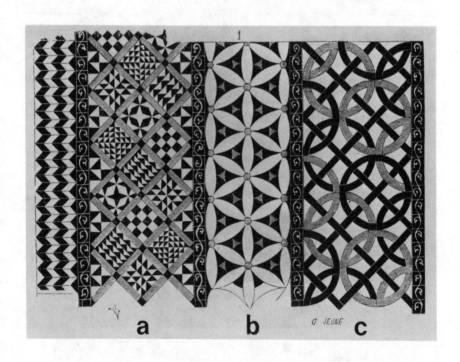

Cothren, Fig. 13 Saint-Denis, drawing of reconstructed tile mosaic
 pavement in the Virgin Chapel. (Viollet-le-Duc)

a　　　　　　　　　　　b

Cothren, Fig. 14　　Saint-Denis, diagram of the composition of two
tile mosaic patterns in the Saint Cucuphas chapel.
(Viollet-le-Duc)

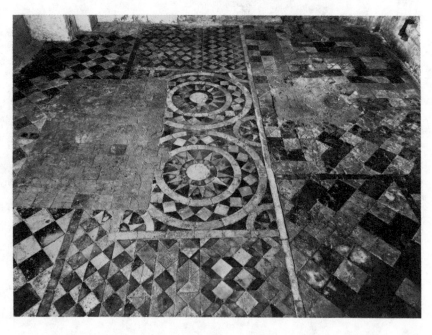

Cothren, Fig. 15 Châlons-sur-Marne, cathedral, tile mosaic pave-
 ment. (Photo: ARCH. PHOT., Paris/S.P.A.D.E.M.)

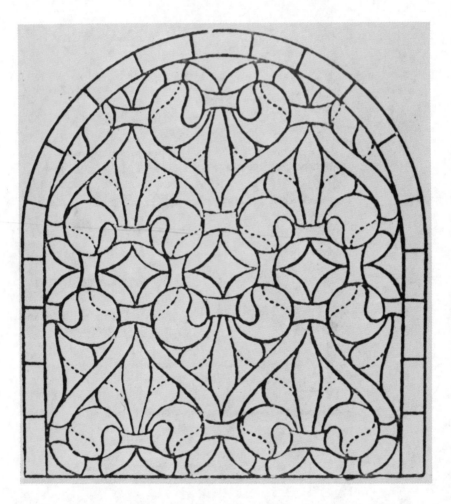

Brisac, Fig. 1 Bonlieu, former abbey church. Lost grisaille panel
 (after 1150). (After Abbé J. Texier)

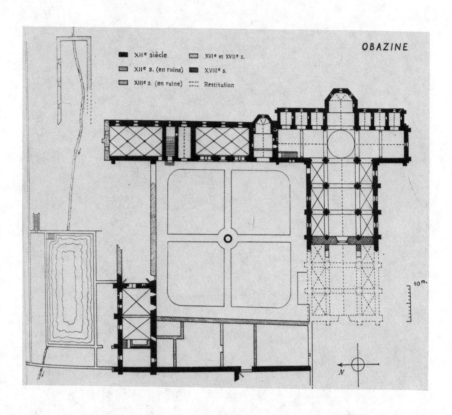

Brisac, Fig. 2 Obazine, former abbey church. Plan.
(After L. Dimier, L'art cistercien, Zodiaque)

Brisac, Fig. 3 Ch H. Purday, Sketch of two grisailles from Obazine
(1873). (Paris, Archives des Monuments Historiques)

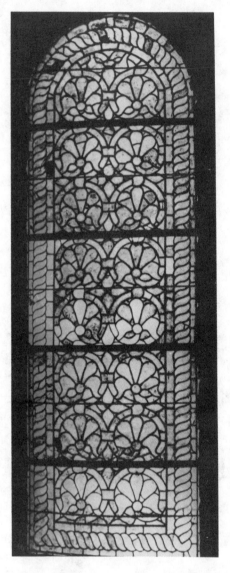

Brisac, Fig. 4 Obazine, former abbey church. Grisaille A, north
 aisle, nave. (Arch. Phot.)

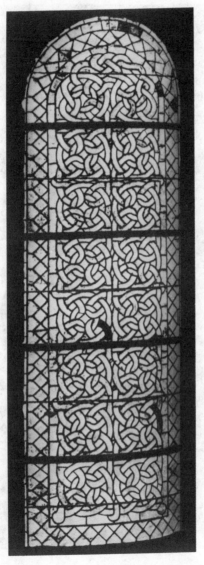

Brisac, Fig. 5 Obazine, former abbey church. Grisaille B, north
aisle, nave. (Arch. Phot.)

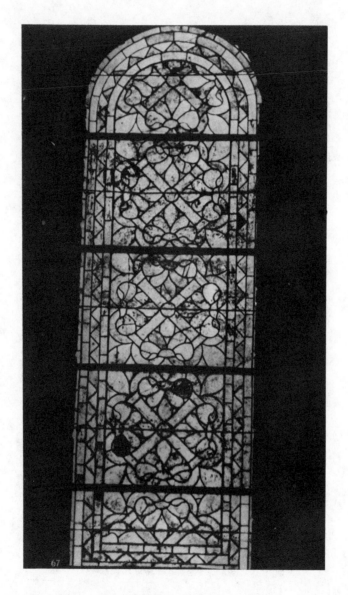

Brisac, Fig. 6 Obazine, former abbey church. Grisaille C, north
 aisle, nave.(Arch. Phot.)

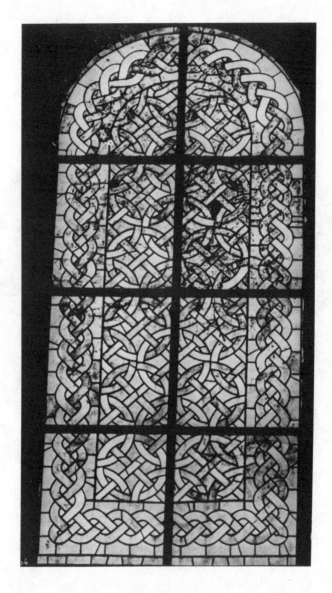

Brisac, Fig. 7 Obazine, former abbey church. Grisaille D, north
 transept. (Arch. Phot.)

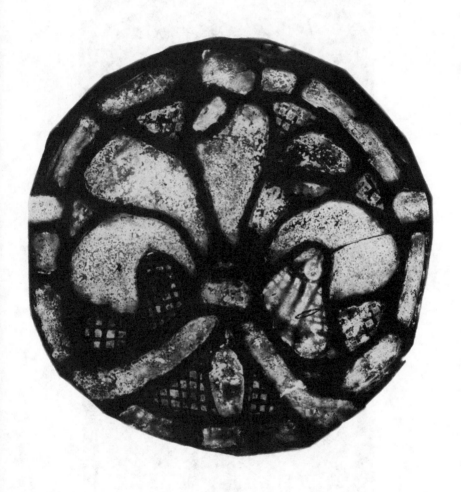

Brisac, Fig. 8 Noirlac, former abbey.church. Grisaille fragment.
(Private collection) (Arch. Phot.)

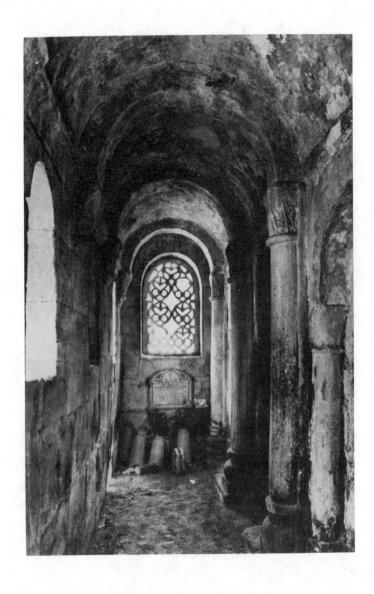

Brisac, Fig. 9 Val de Dios, San Salvador: Visigothic transenna
 (Paris, Université de Paris. iv fonds Gaillard)

Brisac, Fig. 10 Obazine, former abbey church. Grisaille B; diagram
 of the organization of the design according to E.
 Frodl-Kraft (drawing J. Blécon).

Brisac, Fig. 11 Fenioux. *Fenestella* (eleventh century) (Corpus
 des sculptures pre-romanes. D. Fourmont).

Brisac, Fig. 12 Fenioux. Window screen now lost (after C. Enlart).

Brisac, Fig. 13 Saint-Rémy-sur-Creuse (Creuse). Romanesque window
 screen. (C.E.S.C.M., Poitiers).

Brisac, Fig. 14 Verrie (Maine-et-Loire). Section of a blocked
 window screen (C.E.S.C.M., Poitiers).

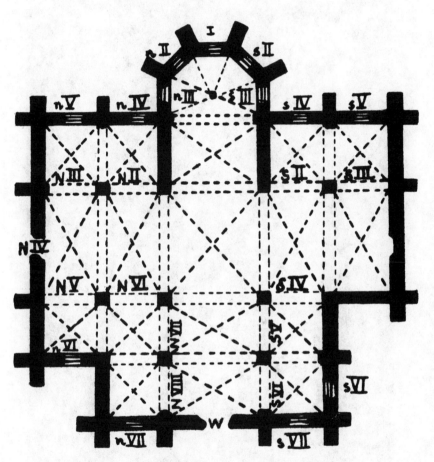

Zakin, Fig. 1 La Chalade. Plan (after M.-A. Dimier, revised by
H. Zakin, drawn by J. Benedict)

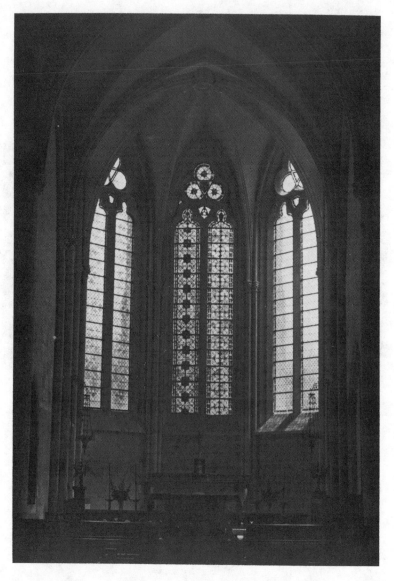

Zakin, Fig. 2 La Chalade. Apse (author)

Zakin, Fig. 3 La Chalade. Grisaille lancet at I, detail
 (author)

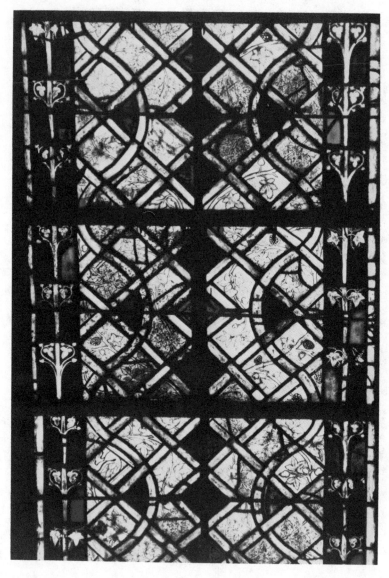

Zakin, Fig. 4 La Chalade. Grisaille lancet at I, detail
 (author).

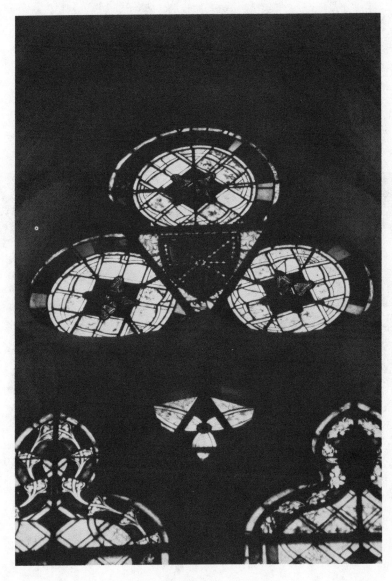

Zakin, Fig. 5 La Chalade. Arms of Navarre at I (author)

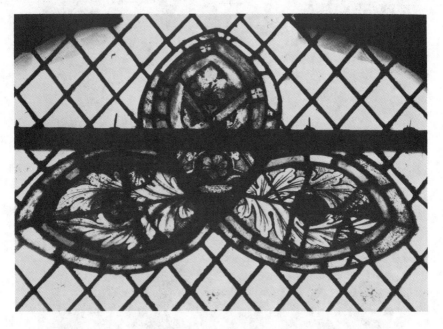

Zakin, Fig. 6 La Chalade. Grisaille trilobe at nV (author)

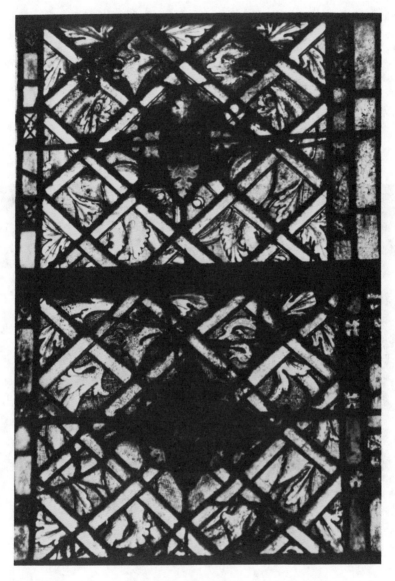

Zakin, Fig. 7 La Chalade. Grisaille lancet at nIV (author)

Zakin, Fig. 8 La Chalade. Grisaille lancet at sIV (author)

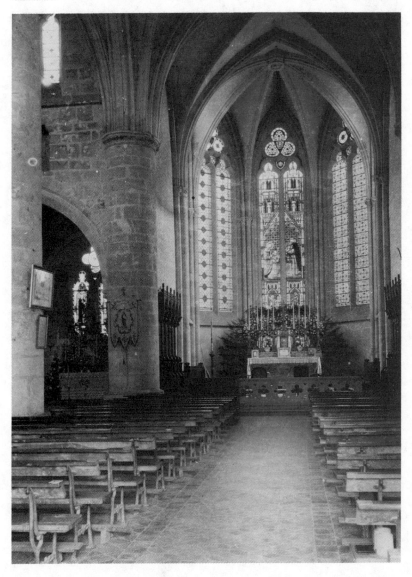

Zakin, Fig. 9 La Chalade. Apse (about 1910) (Arch. Phot.,
Paris/SPADEM.VAGA, New York, 1980)

Zakin, Fig. 10 Saint-Urbain, Troyes. Grisaille lancet, trans-
 sept, detail (author)

CISTERCIAN PUBLICATIONS INC.

TITLES LISTING

THE CISTERCIAN FATHERS SERIES

THE CISTERCIAN STUDIES SERIES

Temporarily out of print †Forthcoming